Assessing New Literacies

new
literacies

AND DIGITAL EPISTEMOLOGIES

Colin Lankshear, Michele Knobel,
and Michael Peters
General Editors

Vol. 34

PETER LANG
New York • Washington, D.C./Baltimore • Bern
Frankfurt am Main • Berlin • Brussels • Vienna • Oxford

Assessing New Literacies

PERSPECTIVES
FROM THE CLASSROOM

EDITED BY Anne Burke & Roberta F. Hammett

PETER LANG
New York • Washington, D.C./Baltimore • Bern
Frankfurt am Main • Berlin • Brussels • Vienna • Oxford

Library of Congress Cataloging-in-Publication Data

Assessing new literacies: perspectives from the classroom /
[edited by] Anne Burke, Roberta F. Hammett.
p. cm. — (New literacies and digital epistemologies; v. 34)
Includes bibliographical references.
1. Computers and literacy. 2. Educational tests and measurements.
3. Internet literacy. 4. Computers and children. 5. Digital media—
Social aspects. I. Burke, Anne. II. Hammett, Roberta F.
LC149.5.R48 371.26—dc22 2008053499
ISBN 978-1-4331-0267-7 (hardcover)
ISBN 978-1-4331-0266-0 (paperback)
ISSN 1523-9543

Bibliographic information published by **Die Deutsche Bibliothek**.
Die Deutsche Bibliothek lists this publication in the "Deutsche
Nationalbibliografie"; detailed bibliographic data is available
on the Internet at http://dnb.ddb.de/.

© 2009 Peter Lang Publishing, Inc., New York
29 Broadway, 18th floor, New York, NY 10006
www.peterlang.com

Table OF Contents

Acknowledgments

We gratefully acknowledge the participants in the various research studies described in this book.

Anne Burke and Roberta F. Hammett express appreciation to Teeba Alsafar who conscientiously assisted with several editorial activities as the book was readied for publication.

Maureen Kendrick, Roberta McKay, and Harriet Mutonyi wish to extend sincere gratitude to all of the students in Canada, New Zealand, and Uganda who so willingly shared their drawings and ideas.

Kay Kimber and Claire Wyatt-Smith wish to thank the Australian Research Council for funding to enable the longitudinal research study conducted by Griffith University, Australia, 2003–2007 and Ms Amanda Bell, Principal, Brisbane Girls Grammar School, Australia, for support of the secondment of Dr Kay Kimber to Griffith University, 2007–2008.

Introduction: Rethinking Assessment FROM THE Perspective OF New Literacies

ANNE BURKE AND ROBERTA F. HAMMETT

INTRODUCTION

Words such as "rethinking" and "new" alert us to the rapid changes in literacies and technology that are challenging and engaging teachers, researchers, readers, and youth globally. Digital text makers and users have taken advantage of the opportunities inherent in developing Internet and information communication technologies (ICTs) to create new textual representations and communicative forms such as wikis, fan fiction, social networking sites like Facebook and MySpace, cyber communities like Second Life, and blogs. These new literacies, as social practices, incorporate both digital and non-digital engagements. Young people especially, in their personal literacy activities, have embraced multimodal forms, combining and remixing visual images and video clips, words, sounds and songs, dance and gesture, and costume—often drawn from popular culture—in creative and expressive ways. Not only do they 'write' and 'read' screens and pages, they also use their bodies as canvases in communication and self expression. In this sense, identities are part of the social and cultural context that, along with technology (the medium), define literacy as practice (Barton & Hamilton, 2008; Gee, 1996; Lankshear & Knobel, 2003). Instant messaging is a good example of representing identities; in addition to abbreviations that make up the alphabetic portion of the conversation, 'speakers' attach constantly-changing icons (animated

characters or popular celebrities) and slogans borrowed from media culture as usernames or 'handles' to represent themselves.

The foregoing examples of online literacy practices demonstrate how social relations and culturally-embedded meanings in the messages and the technologies are central to new literacies, so-called because of their fluid nature, multiplicity, and social character. In new literacies, the importance of discourses, identities, and multimodality is also salient. In this book, authors use other terms synonymous with or integral to new literacies, such as: digital and online literacies, multiliteracies, media literacy, critical literacy and multimodality. They intend that these terms reject an autonomous and skill-driven view of literacy and embrace a sociocultural view that asserts that meanings, purposes, audiences and contexts are central to literacy.

New times, fast capitalism, globalization and immigration, and multinational economies have demanded efficient communication technologies, intercultural understandings, and participants with particular knowledge and cognitive and affective attributes (Gee, 2000; Kalantzis, Cope, & Harvey, 2003). New kinds of workers—knowledge workers—hone their skills on the ever-expanding Internet, which functions simultaneously as a site for education and play. It is with these latter activities that our interest lies; as educators, we are interested in the intersection of education and play online, and the spaces subsequently created inside and outside schools for new literacies. Add the increasingly powerful influence of entertainment media and all forms of popular culture, and you have a mix that truly engages youth.

CHANGING TEXTS

Educators and youth alike understand how Internet technologies are changing the representation of meaning and expanding our communication practices. The increasing dominance of the screen has moved our focus from print-centric texts to moving image texts.

Kress and Jewitt (2003) point out that "[m]ultimodality focuses on the modal resources that are brought into the meaning making" (p. 15). The choices of materiality to be used for representation and expression with digital texts can be endless; besides altering the text itself, practitioners can add animation, wallpaper, emoticons, avatars and a wide variety of other images, all of which are waiting to be transformed by the creator and decoded by the user. This is what makes digital texts like Facebook.com and MySpace.com so attractive; the selection of modes (linguistic, visual, gestural, spatial, aural), which already have social and cultural meanings, and the ways in which they can be bestowed with particular meanings

within the context of communication. Thus sign-making engagements in youth spaces such as Facebook.com are a process of transformation; one in which form and meaning are purposefully combined (or designed and redesigned), with specific effects in mind (Kress, 2004; Cope & Kalantzis, 2000; New London Group, 1996). Young people of all ages create web pages, post their thoughts on message boards, photo-edit and upload digital images to affinity sites like Facebook.com, create and share narrated videos of their experiences on YouTube.com, and participate in virtual communities such as Barbie.com, Teen Second Life, Haboshotel. com, and so much more. Youths' capacity and appetite for these sites are particularly engaged by their collaborative nature, but also by the many possible modes of representation and the enabling materiality of the texts, whether moving images, sounds, music, fonts or graphics.

These particular forms of communicative texts, made "new" through merging popular culture, media, and youth culture, give rise to tensions and bifurcations in school and out-of-school literacies because conversations between educators and youth—that is, students—have not occurred to the extent necessary (Hull & Schultz, 2001; 2002). School classroom spaces and curricular documents define literacy in narrow forms, predominantly forms from which attainable measures may be obtained. As children challenge and push the boundaries and representations of school texts through their own interpretations in spaces such as Facebook, MySpace and YouTube, serious issues of authorship arise. Pop music terms this type of aesthetic reality as "sampling," a redesign process used in youth culture. This action consists of taking recognizable elements from existing pieces of music or from other cultural artifacts, and then incorporating it all into one's own new creation: a new hybrid artifact. To students, these combination pieces are considered new work and just as valuable as an "original" creation. To teachers, they may seem like plagiarism and breaking copyright laws.

Knobel and Lankshear (2008) explain how "[r]emix means to take cultural artifacts and combine and manipulate them into new kinds of creative blends" (p. 2). Some examples they provide are: photoshopping, music and music video remixes, original manga and anime fan art. These are representative of many of the textual practices of young people, but because their multimodal compositions are different from school texts, they are often not understood as being "authentic texts." Viewing literacy through an end-product lens, such as a web page, ignores the process of learning engaged in by the creator because in new literacies this is where literate skills such as sampling or remixing occur. Knobel and Lankshear (2008) suggest looking at the technical, discourse and evaluative dimensions of literacy which are identifiable in remix practices. In this assessment approach the focus is on the process and the cultural aspects one must engage to create the text.

CHANGES IN TECHNOLOGY, COMMUNITY AND SCHOOLS

Lankshear and Knobel (2007, pp. 9–15) provide a comparison chart of views of the contemporary world, designed to demonstrate differing societal views towards technology's role. They divide society's perceptions into Mindset 1, the "physical-industrial" perspective, and Mindset 2, the "cyberspatial-postindustrial" perspective. These mindsets are helpful in developing an understanding of the in-school and out-of-school divides often found in preferred literacies, and are indicative of the difficulties of imagining assessment practices in new literacies. In their comparative table, Lankshear and Knobel discuss the shift in the conception and practice of "expertise." They explain that in Mindset 1, "[e]xpertise and authority are 'located' in individuals and institutions," but in Mindset 2, "expertise and authority are distributed and collective; hybrid experts" (p. 11). It is easy to recognize teachers and schools in the first description, and to conclude that most educational assessment is a product of Mindset 1. Experts determine, teach, and test the learning of curriculum knowledge, almost of all of which has been linguistically encoded and packaged. Assessment, whether large-scale or school- and classroom-based, relies heavily on reading and writing done by individuals because, as Lankshear and Knobel explain, under most current models of schooling, "[t]he individual person is the unit of production, competence, intelligence" (p. 11). New literacies, characterized as "participatory, collaborative and distributed" by Lankshear and Knobel (2007, p. 9), fit within Mindset 2. With a shift away from an individual's personal typographical or text efforts into a digital and group effort, "[t]he focus is increasingly on 'collectives' as the unit of production, competence, intelligence" (p. 11). Assessment in new literacies must therefore be similarly rethought. Alvermann (2008), in her wide-ranging commentary on the problems associated with engaging new literacies in classroom settings, puts the issues very succinctly: "Young people are tirelessly editing and remixing multimodal content they find online to share with others, using new tools to show and tell, and rewriting their social identities... adolescents with access to the Internet are developing the literacies that will serve them well..." (p. 10). The screen is not limited in any way by typographical space and thinking, even though so much of our schools' texts are. Understanding of the forms and practices of youth communication needs to be more clearly articulated. Indeed, Coiro, Knobel, Lankshear and Leu (2008) go so far as to argue that "new literacies are identified with an *epochal change* in technologies and associated changes in social and cultural ways of doing things, ways of being, ways of viewing the world (worldviews) and so on" (emphasis added; p. 7).

The shift in mindset that is characterizing current times in developed countries is not an easy one for educators; much has been written about various aspects

of technology integrations in schools and classrooms (Honan, 2008; Kist, 2005; Lankshear & Knobel, 2003). Not only do teachers sometimes feel ill-prepared and ill-equipped to use technologies in meaningful ways (Cuban et al., 2001; Doering et al., 2003; Granger et al., 2002; Hull & Schultz, 2002), they also typically find they need to adjust to the comparative expertise of their students (Mumtaz, 2000; Ringstaff et al., 1993; Russell & Bradley, 1997). As stated above, there is also the increasing importance of the collective nature of many digital literary spaces. A significant aspect of this design-oriented communicative landscape is the potentialities for building collaborative communities through online tutoring, wikis and blogs, all of which celebrate idea and skill sharing. These multimodal and digital texts present significant challenges to a schooling system in which assessment is strictly based on the successes of the individual learner. New textual engagements of youth are often not individual efforts, but are instead often collaborative in nature which has strong potential to democratize communication through the creation of a participatory culture of learning. As Jenkins (2006) explains, a "participatory culture shifts the focus of literacy from one of individual expression to one of community involvement" (p. 7). More important for the classroom teacher, perhaps, is the issue of how in, say, a collectively authored work like a wiki, "expertise and authority are collectively distributed, thereby blurring distinctions between teachers and learners—especially when the learners are digital insiders" (Alvermann, 2008, p. 14). The subtext of this statement is equally important for educators; as many scholars have pointed out, while students are almost always digital insiders, often their educators are not.

These new texts, technologies and identities created in collaborative communities, challenge schools, curriculum and teachers—the whole education system—to rethink traditional practices and to change mindsets. Recent studies in North America support what teachers and parents already know: children are investing an enormous amount of time in their Internet interactions, time that has enormous potential implications for their literacy behavior. The Pew Internet and American Life Project (Lenhart et al., 2007) conducted a large national survey of teenagers and their parents. This study is particularly interesting as it revealed not just the obvious—that the web is an important social tool for youth—but a more important finding as well. The Pew project focused specifically on the growing level of interactivity engaged in online, pointing out how frequently adolescents actually contribute to websites or create their own websites. For example, researchers found that some 39% of students in the study offer their own creative work online. Another 28% work on web pages in other ways. Over a quarter of those surveyed actually have their own blogs or maintain their own web pages, while more than half maintain a profile on a social networking site like Facebook.com or MySpace.com. The study itself terms teenagers as "Super Communicators" and marvels at how adept

they are at communicating and in using many levels and forms of digital media. While these interactions and communications bear only a passing resemblance to conventional reading and writing, they are an important part of youth's lives, and must be considered in any serious discussion of literacy behavior.

Young Canadians in a Wired World Phase II (Government of Canada, 2005), conducted by the Media Awareness Network in Canada, interviewed over 5000 children and provides an in depth look at the technological world in which children engage. Illustrating how much and how fast technology is changing our world, the study provided a telling example: in just four years, the number of students with e-mail addresses increased from 71% to 86%. In 2005, almost 23% of the children surveyed had their own cell phones, while almost half had access to these devices by the time they reached Grade 11 (p. 4). In 2001, cell phones were still a relatively expensive luxury, yet a few years later, half of a senior class would see them as routine personal accessories. This speaks to the quickened pace of technological change in children's lives and that is characteristic of the 21st century. More important, though, is that both of these studies show the large dichotomy between students' uses of technology for educational purposes and for their own literacy within their own spaces. These trends certainly point to a need to widen current understandings that these literacies are not just connected to the social lives of youth, but to their literate lives and engagements as well.

CHANGING SCHOOLS

Researchers (such as Hull & Schultz, 2001; Alvermann & Heron, 2001; Hagood, 2008; Moje, 2007; and all the authors included in this volume) have noted that the social practices engaged in children's literate lives incorporate multimodal forms of communication different from the largely alphabet-based texts in schools. In order to bridge the social practices of youth from home to school, educators will need to more fully account for these multimodal forms of communication within classroom pedagogy. As Cope and Kalantzis (2000) assert, "[l]iteracy teaching and learning need to change because the world is changing" (p. 41), and this may mean that classrooms need to be more like online communities—"oriented to flexibility and problem solving, and rooted in the understanding that ways of participating differ in particular situated practices" (Gee, 2000, p. 51).

What are other challenges for schools attempting to include new literacies in their classrooms? The literacies of today's youth are quite creative and personal. Youth literacy spaces such as Myspace.com and Facebook.com are framed within cultural understandings of how texts may be used for expression and communicative purposes (Thomas, 2007). Adding new literacies and associated forms of

representation to current curriculum is undeniably challenging. Digital texts are not easily made compatible with traditional print-based texts, and as such there is a lack of broad principles by which they can be defined. Furthermore, beyond the many issues of textual criteria are questions of identity. The context of the user, and how their own digital space is explored, can be interpreted and used in differing ways.

CHANGING ASSESSMENT

Assessment of new literacies is quite complex and past attempts to evaluate these types of engagements have resulted in questioning of their legitimacy, because when defined in terms of school texts, they do not neatly fit into current genres taught in schools (Johnson & Kress, 2003; Jewitt, 2003; Bearne, 2003). Assessment has many forms and functions; it may be formal or informal, summative or formative, large-scale or classroom based. It may be justified in many ways: to improve teaching, to inform learning, to inform parents, for accountability, to evaluate programs, to reveal progress over time, and for comparative purposes (Black & Wiliam, 1998). As several of the authors in this book assert, by its very nature, assessing is a political act—an act of power—that is usually carried out by gatekeepers who define and codify knowledge. Assessment in schools is usually paper-based, typically involves reading and writing, and most often measures individual achievement. Assessment of new literacies has been challenging, because the ephemeral nature of new literacies does not readily lend itself to paper-and-pen assessment, or to standardized tests and the political importance of test scores.

Creating multimodal texts requires many critical processes of learning. To include these texts in school curriculum is quite difficult, because teacher guides and lessons are still quite bound by an assessment culture which is end-product oriented and which negates social learning and composing processes characteristic of multimodal texts (Johnson & Kress, 2003). High stakes assessment provides only snapshots of particular points of learning in particular populations at particular times. In order for assessment to represent the multimodalities characteristic of outside-school literacies, and ultimately represent the types of textual engagements characteristic of youth culture, we need to move away from snapshots of achievement and move towards a more nuanced understanding of youth's practices and development of texts. The task must be to develop new types of assessment which are more in tune with the new literacies important in their lives (Bearne, 2003). Non-school texts, such as fan fiction, weblogging, and participation in affinity spaces, often paint vivid illustrations of students' funds of knowledge, and contribute deeply to our understanding of how they participate and communicate within their literate worlds (Moll et al., 1992; Hagood, 2008; Stone, 2007; Black, 2005).

This book takes up the challenge of considering non-school texts as appropriate school texts and speculating how assessments might change to accommodate them in classrooms.

THE CONTRIBUTIONS IN THIS BOOK

What does it mean to assess the texts that are characteristic of youth culture? As educators, our priority must be to revisit the current definitions and boundaries of text; that is, the rules which delineate schooled notions of literacy. We must embrace larger notions of text and invite multimodal forms of representation into our classrooms. We need to reexamine beliefs about the equity found within language representation, and to learn how to accept and value learning that comes from outside the classroom. Our mindset must change; instead of fearing multimodal representation, we must become its advocate, begin to use these forms in our teaching, and become open to the differing ways texts may be shared. Ultimately, this means we must develop new forms of assessment and in the process shift our whole conception of assessment and ensure it is based on conceptual understandings of new literacies and not print-centric understandings.

Expanding notions of print and encoded texts and the growing predominance of the digital also call for a serious rethinking of literacy education programs for preservice teachers. The challenges of assessing literacy will not be so difficult for the current generation of preservice teachers; by definition, they are already digital natives, and will be more comfortable in digital spaces. But even with a new generation of teachers whose lives are already centered within new literacies, there will be challenges in reconciling the textual practices which frame their lives with those common in schools. In drawing upon these new spaces, and inviting them into our classrooms, we will have to expand our conceptions about language learning, especially our epistemological understanding that literacy is constantly changing because new technologies require new skills and understandings. As we come to understand these spaces, and all the implications that come with them, we can discover how we can go about assessing these practices.

The chapters in this book are founded within many of these ideas about new literacies and schools, and all take up the challenge of rethinking assessment so that it supports, rather than ignores, new literacies. All chapters intend to assist educators in their endeavors to shift mindsets and change their pedagogies to more seamlessly incorporate new literacies in everyday school practices. Most begin with an argument about the ubiquity of digital technologies and students' skills in using them. Most then follow this up with discussions about how teachers can and should lead students toward more purposeful, ethical, transformative, creative,

collaborative, and metacognitive engagements with digital and multimodal texts as both consumers and producers. A wide variety of perspectives on assessment is shared, though most chapters advocate the involvement of teachers and students in developing understandings of new literacies and criteria to scaffold both knowledge development and assessment.

In many of the chapters in this book, authors take care to describe explicitly the features of multimodal texts, to tease out the practices and knowledges engaged in interpreting and composing them, and the connections and similarities to traditional and school-based literacies. By examining the affordances of various Internet sites and other textual engagements, in detail, we may develop understandings of and possibilities for implementation and assessment of new literacies in school. Eve Bearne begins this book and focuses directly on assessment. She starts with familiar texts and tests in classrooms and builds on these to demonstrate what multimodal compositions might look like and how they might be assessed. She vividly describes young authors' impressive multimodal texts and leads readers through a framework for examining them. Maureen Kendrick, Roberta McKay, and Harriet Mutonyi closely examine visual representations produced by children on three continents and offer their methods of interpretation as a model for educators challenged to assess students' visual texts. Visual texts, they assert, reveal what words do not—in particular, imagined freedom, the narrated self, voice, emotions and experiences, and the social and cultural contexts within which the children live and learn. Further, students themselves have perspectives that can and should inform educational policy and assessment practices.

Anne Burke looks at assessment of digital reading on the screen and suggests that students' authored reading trajectories are creative efforts of assembling material, designing and identity formation. By looking at what students do in school with technology, and contrasting their efforts with discussions and observations of their home digital reading practices, she shows how students' expansive designing of texts is representative of future life skills and has strong curricular potential, alongside developing multilayered possibilities for communication.

Margaret Hagood, Emily Skinner, Melissa Venters, and Benjamin Yelm explore implementation of new literacies in social studies, focusing on content-area reading and content learning, and developing understandings of how integrating academic and digital literacies and assessments can be achieved. Teachers used PowerPoint, photostories, web pages, and cartooning, thereby changing their pedagogies and mediating identities as new literacies teachers.

Looking into a different space—that is, Facebook—Jennifer Rowsell aims "to open up what we mean by literacy today" by scrutinizing sample Facebook pages, exploring their authors' identities, and demonstrating how a model for assessing

the rhetorical uses of multimodality can be applied to the pages. The assessment model and Rowsell's questions and comments about naturalized practices, conventions, and identity mediation offer educators foundations for developing assessment practices appropriate to their own classroom contexts.

Jill Kedersha McClay and Margaret Mackey note that some teachers, by their own admission, are not prepared to engage new literacies, while others are enthused and invigorated by the possibilities. They note that current assessment practices are not adequate to measure the new ways of thinking, composing and critiquing offered in new literacy environments, and thus propose distributed assessment as an appropriate and authentic approach to assessment in new literacies. Building on Eve Bearne's framework, they demonstrate how their concerns for participation, transparency and ethics may be incorporated within assessment processes and shared responsibly among teachers and learners. They also suggest that an audit of assets—knowledge and use of a wide variety of technologies—be added to learning contexts.

Like Hagood and her coauthors, Kay Kimber and Claire Wyatt-Smith begin with the home-school literacies divide, and describe twenty-first century learners who may be engaged in new literacies and disengaged in school. They provide a framework that can guide implementing and assessing new literacies. Throughout their chapter, they gradually build the framework, explicating the foundational knowledges, the essential digital learnings, the habits of mind, and the over-arching capacities that could well support educators as they facilitate a classroom ecology where virtual and physical, home and school practices, and community, curricular and criterial knowledges are engaged. Rather than focusing on content and facts, Kimber and Wyatt-Smith argue, education ought to evoke a learner's cognitive, metacognitive, performative and transformative capacities. In suggesting a framework for essential digital learnings, Kimber and Wyatt-Smith provide a useful model for all literacy learning and assessment, including: e-proficiency, e-credibility and e-designing, extending through to meta-learning.

Richard Beach, Linda Clemens, and Kirsten Jamsen illustrate how digital tools may be used as assessment tools. Similar to most authors in this book, they assert the importance of developing criteria to describe multimodal texts as a significant step toward appropriate assessment. They develop their argument based on insightful and extensive descriptions and demonstrations of multimodality, hypertextuality and interactivity in their teacher education programs. In the final chapter, Roberta Hammett also turns her attention to teacher education, arguing the importance of incorporating new literacies in teacher education programs. She draws on self-assessment data collected from preservice teachers to understand their struggles and successes as they learn to use and implement new technologies in their teaching.

In sum, throughout this book, authors offer thoughtful responses to assessment concerns. Contributors draw on theory and explicate it with a wealth of applications and examples. Some authors provide frameworks and models to guide thinking about and planning for assessment. Most explore possibilities without preconceived orthodoxies, and all present rich descriptions of classrooms, new literacies environments and multiple examples of texts and text making. We hope readers will be left with a strong sense of the importance of new literacies in school contexts and educators will be enthusiastic to implement them in curriculum and develop complementary ways of assessing them.

REFERENCES

Alvermann, D., & Heron, A. (2001). Literacy identity work: Playing to learn with popular media. *Journal of Adolescent & Adult Literacy, 45*(2), 118–122.

Alvermann, D.E. (2008). Why bother theorizing adolescents online literacies for classroom practice and research? *Journal of Adult and Adolescent Literacy, 52*(1), 8–19.

Barton, D., & Hamilton, M. (2000). Literacy practices. In D. Barton, M. Hamilton, & R. Ivanic (Eds.), *Situated literacies: Reading and writing in context* (pp. 7–15). New York: Routledge.

Bearne, E. (2003). Rethinking literacy: Communication, representation, text. *Reading Literacy and Language, 37*(3), 98–103.

Black, P., & Wiliam, D. (1998). Assessment and classroom learning. *Assessment in Education, 5*, 7–74.

Black, R.W. (2005). Access and affiliation: The literacy composition practices of English language learners in an online fanfiction community. *Journal of Adult and Adolescent Literacy, 49*(2), 118–128.

Coiro, J., Knobel, M., Lankshear, C., & Leu, D.J. (2008). Central issues in new literacies and new literacies research. In J. Coiro, M. Knobel, C. Lankshear, & D.J. Leu (Eds.), *Handbook of research on new literacies* (pp. 1–21). Mahwah, NJ: Erlbaum.

Cope, B., & Kalantzis, M. (2000). Introduction. In B. Cope, & M. Kalantzis (Eds.), *Multiliteracies: Literacy learning and the design of social futures* (pp. 41–42). London and New York: Routledge.

Cuban, L., Kirkpatrick, H., & Peck, C. (2001). High access and low use of technologies in high school classrooms: Explaining an apparent paradox. *American Educational Research Journal, 38*(4), 813–834.

Doering, A., Hughes, J.E., & Huffman, D. (2003). Preservice teachers: Are we thinking with technology? *Journal of Research on Technology in Education, 35*(3), 342–361.

Gee, J.P. (1996). *Social linguistics and literacies: Ideology in discourses* (2nd ed.). London: Taylor & Francis.

Gee, J.P. (2000). New people in new worlds: Networks, the new capital, and schools. In B. Cope & M. Kalantzis (Eds.), *Multiliteracies: Literacy learning and the design of social futures* (pp. 43–68). London and New York: Routledge.

Gee, J.P. (2000–2001). Identity as an analytic lens for research in education. *Review of Research in Education, 25*, 99–125.

Government of Canada, Industry Canada (2005). *Media Awareness Network. Young Canadians in a Wired World.* ERIN Research Inc. Retrieved on April 30, 2008 from www.media-awareness.ca

Granger, C.A., Morbey, M.L., Lotherington, H., Owston, R.D., & Wideman, H.H. (2002). Factors contributing to teachers' successful implementation of IT. *Journal of Computer Assisted Learning, 18*(4), 480–488.

Hagood, M.C. (2008). Intersections of popular culture, identities and new literacies research. In J. Coiro, M. Knobel, C. Lankshear, & D.J. Leu (Eds.), *Handbook of research on new literacies* (pp. 531–551). Mahwah, NJ: Erlbaum.

Honan, E. (2008). Barriers to teachers using digital texts in literacy classrooms. *Literacy, 42*(1), 1–8.

Hull, G., & Schultz, K. (2001). Literacy and learning out of school: A review of theory and research. *Review of Educationl Research, 71*(4), 575–611.

Hull, G., & Schultz, K. (Eds.) (2002). *School's out! Bridging out-of-school literacies with classroom practice.* New York: Teachers College Press.

Jenkins, H., with Clinton K., Purushotma, R., Robinson, A.J., & Weigel, M. (2006). *Confronting the challenges of participatory culture: Media education for the 21st century.* Chicago, IL: The MacArthur Foundation. Retrieved on November 18, 2008 from http://www.digitallearning.macfound.org

Jewitt, C. (2003). Re-thinking assessment: Multimodality, literacy and computer-mediated learning. *Assessment in Education, 10*, 83–102.

Johnson, D., & Kress, G. (2003). Globalisation, literacy and society: Redesigning pedagogy and assessment. *Assessment in Education: Principles, Policy & Practice, 10*(1), 5–14.

Kalantzis, M., Cope, B., & Harvey, A. (2003). Assessing multiliteracies and the new basis. *Assessment in Education, 10*(1), 15–26.

Karchmer, R.A., Mallette, M., Kara-Soteriou, J., & Leu, D.J. Jr. (Eds.) (2005). *New literacies for new times: Innovative models of literacy education using the Internet.* Newark, DE: International Reading Association.

Kist, W. (2005). *New literacies in action: Teaching and learning in multiple media.* New York: Teachers College Press.

Knobel, M., & Lankshear, C. (Eds.) (2007). *A new literacies sampler.* New York: Peter Lang.

Knobel, M., & Lankshear, C. (2008). Remix: The art and craft of endless hybridization. *Journal of Adult and Adolescent Literacy, 52*(1), 22–23.

Kress, G. (2004). You made it like a crocodile: A theory of children's meaning-making. In T. Grainger (Ed.), *The Routledge Falmer reader in language and literacy* (pp. 69–83). London: Routledge.

Kress, G.R., & Jewitt, C. (Eds.) (2003). *Multimodal Literacy.* New York: Peter Lang.

Lankshear, C., & Knobel, M. (2003). *New literacies: Changing knowledge and classroom practice.* Buckingham, UK: Open University Press.

Lankshear, C., & Knobel, M. (2006). *New literacies: Everyday practices and classroom learning.* New York: McGraw-Hill; Open University Press.

Lankshear, C., & Knobel, M. (2007). Sampling the "new" in new literacies. In C. Lankshear & M. Knobel (Eds.), *A new literacies sampler* (pp. 1–24). New York: Peter Lang.

Lenhart, A., Madden, M., MacGill, A.R., & Smith, A. (2007, December). *Teens and social media. Pew Internet and American Life Project.* Washington, DC: Pew Charitable Trusts. Retrieved on April 6, 2008 from www.pewinternet.org

Leu, D.J., Jr., Leu, D.D., & Coiro, J. (2004). *Teaching with the Internet: New literacies for new times (4th ed.).* Norwood, MA: Christopher-Gordon.

Moje, E. (2007). Youth cultures, literacies and identities in and out of school. In J. Flood, S.B. Heath, & D. Lapp (Eds.). *Handbook of research on teaching literacy through the communicative and visual arts* (Vol. 2, pp. 207–219). Mahwah, NJ: Erlbaum.

Moll, L., Amanti, C., Neff, D., & Gonzalez, N. (1992). Funds of knowledge for teaching: Using a qualitative approach to connect homes and classrooms, *Theory and Practice, 31*(2), 132–141.

Mumtaz, S. (2000). Factors affecting teachers' use of information and communications technology: A review of the literature. *Technology, Pedagogy and Education, 9*(3), 319–342.

New London Group. (1996). A pedagogy of multiliteracies: Designing social futures. *Harvard Educational Review, 66*, 60–92.

Poster, M. (2006). *Information please: Culture and politics in the age of digital machines.* Durham and London: Duke University Press.

Ringstaff, C., Sandholtz, J.H., & Dwyer, D.C. (1993). *Trading places: When teachers utilize student expertise in technology-intensive classrooms.* (Apple Classrooms of Tomorrow Publishers Report #15), Cupertino, CA: Apple Computer Publications.

Russell, G., & Bradley, G. (1997). Teachers' computer anxiety: Implications for professional development. *Education and Information Technology, 2*, 17–29.

Stone, J.C. (2007). Popular websites in adolescents' out of school lives: Critical lessons on literacy. In C. Lankshear & M. Knobel (Eds.), *A new literacies sampler* (pp. 49–65). New York: Peter Lang.

Thomas, A. (2007). *Youth online: Identity and literacy in the digital age.* New York: Peter Lang.

Assessing Multimodal Texts

EVE BEARNE

Multimodality is a relatively new element in discussions about the curriculum, and assessment of multimodal texts is very much in its early stages. This chapter considers assessment of multimodality within the curriculum areas of literacy/ English/language arts since this is the area of the curriculum where multimodal communication and representation have been most evident.[1] While both reading and composing/creating multimodal texts are discussed, this chapter ends with suggestions for a framework for describing composed multimodal texts with descriptors of progress which might act as a basis for assessment.

There are tensions and difficulties in setting up assessment procedures at a national level for multimodality. Much of the current understanding of multimodality is based on the notion of design (Cope & Kalantzis, 2000; Bearne & Kress, 2001) and is therefore often unfamiliar to teachers of English/literacy (Matthewman, Blight, Davies, & Cabot, 2004). Also, as Matthewman points out, multimodality crosses subject areas of the curriculum so there are tensions between the subject boundary of English and other subjects. Besides this, at the moment, many of the key terms and concepts associated with multimodality relate to different disciplinary discourses, for example, the performing arts, technology, graphic design, and media studies as well as English or language arts. This strongly suggests the need for a more explicit discussion of multimodality as realised in the wider curriculum.

The impact of digital technologies on education has meant that an increasing number of texts which include words and images are produced through different media of communication, for example:

- the computer: Internet information and PowerPoint presentations
- paper-based texts: picturebooks, magazines, novels, information books
- sound and visual media: radio, television, videos and DVDs.

However, multimodal texts are also created and viewed through the media of sound and vision without screens—as told stories, drama, and presentations—and these need to be included in descriptions and definitions of multimodal texts (Bearne, 2009).

Whatever the medium of communication, multimodal texts are made up of different combinations of modes:

- gesture and/or movement
- images: moving and still, diagrammatic or representational
- sound: spoken words, sound effects, and music
- writing or print, including typographical elements of font type, size, and shape.

Over time, cultures develop regularities in any mode(s) of representation. In multimodal texts these patterns and expectations—and the associated metalanguage—are somewhat different from the texts usually associated with English or language arts as subjects in the curriculum. The culture's set of values creates expectations about what makes a "good" or successful text and these judgements influence assessment practices. In this way, both the content and treatment of multimodal texts are necessarily culturally shaped.

THE CURRICULUM AND ASSESSMENT

Before looking more closely at assessment and multimodal texts, it is important to consider the practices which surround assessment of literacy. As Johnson and Kress explain, assessment of literacy needs to be seen in the context of increasing diversity:

> The multilinguistic and multicultural nature of society…requires us to think in new and different ways about what literacy is, and how it ought to be considered "successfully mastered" (Johnson & Kress, 2003, p. 9).

At global and national levels, then, assessment of multimodality is influenced by shifting concepts of literacy. However, Johnson and Kress also argue that these

shifts operate not only globally, but locally and culturally as well:

> We would have thought that the design of new literacy curricula and literacy peda-
> gogy would reflect a move away from the conception of literacy as a narrow, singular
> standard, to one which encourages people to learn a range of new discourses and
> modes of communication to enable them to deal with local diversity and the demands
> of local cultures (Johnson and Kress, 2003, p. 9).

For many years it has been acknowledged that reading and writing are not just the responsibility of English/literacy/language arts teaching but permeate the whole curriculum. Although multimodal texts also span the curriculum, much of the development around multimodality has derived from literacy and language studies.

Reading multimodal texts is already a part of the formal language and literacy curriculum (in schools in the U.K. this is often seen in "media studies") and appears sometimes within current tests and examinations under the guise of "comprehension." However, representation—that is, composing or creating multimodal texts—does not appear at all in English tests since assessing multidimensional texts is not seen as possible within current frameworks used for national tests of writing ability. Not only are there challenges related to the nature of the texts, but there are practical difficulties. Nationally administered testing usually depends on material being taken away and assessed at a different place and time from the classroom in which it was written. The work then can be described, commented on, and assessed at a distance. There is an immediate problem for multimodality here as writing is only part (if at all) of a multimodal text. Even where the texts created are gestural and visual—for example, drama or films—national testing requires a written element to substantiate judgements of worth.

A further challenge lies in the difference in cultural sites of making texts in relation to the curriculum. Kalantzis, Cope and Harvey identify an increasing demand by governments for "basic skills" testing which can reflect national standards (Kalantzis, Cope, & Harvey, 2003, p. 15). This seems to be at odds with the world outside the classroom where knowledge is: "highly situated; rapidly changing; and more diverse than ever before" (ibid, p. 16). They argue that successful learners will need to be flexible, collaborative, and versatile. For this to happen not only will curricula need to be differently conceived and shaped but also will teaching and learning need to reflect greater diversity of approaches and texts. This implies considering the kind of pedagogy which will best foster versatility and support learners getting to grips with the increasing demands of a multimodal English/literacy curriculum.

There is already some exciting multimodal teaching going on (Newfield, Andrew, Stein, & Maungedzo, 2003; Comber & Nixon, 2005; Marsh, 2005)

which involves not only active, imaginative involvement by learners, but also the production of a range of texts: enacted, constructed, embroidered, drawn, photographed, and designed on computer screens (see also Kendrick et al., this volume). These are sometimes individually composed, but often multimodal production is a matter of collaboration. The range of approaches, the variety of texts and the teamwork associated with production, suggest the complexities of assessing multimodal texts. Before considering how the texts might be assessed, however, it is worth revisiting some issues about assessment itself.

WHAT—OR WHO—IS ASSESSMENT FOR?

There are several answers to this question. At one end of the spectrum are high stakes assessments carried out through national tests to give governments oversight of the standards of education provided in a country. At the other end are the minute-by-minute assessments made by teachers and practitioners as they adjust their teaching to help individual children get to grips with learning. The purpose of any assessment determines the kind of process used. If a nation wants a standard by which to measure educational provision and assess levels of competence or "performance," then a national test, managed and assessed by a government-authorised organisation, is seen as the most efficient way to ensure trustworthy measures and results. While this can often seem inflexible, the fact remains that access to further and higher education and to many occupations depends on an individual being able to show attainment at certain levels of such tests. A tension for teachers can be how to balance the urge to foster the student's potential and maintain individuality, with the knowledge that it is a student's right to be provided with access to the academic qualifications which stand as gateways to the future.

Further to the tensions between assessment to promote individual achievement and also reach national standards, assessment models and processes are constructed within particular cultural contexts for specific political and social purposes. If multimodality is difficult to assess nationally, then it is likely to be squeezed out of the curriculum and valuable cultural capital squandered (Bearne, 2003). From a South African perspective, Stein (2006) argues that in terms of reading, it is possible to assess multimodality at a national level. Her work indicates that some aspects of multimodal teaching and learning can be accommodated in national testing arrangements. However, whilst she focuses on reading, in most subjects, for older students at least, writing remains the predominant medium of assessment—even in creative areas of the curriculum. One of the problems for assessing multimodally-composed texts is that national summative tests are

necessarily assessments of learning which do not readily embrace multimodal forms of text. You cannot carry away a verbal presentation which has been accompanied by digital technology. While the screens can be captured and even the voice recorded, the gesture, expression, and movement associated with a demonstration of learning cannot be taken away and assessed by a distant examiner. It is likely that in the future some types of multimodal texts, for example, image plus writing, might be included in assessing multimodal texts, perhaps presented in portfolios (both in electronic and paper-based forms), but this does not answer the fundamental problem of nationally-managed assessment systems being organisationally prevented from properly assessing multimodal texts. In looking to the future of assessment of multimodal texts, the indications are that there will be a shift away from summative assessments *of* learning towards processes of continuing assessment or assessment *for* learning.

In contrast with national summative tests of performance which are focused on the achievement of the individual, when teachers and practitioners want to confirm that their teaching is genuinely catering to all pupils, they use processes of formative assessment. Weekly (sometimes daily) and term or marking period records help to track the progress of the teaching as well as providing information about individuals. Importantly, formative assessment is more inclusive, as it means sharing learning goals with pupils and providing feedback to help them to identify how to improve. Together, teacher and pupils review and evaluate work. In this way the pupils come to understand both the language and processes of assessment so that they learn how to make judgements about the quality of their own work. The inclusive and recursive nature of formative assessment means that it contributes to developing the learner's reflective understanding. Recommendations to share assessment goals and criteria and the inclusion of student self-assessment represent a shift from end-point, summative assessment towards a more collaborative approach. Developing such a process depends on teachers having a sense of what they should be teaching, and national curricula and frameworks provide the guidance. This sounds all well and good. The recent revision of the Literacy Framework in England (2006) now includes "reading on paper and on screen" and "writing on paper and on screen" which might signal a more open acceptance of multimodal texts. However, these are not likely to be nationally tested in the very near future. This means that teachers' own assessments will need to be very well informed about the dimensions of multimodal teaching and learning and the ways in which progress in multimodality might be described. Accordingly, this implies a shift in teachers' perceptions of what constitutes "literacy." It means a move away from traditional views of reading and writing and the development of a metalanguage to support this change of emphasis.

ASSESSING PRODUCTION OF MULTIMODAL TEXTS

It is time, then, for "rethinking literacy" (Bearne, 2003) since any approach to classroom literacy needs not only to recognise the new forms of text which children meet every day but also to give multimodal texts a firm place in the curriculum. If young learners' experience and knowledge about multimodality are to be realised in the classroom, practitioners will need "a means of sharing common terminology about text structure and cohesion whilst recognising the different affordances of modes and media" (Bearne, 2003, p. 102), in other words, a framework for describing multimodal texts. This will require some attentive and careful work by teachers so that they cannot only help children to adopt a critical view of the texts they come across, but also give them the means to analyse the cultural conditions in which these texts are produced. However, it is not enough to expect individual teachers to extend their expertise independently; this will have to be supported by inclusion of multimodality in institutional arrangements for assessment.

I want to argue that this can be made possible partly by building on current assessment criteria and processes. Two research projects in the UK: *More than Words 1 and 2* (UKLA/QCA, 2004, 2005) used nationally agreed descriptors, or "strands," for assessing writing to see how far these, as part of an existing national assessment framework, might accommodate multimodal texts created by pupils aged 5 to 12 years. The main strands are: *Composition and Effect, Text Structure and Organisation,* and *Sentence Structure and Punctuation.* Some of these proved to be more accommodating to the assessment of multimodal texts than others. The research reports show that in terms of *Composition and Effect* the assessment strands for writing are broadly applicable to both paper-based and screen-based multimodal texts. However, there were constraints associated with the strands *Text Structure* and *Organisation.* It was possible to describe paper-based multimodal texts using both these strands, but the categories needed expansion to take into account screen-based multimodal texts. Two other factors were identified as constraints in using the strands to give an adequate description of multimodal texts. One was associated with the fact that a printed publication cannot capture a multimodal text fully:

> The screen-based texts which we chose to analyse were mostly presented using presentation software. Although it has been possible to describe such texts in this booklet, we have noted that the annotations can only be partial since they do not take into account the spoken and gestural aspects of the presentations. In one case the pupils had added sound, both as dialogue and sound effects, introducing a further layer of complexity when describing such texts in a booklet (UKLA/QCA, 2005, p. 35).

The second was associated more with the difficulty of disentangling an individual contribution from the group's work:

> One of the key features of the screen-based text production was the collaborative nature of the work. This raises implications for assessment. The partial nature of the presentation software texts presented here also suggests that a single assessment may not be the best way to evaluate screen-based multimodal texts (UKLA/QCA 2005, p. 35).

The reports concluded that although there was some scope for using the writing assessment strands for end-point description and assessment of multimodal texts, there was greater promise in using them for formative purposes. However, it emphasised that the strands would need expansion if they were genuinely to take into account all the features of multimodal texts.

Another research project, *Reading on Screen* (Bearne et al., 2007), examined on-screen reading in different curriculum areas in a range of school contexts with pupils in the 5 to 16 years age range. Its findings indicate that there are several aspects of on-screen reading which are not covered by the assessment processes in national tests of reading; for example, interpreting sound effects, music, and spoken dialogue, all of which are integral to on-screen reading. Although many of the descriptors used in national assessments are applicable to moving image texts, there is no explicit inclusion in terms of purpose, viewpoint, and overall effects on the reader for interpreting the speed, direction, size, angle or focus of shots, the sound effects, dialogue, music, colour (Bearne et al., 2007, p. 28). Similarly, although the animation of text or images contributes to the effect of a text on the reader, national assessments of reading do not include any mention of interpreting movement.

There is scope, however, for national assessments to expand to include multimodal texts, both screen-based and paper-based. There are existing criteria and processes within the areas of media education, the language arts and the performing arts and in the future these will need to inform each other if there are to be useful assessment possibilities for multimodal texts. Any assessment system depends on developing criteria. In other words, there needs to be a way of describing the dimensions and characteristics of multimodal texts and, importantly, a way of describing what progress in multimodal reading and text composition might involve. The final section of this chapter sketches a framework for describing progress in multimodal composition. The focus is on composition of texts rather than reading since this is the aspect of multimodality where teachers are generally much less secure in judgements.

WHAT DOES GETTING BETTER AT MULTIMODAL COMPOSITION LOOK LIKE?

The *More than Words* study (2005) used categories associated with writing. However, it made clear that writing assessments are not adequate to describe screen-based multimodal texts. The following descriptors take all modes into account and cover both paper-based and screen-based compositions.[2] In line with the need for formative assessment, they also include the ability to reflect on and evaluate one's own composition.

Progress in multimodal text-making is marked by increasing ability to:

(i) Decide on mode and content for specific purpose(s) and audience(s)

- choose which mode(s) will best communicate meaning for specific purposes (deciding on words rather than images, or gesture/music rather than words)
- use perspective, colour, sound, and language to engage and hold a reader's/viewer's attention
- select appropriate content to express personal intentions, ideas, and opinions
- adapt, synthesise, and shape content to suit personal intentions in communication.

(ii) Structure texts

- pay conscious attention to design and layout of texts, use structural devices (pages, sections, frames, paragraphs, blocks of text, screens, sound sequences) to organise texts
- integrate and balance modes for design purposes
- structure longer texts with visual, verbal, and sound cohesive devices
- use background detail to create mood and setting.

(iii) Use technical features for effect

- handle technical aspects and conventions of different kinds of multimodal texts, including line, colour, perspective, sound, camera angles, movement, gesture, facial expression, and language
- choose language, punctuation, font, typography, and presentational techniques to create effects and clarify meaning
- choose and use a variety of sentence structures for specific purposes.

(iv) Reflect

- explain choices of modes(s) and expressive devices including words
- improve own composition or performance, reshaping, redesigning, and redrafting for purpose and readers'/viewers' needs

- comment on the success of a composition in fulfilling the design aims
- comment on the relative merits of teamwork and individual contribution for a specific project.

All of these indicators of progress would depend on pupils having access to a full and growing repertoire of different types of multimodal texts and opportunities to discuss them and the authors'/directors' choices to create specific effects. The suggested framework makes it possible to describe the development of multimodal text-makers from: *a multimodal text maker in the early stages* through to being *an increasingly assured multimodal text maker,* then becoming *a more experienced and often independent multimodal text maker* and later *an assured, experienced, and independent multimodal text maker.* The descriptors offer teachers a starting point from which they may develop a vocabulary to talk about multimodal texts, since establishing a metalanguage is an essential part of creating possibilities for assessment which values all elements of multimodality.

As has already been mentioned, it is impossible to present screen-based texts on paper so the examples which follow are from paper-based texts, although these draw on screen experience to present ideas.[3] The following two examples serve to show how progress in multimodal text-making can be described and the second, particularly, shows that this is possible even when the composition is a shared endeavour. When pupils collaborate to create a text, there can be an understandable concern that it is difficult to give credit to the contribution of each. Since Lauren and Hannah decided to divide the work as author and illustrator, it is possible to see—and describe—what each has achieved. The first example is Alex—*an increasingly assured multimodal text maker*—who composed an individual book after his teacher had taught the children to notice how films and picture books can create specific effects.

ALEX'S PICTURE BOOK BASED ON A FAVOURITE FILM

Alex is not yet seven years old. His remarkable book, *The Lion King 4 Nala come's back* (sic), was made after a teaching sequence planned by his teacher, Viv Sharpe, using film as a basis for making picture books. These books were to be shared within the class. The extracts in Figures 2.1, 2.2 and 2.3 are part of an eight-page book in which Nala leaves to go to a new home; Simba follows her and is helped by other animals to find her. They are reunited and Nala returns with Simba.

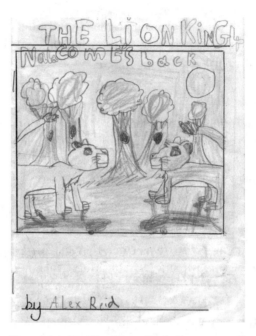

Figure 2.1. *The Lion King*—Book Cover

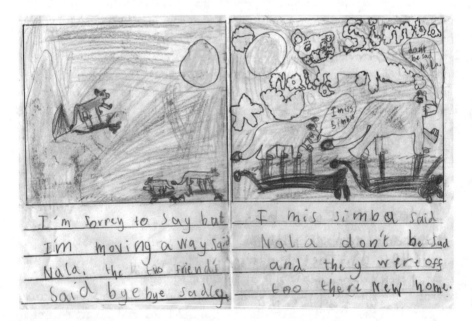

Figure 2.2. *The Lion King*—Alex's first double page spread, Frames 1 and 2

Frame 1: I'm sorry to say but I'm moving away said Nala. The two friends said bye bye sadly.
Frame 2: I miss Simba said Nala don't be sad and they were off to their new home.

Figure 2.3. *The Lion King*—Alex's second double page spread, Frames 3 and 4

Frame 3: Please come back Nala said Simba. The clouds passed by. Simba ran after her.
Frame 4: Simba thought about Nala he was very very very very sad. He saw some animals on the way.

(i) Deciding on mode and content for specific purpose(s) and audience(s)

- Alex has chosen characters from a favourite film as a basis for his own story, specifically focusing on the theme of friendship.
- He draws on experience of film texts, varying the perspective to lead the reader's eye through the story. He uses a mid-shot for the cover to show the relationship between the two central characters, a longer perspective for Frame 1 where the two lions part from each other, mid-shots for Frames 2 and 3 to show the characters and their thoughts (the clouds which passed by) and a long shot in Frame 4 to show Simba being helped on his journey by other animals.
- He adapts the film characters, the setting, and the theme of "leaving and returning" to suit his own intentions.
- Alex has chosen to use words mostly for action and dialogue. The pictures provide the setting and mood, and mostly the thoughts and emotions of the characters. The language and dialogue in the written part of the text are direct and engaging.

(ii) Structuring texts

- The choice of frames was made by his teacher but Alex has divided the narrative into episodes.
- The pictures and words are balanced within the format provided.
- The colour of the characters and their movement from left to right of the frames create the forward drive of the narrative, except for the title page where Simba and Nala are facing each other, summarising the theme of the book. The final image similarly presents the characters facing each other, reunited after Simba's journey, creating a beginning-middle-end structure through the images.
- Alex shifts the setting from the background detail of the forest on the cover to the sun, blue sky, and shadows of the plain on the following pages as Nala leaves and Simba follows her. The images of Simba and Nala as thoughts in Frames 2 and 3 create mood, depicting the emotions of the characters.

(iii) Using technical features for effect

- Alex uses line adeptly to distinguish the characters, drawn with clear outlines, and their thoughts, drawn with wavy outlines. He uses facial expression to show emotion, particularly the contrast between Simba's determined look and the dropping tears of his thought image in Frame 3 and the thought bubble in Frame 4 which indicates that Simba is still thinking of Nala. Alex varies the perspective to support characterisation and narrative action.
- He does not vary the font style or size of his written text. In the pictures he uses speech and thought bubbles to clarify the meaning of the narrative, but his punctuation is not consistent in the written part of the text.
- In the written part of the text Alex generally uses, but does not always mark, simple sentences and does not include "quotation marks."

Alex's sophisticated use of filmic techniques—the text cohesion he creates through the visual part of the text by the use of colour, placing of characters in their settings, and the ways he establishes the relationships between Nala and Simba—is echoed to a certain extent by his choice of language. Together, the visual and verbal parts of his book make a powerful combination in telling a story of loyalty and courage. His teachers now know just how accomplished he is as a text maker, but they also can identify points where he will be able to make progress. This might be in the development of stories from his own imagination rather than using the models of known texts; composing texts in different genres; improving the technical aspects of the written parts of his text; or learning to vary

the design of the text as a whole. Some of these features can be seen in the work of the two multimodal text makers whose work follows.

LAUREN AND HANNAH COLLABORATE TO MAKE A PICTURE BOOK

The second example is a collaborative book, written by two eleven-year-olds who are undoubtedly *assured, experienced and independent multimodal text makers.*

Lauren and Hannah's teacher, Jane Granby, planned a sustained teaching sequence using information books, Internet sources including personal journals and picture books to gather information about the Second World War. The girls have written from the perspective of children in Germany. The sequence culminated in pairs of children composing complex picture books. She used *Rose Blanche* by Ian McEwen illustrated by Roberto Innocenti as a starting point. Figures 2.4, 2.5 and 2.6 show the cover and two double-page spreads from *The Last Goodbye* by Lauren (illustrator) and Hannah (author), both aged 11 years.

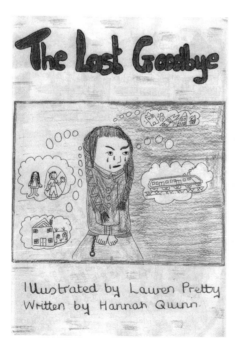

Figure 2.4. *The Last Goodbye*—cover by Lauren and Hannah

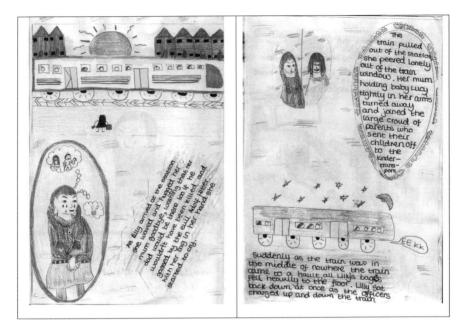

Figure 2.5. *The Last Goodbye* (first double-page spread)

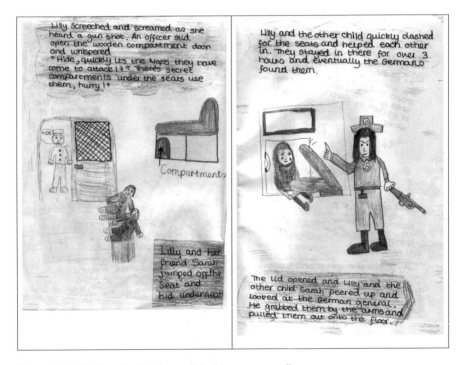

Figure 2.6. *The Last Goodbye* (second double-page spread)

(i) Deciding on mode and content for specific purpose(s) and audience(s)

- The author and illustrator collaborated on decisions about content represented in the words, pictures, and design. They have chosen to write about a girl and her new-found friend being sent on *Kindertransport* to escape the Nazis. They focus on the emotional impact on the central character.
- They have drawn on a range of sources, adapting and synthesising them to create their own view of what children might have experienced in Germany at the beginning of World War II.
- They have chosen to echo the action and emotional content through both words and images. However, at times they have cleverly included elements of the narrative in the images which they do not repeat in the words. For example, Lilly's new friend Sarah is introduced in the image at the top of the right hand page of the first spread but not mentioned in the verbal text until the bottom of the left hand page of the second spread.
- The third person narrative with dialogue allows Hannah to draw the reader in by giving the historical setting and family details. Lauren uses the train image at the top of the first spread and the picture of Lilly on the extreme left as hooks to engage and hold the reader's attention, prompting the inner questions: *Where is the train going? What will happen to Lilly?* This audience engagement is maintained through both elements of the narrative.

(ii) Structuring texts

- Lauren and Hannah have designed their text with great care, using page spreads, blocks of text, images, and layout to pace the narrative. For example, the first double-page spread moves from Lilly's arrival at the station on the left hand page to the train moving off on the right hand side. As visual support, the text block at the top right hand of the first spread is encircled by train images.
- The text is fully integrated.
- Lilly's name and her image, with plaits, lavender top, and soulful eyes, are used for verbal and visual cohesion. The words and images are carefully planned to complement each other. For example, the train image, first of all with the sun behind it, then with stars, acts as a temporal cohesive device with no indication of time needed in the verbal text.
- The backgrounds on the cover are used effectively to show Lilly's thoughts of leaving home—the things she will miss on light yellow and the future a darker brown. The double-page spreads have light patterned repeats of red streaks, gently interrupting the background

white space to indicate movement, while the blocks of texts have faintly coloured backgrounds to indicate mood: paler for a sense of loneliness, darker as on the left of the second double spread, to indicate heightened emotion.

(iii) Using technical features for effect

- Both author and illustrator handle the technical demands of a complex picture book with skill. The line, colour, gesture, and facial expression complement the language which focuses on Lilly's emotional world.
- Hannah does not vary the typography of the verbal text, but the design includes some words to give clues about the action. For example, just before the page turn of the first spread, Lauren has included the screech which Hannah introduces in the written part of the story on the following page and labelling to help the reader understand about the hidden compartment.
- Hannah uses mainly extended sentences at the beginning of the story to suggest sombre emotions but shifts to short sentences in the dialogue, indicating urgency.

Comparing Alex's book with Lauren and Hannah's shows how, in developing as a multimodal text maker, the composer often becomes more allusive than explicit, allowing the pictorial element to do as much (if not more) of the work than the words. For example, where Alex repeats the content of his story in the images and the words, Lauren and Hannah have come to understand that the placing and content of the images can carry messages which would be difficult to convey in words. The images can hint at what is to come and the two girls also use image to carry part of the narrative where Alex largely uses the pictorial text for atmosphere and setting. While both *The Lion King 4* and *The Last Goodbye* draw on the characters' thoughts, Lauren and Hannah use visual detail to express emotion while Alex puts thoughts into words. As would be expected, too, given the different ages of the authors, the two girls handle written syntax in a more assured way than the younger boy. Similarly, as would be expected, the pupils' text, or genre, knowledge will make a difference to what they can draw on to help them compose as they grow in experience. Alex draws on his knowledge of picture books and animated films, whereas Lauren and Hannah use a wider range of text experience: historical information, Internet sources including personal journal writing, picture books, and films to create the atmosphere and narrative tension of their story. These two examples show that while young authors can create impressive multimodal

texts, it is possible for them to get better at it as their knowledge and experience of texts increase—and they discuss the different structures and effects created by their authors/directors.

Unfortunately, it was not possible to ask Alex, Lauren, and Hannah for their own reflective comments on their work. Some insight into the pupils' own evaluations of their work as outlined in the suggested framework would add a further dimension to their already impressive achievements.

CONCLUSION

Any consideration of multimodality and assessment needs to be seen in the context of a changing world of communications. Since children and young people bring sometimes quite extensive experience of multimodal texts into the classroom, teaching approaches will increasingly need to reflect the kinds of texts with which students are familiar. In line with this, assessment of multimodality will also need to include performance, three-dimensional constructions, music, moving image, collages of different kinds of texts accompanied by spoken explanations or sound recordings and to allow for visual and tactile elements; colour; pattern; texture, line and tone, shape, form, use of space, and perspective; expression and gesture, and probably more. In addition, teaching itself will become more multimodal, acknowledging the range of ways that young people come to understand concepts through sound, image, movement, and words. It has been argued that assessment practices cannot adequately accommodate multimodal teaching but there are possibilities of extending assessment practices to give value to children's production of multimodal texts, particularly the area of formative assessment. Although the framework offered here might form a basis for assessment, much more work needs to be done in developing ways of describing complex composition of texts which might combine, for example, movement, sound, image, and words. This is a matter of urgency if children's out-of-school knowledge and experience is to be recognised, valued and developed in formal educational settings.

NOTES

1. Although the curricula for Northern Ireland, Scotland and Wales are similar to those for England, there are significant differences and these affect the assessment arrangements. For this reason, references to assessment arrangements are about England.
2. These descriptors have been arrived at by extensive discussions with teachers.

3. For examples of these descriptors applied to screen-based texts, see Bearne and Wolstencroft (2007) which analyses presentational text and shows these on the CD-ROM which accompanies the book.

REFERENCES

Bearne, E. (2003). Rethinking literacy: Communication, representation and text. *Reading Literacy and Language, 37*(3), 98–103.

Bearne, E. (2009, forthcoming). Multimodality literacy and texts: Developing a discourse. *Journal of Early Childhood Literacy, 9*(2).

Bearne, E., & Kress, G. (2001). Editorial. *Literacy, 35*(3), 89–93.

Bearne, E., & Wolstencroft, H. (2007). *Visual approaches to teaching writing: Multimodal literacy.* London: Sage.

Bearne, E., Clark, C., Johnson, A., Manford, P., Mottram, M., & Wolstencroft, H. (2007). *Reading on screen.* Leicester: United Kingdom Literacy Association.

Comber, B., & Nixon, H. (2005). Children reread and rewrite their local neighbourhoods: Critical literacies and identity work. In J. Evans (Ed.), *Literacy moves on: Using popular culture, new technologies and critical literacy in the primary classroom* (pp. 127–148). London: David Fulton.

Cope, B., & Kalantzis, M. (2000). *Multiliteracies: Literacy learning and the design of social futures.* London: Routledge.

Johnson, D., & Kress, G. (2003). Globalisation, literacy and society: Redesigning pedagogy and assessment, *Assessment in Education, 10*(1), 5–14.

Kalantzis, M., Cope, B., & Harvey, A. (2003). Assessing multiliteracies and the new basics. *Assessment in Education, 10*(1), 15–26.

Kress, G. (1997). *Before writing: Rethinking the paths to literacy.* London: Routledge.

Lankshear, C., & Bigum, C. (1999). Literacies and new technologies in school settings. *Pedagogy, Culture and Society, 7*(3), 445–465.

Marsh, J. (2005). Moving stories: Digital editing in the nursery. In J. Evans (Ed.), *Literacy moves on: Using popular culture, new technologies and critical literacy in the primary classroom* (pp. 30–49). London: David Fulton.

Matthewman, S., Blight, A., Davies, C., & Cabot, J. (2004). What does multimodality mean for English? Creative tensions in teaching new texts and new literacies. *Education, Communication and Information, 4*(1), 153–176. Retrieved on September 16, 2008 from http://www.tlrp.org/dspace/handle/123456789/169

Newfield, D., Andrew, D., Stein, P., & Maungedzo, R. (2003). "No number can describe how good it was": Assessment issues in the multimodal classroom. *Assessment in Education, 10*(1), 61–81.

Qualifications and Curriculum Authority (2005). English 21, *Playback.* Retrieved on March 19, 2009 from http://www.qca.org.uk/qca_9928.aspx

Qualifications and Curriculum Authority (2007). *Assessment for Learning.* Retrieved on March 19 2009 from http://www.qca.org.uk/qca_4334.aspx

Stein, P. (2003). Representation, rights and resources: Multimodal pedagogies in the language and literacy classroom. In B. Norton & K. Toohey (Eds.), *Critical pedagogies and language learning* (pp. 95–111). Cambridge: Cambridge University Press.

United Kingdom Literacy Association/Qualifications and Curriculum Authority (2004). *More than words: Multimodal texts in the classroom.* London: QCA. Retrieved on March 19, 2009 from http://www.qca.org.uk

United Kingdom Literacy Association/Qualifications and Curriculum Authority (2005). *More than words 2: Creating stories on page and screen.* London: QCA. Retrieved on March 19, 2009 from http://www.qca.org.uk

Checkmarks ON THE Screen: Questions OF Assessment AND New Literacies IN THE Digital Age

ANNE BURKE

I learned to put these things on my website from home. We have two periods of tech, but you don't do that kind of stuff in tech. We do more school involved things like we do slide shows and power points. Meredith, age 13.

Meredith's comment (all student names are pseudonyms), in response to a question about her personal web site, is pretty typical of the conversations that I have experienced when conducting research in middle grade classrooms. Invariably, the students' out of school text-making greatly exceeds the skills and texts required in a typical computer equipped classroom. In general, school usage of digital tools is confined to word processing, creating visual lectures using PowerPoint software, or using the Internet as an encyclopedia, all of which are also representative of what schools view as desirable literate skills (Lankshear & Knobel, 2003). In actuality, through their many digital engagements, youths are developing very sophisticated skills which incorporate an understanding of the key concepts of multimodality—such as how communication in digital spaces makes use of many textual forms to bring meaning. These are literate skills that typically go well beyond standard school curriculum. For example, through their participation in discourse communities such as Facebook and Teen Second Life, adolescents are creating virtual identities using template texts which extend their social practices within participatory communities (Gee, 2003). Students are also designing texts online, and they are aggressively using other new forms of representational and

communicational text (Alvermann, 2002; Gee, 2003; Lankshear & Knobel, 2006; Jewitt & Kress, 2003; Mackey, 2004). Meredith's response suggests how new literacies involve communication methods which are typical of the sophisticated multimedia skills used in youth worlds. This new text making is explored through personal literacies such as blogs, wikis, web pages, and instant messaging services. What is more important is how digital texts created by students, such as blogs and social web pages (Blogger and MySpace, for example), hold significant capital within adolescent worlds. The interactive capabilities and modal design of these texts appeal to students through their properties of instant communication, and by their striking visual images and sounds, all of which are characteristic of computer screens (Snyder, 1998; 2001). Students use these texts constantly, but neither they themselves nor their educators always understand the skills of design, production and the analysis needed for such texts (Burke & Rowsell in press, Kress & Van Leeuwen, 1996; Kress, 2003; Lankshear & Knobel, 2006).

As a result, assessing these types of texts can challenge adults and educators who are not of the "Net generation," and are instead known as "digital immigrants" (Prensky, 2001). Because of the hybridity in their textual construction, and the varying discourses needed to fully comprehend and engage the intertextuality of these texts (Bearne 2003; Burke & Rowsell, 2008), educators who are not familiar with their breadth and usage can easily ignore their role in students' social practices of literacy and education. Students see and make use of the implicit power found in the affordances of digital text. Visual communication is just as important on the screen, through the selection of text fonts, graphics, and sounds. New literacies, which have become the foundation for many of their communication platforms, require skills such as critical understanding of how the forms of language may be used through construction and integration for the purposes of communication. For example, posting on a blog, contributing to a wiki, or creating avatars, all require a different set of skills from those which are expected by the schooled tasks which frame most curricula (Kress, 2003). The result is that adolescents' out of school textual engagements now resemble those of new literacies, and they are significantly different from their engagements with the traditional texts and word-processed documents typically used in the standard school curriculum. The increasing visibility of new literacies in youth cultural worlds can be illustrated through fan fiction sites, video sharing sites like YouTube.com, gaming sites, and music sharing sites, all of which emulate the rapid social and cultural changes reminiscent of computer technology itself. As a result, adolescents' literate lives present many new challenges for teachers, not the least of which is assessment. Increasingly, the question *how does one measure literacy in a digital and global society?* is one which educators must be prepared to answer.

This chapter looks at a one-year study of the online reading engagements of four students, all aged 13 years, and differentiated through their reading, writing, and interaction with digital texts on the Internet. Merriam (1998) describes case study as an "intensive, 'holistic' description and analysis of a single instance, phenomenon, or social unit" (Merriam, 1988, p. 21). Through the data collection of focus group interviews, screen reading interviews, literacy logs, and student digital online texts, I look at what it means to read on the screen. In particular, by looking at what students' do in school with technology and contrasting that with discussions and observations of their home digital reading practices, I show how new literacies are richer in skills and engagement in comparison with the computer practices used for schooled tasks. The data presented in this chapter illustrate how students' expansive designing of texts is representative of future life skills—which in turn has important curriculum potential—alongside their multilayered possibilities for communication.

During my years in the classroom, my students' interactions with digital reading have often been dismissed by fellow educators with remarks like "that's just something that they do," or "it doesn't count," or "that's just computer games." Often, the students' digital literacies are not seen as holding the same legitimacy as school texts, and digital texts are not valued as creative work, nor do they have any real bearing on curriculum. In this chapter, I submit that these texts of creativity show how students' digital reading and text creation demonstrate an authored reading trajectory, and reveal sophisticated understandings of a student's critical choices when engaging in an act of reading and/or writing. These choices include the assembling of text (Kress, 2003); the reader's understanding of design content (Bearne & Kress, 2001; Rowsell & Burke, in press); the reader's created identities (Thomas, 2007; Black, 2005; Black 2007; Chandler-Olcott & Mahar, 2003) when engaged in the act of reading; and, finally, the understanding and acquisition of discourses (Gee, 1996; 2004). These processed assembling, designing and created identities in reading engagements on the screen show how students' digital reading needs to be conceived differently from print-centric design, not only for the purposes of pedagogical instruction but also for skills assessment (Kress, 2003; Johnson & Kress, 2003). Legitimacy and acceptance of new literacies in the classroom is dependent upon a clear understanding of the conventions and nature of new literacies texts, and how to assess such texts, in order for their inclusion in school curriculum.

MOVING LITERACY FORWARD

There have been many different descriptions of what it means to be literate within our global society. The school system, which includes educators, teachers, students,

parents, and what is termed "curriculum," is held accountable for complex social outcomes by society. North American society is often preoccupied more with global economic competition than with achieving lofty educational goals. A reductionist perspective of literacy argues that standardized testing should determine what should be taught in schooling systems. Economic growth and success are often equated with (the quality of) a society's literate behaviors, and inevitably the role of education and the assessment of curriculum goals fall into this complex puzzle. Literacy accountability through testing, and evaluation of reading in large scale assessments such as that conducted by the OECD, in its Program for International Student Assessment (PISA, 2008), has determined the delivery and content of English and language arts curricula for many countries. For countries such as Canada, New Zealand, Australia, and the United Kingdom, the delivery and content of English curriculum have come under much public scrutiny, particularly as to how these programs meet the needs of society because current curricula focus on "skills and knowledge around values and communications" (Kress, 2006, p. 2). New literacies raise awareness of how the acts of reading and writing, in the simplistic forms of encoding and decoding, deny other valuable reading skills such as visual representation and gestural communication. Indeed, over the past century, the English curriculum has often changed in response to demands brought about by economic, technological, and cultural diversification (Cope & Kalantzis, 2000). Kress argues that the question "What is English?" has reached a turn in the road, brought about by new demands from digital technology and the prevalence of the image as a form of communication. The presence of multimodal spaces for learning has grown as a result of Web 2.0 technology and changing perceptions of literacy. Carrington (2005) points to the challenges for educators, parents, and policy makers in terms of how the "new textual landscape" that has been brought about by technology summons new understandings about what it means to be literate. Mathewman, Blight, and Davies (2004) call for the development of a "metalanguage which is accessible and useable for teachers and pupils" (p. 171). New literacies have further raised awareness as to what is needed to be taught (and more importantly for our purpose here, actually *learned*) in our English and language arts curriculum.

AUTHORING A READING TRAJECTORY

The traditional definition of the act of authoring would refer strictly to the creation of the text itself. The reading path of print-based texts follows a logical and linear trajectory, according to the design of the original author. However, one of the key elements of new literacies engagement is the discursive nature of the reading path (Kress, 2003). Digital texts are rarely linear, can avoid logic altogether, and have

shifted the nature of any conventional "authorship." Instead, it is digital users themselves who are in a sense "the author." Control of a cursor, which determines where one begins to interact with a digital text, is of no small importance. Each user of a digital text has the ability to determine where and what they read, in effect, to choose their own reading path and trajectory (Kress, 2003). Thus, in a very real sense they *are* an author of the text, as each user can determine how the text is to be read and understood. What was once just the purview of the traditional author is now part of every digital user's experience. Previously, the choice and order of words one used to express one's thoughts was the dominant mode of communication. Digital reading is coupled with a seemingly endless choice of modes, each of which assists in guiding one's reading trajectory. These have become new tools for a reader's expression. There has been some research in reading online which has raised awareness of a different skill set needed for comprehension of online texts. Eve Bearne's research with the United Kingdom Literacy Association and Qualifications and Curriculum Authority (2004, 2005; see also Chapter 2, this volume) examines children's digital texts and describes a framework for describing multimodal texts. Her recent study for *Reading on Screen* (UKLA, 2007) discusses the need for an expansion of the descriptors needed for reading screens such as inclusion of music, dialogue, and sound effects. Research in elementary students' online reading by Coiro & Dobler (2007) shows how online reading requires skills similar to those needed for reading print texts, yet, at the same time, also calls for more complex skills, especially of its young readers. In this study, elementary students employed a number of reading skills such as skimming for sports facts, scanning for fashion icons, using pictorial, typographical, and organizational features to obtain information while also making critical choices about the relevance of material chosen while reading online. My own work with Jennifer Rowsell on middle school reading practices looked at the design of texts (Burke & Rowsell, 2005); assessment of multimodal reading (Burke & Rowsell, 2007); the importance of motivation, comprehension, and engagement with design in the overall digital reading event (Burke & Rowsell, 2008); and how reading online includes comprehension of design (Rowsell & Burke, in press) and personal engagement with sites. This study described in this chapter builds upon this work, suggests a model for understanding digital readers as authors of their reading engagements, and describes a continuum along which these skills work in tandem during reading comprehension.

NEW LITERACIES

New literacies are the inevitable companion of computer technologies. They are changing our perception of what it means to be literate. Literacies which inform

specific practices are framed within specific social and cultural spaces, for intended purposes, and result in shared meanings (Scribner & Cole, 1981). New literacies invite powerful interconnections among many people, embracing multiple perspectives which are represented through semiotic diversifications of text through the likes of blogging, Facebook, online video games, music, and photograph sharing sites. The speed at which knowledge is shared and accessed through these texts is a key characteristic of new literacies, and calls upon learners to have an understanding of the context, culture, and the potential offered through screen technologies. In turn, this understanding has caused an evolution in our conception of the diverse ways in which literacy is contextually constructed, experienced, and instructed in classrooms (Leu, 2000; Leu, Kinzer, Coiro & Cammack, 2004). Comparison of new literacies such as blogging, wiki spaces, and fanfiction to conventional literacy engagements such as bulletin board posting, encyclopedias, and book clubs show, how new literacies are more "participatory, collaborative and distributed in nature than conventional literacies" (Lankshear & Knobel, 2007, p. 9). With new forms of text making come new ideas about how communication is formed and rendered, asking the reader for a critical understanding of the construction and deconstruction of such texts. As Lankshear and Knobel point out, the literate landscape is changing "as a result of people imagining and exploring new ways of doing things and new ways of being that are made possible by new tools and techniques, rather than using new technologies to do familiar things in more 'technologized' ways" (Lankshear & Knobel, 2007, p. 10).

Essentially, new literacies require new skills of the learner, largely because of the constant change brought about by technology. Learners use and renew social practices in how the message is shared with others and the form with which it is communicated. Textual representations are no longer restricted to fixed typographic representations on the printed page. They are also embracing expanded notions of text, notions that are varied in form and representation, and share many different perspectives and viewpoints on the part of the user.

Global literacy testing, such as that promoted by UNESCO, recognizes literacy attainment in terms of pencil and paper textual representations. Such measurements are based on very functional forms and definitions about what it means to be literate. Seen within a functional literacy form paradigm, the use of digital texts can be marginalized as a form of communication. It lacks an understanding that the cultural forms and perceptions of how we communicate need to be realized in order to address the multiple semiotic forms of how language is represented and realized through technology. The policy waves that spread out from the United States Federal government's "No Child Left Behind Act" (2001) have caused schools to emphasize attentive literacy instruction within traditional print-based reading programs, in effect largely ignoring how online reading and practices

represent massive out of school literacy practices of youth culture. The end result is that we have a denial of the valuable, complex, and revealing texts which are such a huge part of our students' life worlds.

Differing perspectives need to be addressed about what it means to be literate, and how new literacies frame our understanding of how to assess the skills with which children create meaning. If we take into account such things as the rapid changes and cultural diversification produced by technology (Cope & Kalantzis, 2000), the critical strategies one can use to acquire information on the Internet (Leu, 2000), or how new literacies engage learners in new discourses or ways of being (Gee, 2003) or as multimodal communicative forms (Snyder, 1998; Bearne & Kress, 2001; Jewitt & Kress, 2003), I suggest that we need to rethink what it means to communicate through technology and to focus on developing a contextual understanding of how literate experiences are created, experienced, and practiced through its learners (Lankshear & Knobel, 2003; 2007). In order for new literacies to become a valued and valid part of schooling, they need to be viewed as authentic literate practices which engage and inform the lives of users. Attempting to understand new literacies in forms which are strictly about reading and writing (in a traditional sense) limits the power and experiences texts such as Facebook, blogging, virtual play worlds, and fan fiction engagement offer. Marginalizing these types of texts to youths' out of school practices negates the valuable literate skills and home literacy practices which characterize the lives of our students. The global reaches of new literacies invite a closer understanding of what it means to partake in these literacies. As new literacies are multifaceted in genre and in use, we need multiple visions of what it means to engage with and through these texts, as well as new visions about how to assess them. Through conversations about assessment, we begin exploratory suppositions of what it means to rethink the assessment of these types of texts and for this chapter's purpose what it means to read and write in the digital age.

ASSESSING NEW LITERACIES

What makes assessment of the new literacies skills (such of those described by Meredith in my opening quote) such a challenge? How do we account for the skills and associated values with which youth compose texts representative of new literacies? The inclusion of new literacies in the classroom presents great challenges to educators. These require careful analysis of the defining characteristics within these texts, as well as a clearer understanding of the step-by-step creation processes through which new literacy texts are conceived, and how these configurations are used (and for what purpose) by the students. The desire to assess such activities

with a realism which corresponds to the complex learning needed to compose and engage with texts of new literacies is a particular challenge, especially given that the evaluation and criteria of such assessment is often based on subjective and judgmental perceptions which are difficult to standardize. As a result, only those digital tasks which may be easily conceptualized within classroom spaces become the norm. Assessments that are characteristic of the paper and the pencil are often described as "fair," "efficient," "objective," "valid," or "easily scored." These characteristic descriptors of reading scores privilege particular skills such as word and vocabulary recognition, decoding knowledge, comprehension, identification of key ideas, memorization, and classification, skills which tend to sit in a minimal number of communicational and representational modes (Jewitt, 2003; Bearne, 2004; Kress & Johnson, 2003). The reality is that in order for clear and concise assessments of texts to be realized within our schooling systems, we need to articulate what it is that children learn from the use and implementation of new literacies. In doing so, we need to speak to the skills representative of new literacies, such as interpreting critically shared ideas; manipulating, remaking and remixing texts for one's own purpose; creating new forms of language communication through technology; and mastering subtext (a key informational aspect of almost all online texts). All of these skills are needed to advance and partake in communities significant to new literacies. We also need exemplars which illustrate the "what" and "how" of multimodal texts, combined with explicit criteria which uphold authentic and realistic assessment, and provide feedback that values the basis of these texts as representing the communication which governs youth worlds (Ross, Rolheiser & Hogaboam-Gray, 2002; Burke & Rowsell, 2007).

Perceived shortcomings in programs and student achievement have led to a push to obtain higher test scores, and, as a consequence, considerable pressure is placed on teachers, administrators, and schools to respond to these desires. As a result, teachers have favored instructional skills which focus on those needed to complete tests (a.k.a. "test completion skills") and have copied many of their class materials from standardized models. The desired push toward authentic assessment, representative of the skills and abilities of students' real-life worlds, is made more difficult when standardized assessment tools actually honor tests which celebrate individual achievement, and not skills relevant to new literacies' skills such as remixing, collaborative authoring, or critical understandings of subtext. Assessment practices which liberate student processes of understanding, rather than relying on crated knowledge products, would legitimize the literacy practices of new literacies in the classroom. We know that balanced practices in assessment should respond to the areas of testing and performance, wherein both inform each other and the end product of that assessment (Black, Harrison, Lee, Marshall & Wiliam, 2003; Black & Wiliam, 1998). With this said, we still have a distance to

go when it comes to providing a corresponding curriculum which embraces the new literacies practices of those we teach, especially for needed skills in digital reading, and cultural understanding and representation of the texts such as wikis and blogs which illustrate the lives of these students.

DIGITAL LEARNERS

Each of the digital learners involved in this study are profiled below:

> *Meredith*: Meredith is a confident student with good grades and is an excellent athlete. She is active in online activities such as MSN chat, photosharing sites, and online shopping at popular youth shopping sites such as Old Navy and Abercrombie & Fitch. Her online practices reveal her to be a self-labeled "fashion diva."
>
> *Suzette*: Is an English language learner who uses the Internet to visit sites for social networking. She works very hard in school and is most supportive of classroom peers from her native country.
>
> *Jeff*: Jeff is also an English language learner, with a keen intelligence and a curious mind. He uses the Internet to research anime, which he enjoys drawing, and to participate in various fan sites. He is also a sports fan and uses the web to communicate with faraway friends and relatives.
>
> *Rick*: Rick loves all sports and spends a great deal of time surfing sites to keep abreast of the latest scores of the sport he is keeping track of. His sports talk extends from the screen as he shares the latest stats and know-all with his classmates.

Skills of Possibilities in Virtual Spaces

In discussions with these four students about the potentials and constraints of school textbooks, all of them were well aware of and acquainted with the inherent possibilities of digital texts. Meredith shared how the design of digital texts offered the convenience of choice, speed, and access to other information sources, in comparison to print texts: "I think that the Internet gives you more choices… it's faster because it takes a long time to read a book and find what you want and with Internet you can find the information faster." Like many of her peers, she discussed the screen's potential for multitasking: "you can do everything on the Internet—you can read, you can draw, you can read the newspaper, you can search for a person or a project." Students also spoke about the social potentials of text, voicing how the Internet has made the global world accessible to all who engage in online literacy practices. Jeff said, pointedly, that the Internet "draws people together—like MSN and all these different chat clubs and stuff and you can talk to people all around the world." In many ways his comment suggests how spatial

boundaries once physically contained have expanded as a result of virtual spaces (Leander, 2003). Prior to the proliferation of Internet-based networks and other online tools, peer relationships would have been bound to spaces such as neighborhoods, home, and school. While mobile phones tend to be used with close friends and family, they do extend students' worlds beyond the geographic limitations of person-to-person spaces. Understanding "ways of being," and the discourses needed to participate in these communities, would be tied to specific knowledge about local spaces (Gee, 1996). Later in our conversation, Jeff discussed his participation in game-related chat sites, which included participants from around the world. He pointed out that if one were to be effective on these sites, one needed to develop an understanding of the discourses of gaming, such as which specific questions one can ask, and who on the boards was qualified to answer. The Internet's broadband speed, and its varied tasking and social opportunities, was seen by Jeff as a vital and contributing factor to important learned skills which help these young people.

Rick compared the static nature of the multimodal design in sports news magazines to an National Basketball Association web site about players, pointing out that "what's there is there with a magazine, basically, but with this, as I clicked on a person's name...then this comes up here, it gives you his date of birth, age, his college, height, weight, seasons played, with a text—with a hyperlink—you click and you can get a whole new page with new stuff on it but with a text you don't have the option of choosing other information." His comments on the potentials and constraints of the print and digital reading experience, through clicking and guiding his reading trajectory, show how obsolete print texts are in comparison to the here and now of digital texts. This shows the importance of understanding that digital reading is governed under differing principles compared to screen reading (Kress, 2003; Bearne et al., 2005). Rick is actually providing an example of what I call an "authored reading trajectory." When Rick and the other students are interacting with these web sites, they are not just reading one text as it unfolds on the page. They are instead critically assembling a text of their own, one suited entirely to their own purposes, one mutable and flexible, discursive and multilayered, serving many two-way communication functions, all at the same time. These students are not just the audience for someone else's writing—they are also in a fashion the authors of their own texts. The fact that the text is not easily measured, or that it does not function as a single entity, or that it cannot be copied into a notebook, does not mean that it is not a legitimate text. This is a new skill, one quite different from the traditional text composition. It is an aspect of these students' literate engagements we must begin to recognize if we are to be successful in creating useful assessments of new literacies.

Judging by the comments of the students in this study, we still have a long way to go. There were sobering statements about how the constraints of digital texts still sit outside of what is perceived as valuable for school assessment. Suzette, an English language learner, explained how textbooks in school are still the valued source of knowledge, and by default the source of evaluation: "Most of our school work comes from (school books) and same as the tests, you would never have a test on what is on the computer." Her remarks about the valuing of prescribed text books (as the basis for assessment) show how the testing culture is still very much bound to what happens in the school's physical space and the spaces contained within printed books.

Authored Reading Trajectory and Identity

All participants preferred certain web sites, sites which they would visit on a regular basis at home or in school during lunch and recess period. Most of these web engagements illustrated both their personal interests and their understanding of the complexity of digital reading and the engagement that comes with these sites. These sites made multiple demands on the students' literacy skills and knowledge, knowledge which at the same time served many social purposes. More importantly, these textual engagements showed how identity contributed to their authored reading trajectory. For example, in her explorations of online shopping sites, Meredith showed her understanding of how the designs used by the web site contributed to her understanding of the discourse of online shopping and the identity associated with being a "savvy shopper" on the Internet. For example, her savvy consumer shopping skills depended on her ability to construct meaning through understanding the subject specific language characteristic of shopping sites, the organization of menus, and how to use the provided interface for her own social positioning. These online engagements provided her with social capital in her teenage world as she cut and pasted the icons and graphics from her online shopping engagements in order to design her own webpage. I observed the following authored reading trajectory:

"Well first you go to the top [of the webpage] and pick your category because there's a menu on the homepage.... So you can either click there or on the bottom, it shows you the different categories of clothing. Then you can just go in and it shows a visual of every category. You go into each one individually and look...and if you like it you could put it into your shopping cart, or you could just click and change the color of the item or choose your size."

Meredith's discussion shows her understanding of how these sites work and how a student authors a particular reading trajectory to define her literacy practice. Later, when looking at an Old Navy clothing store web site, she explained with some

expertise how the similar Abercombie.com site was more successful in appealing to the aesthetics of the consumer through its enhanced interactivity. For example, on the latter web site, she could look at the front and back of the garment she was examining online at the same time in separate garment boxes. She also talked about how she could shop online: "But now that we have a store here, I can just go and pick something from here [i.e., the web site], then go to the store and know what I want to get." Her savvy consumer attitude shows the available affordances of on-line shopping and provides a virtual space that adds to her identity as a fashion diva. Meredith's use of these modes as a part of her authored reading trajectory is an example of Kress's (2003) position that meaning making in adolescent worlds has moved from "telling the world to showing the world" (p. 140). Her use of images, such as fashion logos, shows how she is not just reading the world linguistically, but (similar to an author) she assembles the semiotic resources of language to communicate and position herself in her life world among her peers as fashionable. Her apparent accomplishment would be easy for a teacher to dismiss; successful shopping is not highly valued in any school. Meredith's real achievement is in her ability to analyze complex sites' affordances and fashion ability and apply them to her own situation. Her skill at deciphering the web sites demonstrates how she has developed critical analysis, a skill associated with new literacies, yet scarcely noticed in the curriculum.

Rick's reading trajectory was authored and pieced together by what he wished to find out about professional basketball and how he identified with particular players of the game. Our discussion shows how students use many affordances found on the screen to construct their reading engagement. In the following exchange, I asked Rick to explain how he constructs and assesses what he needs to know to inform his own understanding:

Anne: Where do you start to read the page, Rick?
Rick: I start at the headlines, and I read the captions and then, if they capture my attention, I will go into the story...I would move down here and read the stats and then the team leaders and compare the players.
Anne: Why do you like this webpage?
Rick: First of all, the top part here (the heading) brings the basketball mood and it's got the sidelines and stuff, and it's got the logo and everything, and then they've got pictures, and you can hyperlink the players.

His discussion of the visual entities provided on the screen speaks to the affordances of screen technology. He chatted about the "basketball mood," wherein the aesthetics are guided by the multimodal representations on the screen, such as the menus and NBA logo, visual pictures from games in action, and the ability to link to the players' own sites. His response shows the prominence of the images on the screen in the digital text-making of adolescents and reveals how communication

has become a multiple semiotic practice, one where the image can work to a child's advantage because of the increased capital in the texts which they use for communication. Rick is completely comfortable with this multifaceted trajectory.

DISCUSSION

Students' reading trajectories and engagement with texts online were largely guided by their constructed identities. For example, Meredith's constructed identity as a fashion diva determined the type of sites she visited and how she authored her reading trajectory within the site. Students used a number of forms to construct texts which were personal expressions of their constructed identities. Students' choices in creating these texts showed how they could use various modes characteristic of new literacies to communicate their intended meanings.

These students' responses suggest an understanding of how literacy is a sociocultural entity and that how we define literacy has expanded beyond skills as illustrated in reading and writing. These include all the ways and methods in which we find and assess information: the aforementioned sharing of ideas and authorship online; the ability to manipulate, remake, and remix texts for one's own purpose; the creation of new forms of language communication through technology; the ability to create entire social worlds beyond the geographic; the mastering of subtext and other implied nuances of the online world; and a general ability to see the world's information on both visual and textual terms at the same time. Students noted that the Internet has made the global world more accessible, offering more opportunities for knowledge construction and the construction of new relationships through online texts. Although students were excited by the endless opportunities offered on the Internet, Suzette's comment suggested that they still valued traditional texts because of the textual authority associated with the print based alphabetic texts in their school worlds. Her response addresses the autonomous viewpoints which characterize schooling, in particular those representatives of standardized testing which speak to the power of texts, the politics of school, and the valuing of particular texts (Street, 1995; Delpit, 2006). Although texts may be governed by the visual (Kress, 2003), the reality is that curricular development, curriculum implementation, and government forms of evaluation still privilege alphabetic texts. To move beyond this narrow construction of assessment, we need to understand how language, structure, and form are more transparent and valued in the construction of reading and writing digital texts by youth culture. More importantly, it is a process by which skills are acquisitioned. This may help to move new literacies to a favorable standing in schools. Ultimately this may hasten their inclusion in curriculum.

Seeking Space for New Literacies in School Worlds

Many of the students' comments underscored the change in form wrought by digital texts; that is, how the Internet has spatialized literacy practices in new and exciting ways (Leander & Sheehy, 2004). Unfortunately, the conventional books which comprise the majority of teaching materials used in adolescent classrooms may look very different from the screen engagements favored by students, which studies such as *Young Canadians in a Wired World* (Government of Canada, 2005) and *Pew Internet Report* (2007) appear to show. As early as the mid-1990s, Kress and VanLeeuwen (1996) discussed how the visual has taken a more formative stance in our communicational landscapes. This change in the chain of command of modal representation is evident in many digital texts, where alphabetic representations can be superseded by the visual. Meredith's literate world showed close interactions with digital texts, via her web site chronicling fashion and online shopping. She saw the conveniences provided through digital texts as a way to enhance her literacy engagements and social standing in her peer world. These interviews and observations of adolescent literacy practices show how adolescents' perceptions of texts, forms, and literacy differed substantially from many of their teachers, who were not naturally part of the computer using generation. The students' classroom teacher said, "I try to incorporate technology a lot because I recognize that literacy involves many things, whether it's through the use of computers, obviously we have to stick to your typical textbooks—that is what is expected." Her comment suggests a genuine desire to engage her students' interests, as she understands the importance of a changing literate landscape for communication purposes; however, note that she also returns to the curriculum and the community's standardized practice of using textbooks as the basis of teaching and assessment. When asking students about the challenges facing them to include the skills of new literacies, like their abilities to remake text, or use authorship to determine their own social worlds, students shared similar concerns as those of Meredith, from the quote at the beginning of the article. For example, in one interview, Jeff said, "I do not think computers are shared the same way." The challenges which face the take-up of new literacies in classrooms include the variety of genres not typically found in classrooms, the hybridity of textual creations, and finding valid representation in school activities, to name but a few. Validation of new literacies which are characteristic of cultural youth communicative spaces will have to be perceived by teachers as more than merely "creative" play and move beyond a belief that the medium "technology" affords what is needed for the construction of these texts.

The shared reading trajectories of the students in this study show how each was very comfortable working with their own form of authorship, assembling, designing, and constructing identities in the reading experience, and understanding the

discourses to delve deeply into the reading experiences. This type of intricate reading experience shows how it is more than the bells and whistles offered in the technology of new literacies. The multimodality of the screen does motivate young adolescents like Meredith, Rick, Suzette, and Jeff to commit vast amounts of time to the creation of these texts. Technology as a medium affords many platforms on which digital reading may be constructed. Digital screens are bright, reactive, full of motion and audio, all of which are lacking in print medium; however, this study shows the process of building which takes place to "create" an authored reading trajectory when engaging digital texts. From decoding to encoding the linguistic, visual, aural, and gestural, to the assembling of texts, such as Meredith building her fashion site, Rick designing his reading trajectory to cull the information he wishes from an NBA site, to Jeff, whose understanding of the importance of discourses needed to construct particular identities when engaging in participatory cultures such as gaming and social networking sites, these are all skills needed to become literate in the 21st century.

When we look at comments from Meredith when designing her webpage with the latest fashions and icons to gain capital with friends, when we hear Suzette as an English language learner comment on the importance of print-centric texts in standardized texts, and when we see Rick talk about the ease, convenience, and identity formations which are the affordances of digital texts, these understandings are a part of the constructed knowledge needed to be used as a mobilizing tool for social positioning for these young learners in digital worlds. These students show how reading within particular medium, such as digital texts, requires different skills. What is more, digital texts call for a different understanding in how they work—and to what purpose.

In order for new literacies to be seen as having a place in curriculum, they must be clearly defined. Table 3.1 defines a continuum of the processes in creating

Table 3.1. Reading Trajectory Processes

Decoding and Encoding	Collective Text	Design Contribution	Idealistic Identity	Discourses
To be able to read, (and write) in a code that is understood by the user and others.	Scaffolding understanding through the modes	Understanding how each mode feeds into the overall design	Creation of an identity which aligns with the ideals of the group	Reading and understanding the discourses in or to participate; understanding why discourses are fundamental to the group

an authored reading trajectory. All of the processes work in tandem to inform the reading engagement.

MODES AND SKILLS: WHERE DO WE NEED TO GO?

All of the students in this study were above average students, with solid academic records. It is safe to say that they would not have had any difficulty with a standardized literacy test. However, their comments about their interactions with digital media are very telling: all of these students interact with new literacies in a profound and serious fashion, every day of their lives. In so doing, they have developed unique identities, mastered a complex set of discourses, learned to decode the conventions of a myriad of technological platforms, become familiar with the elements of design, and discovered how to scaffold their own ideas upon the shared platforms common to the Internet. To put it succinctly, via their many interactions with digital media, they have acquired a skill set: sharing of ideas and authorship online, the ability to manipulate texts, creating of new forms of language communication through technology, the ability to create social spaces beyond the geographic, the mastering of online subtext, and a highly fluent visual literacy. Although this skill set engages with some of the skills valued by the education system (and some skills are very relevant to modern life, vis-a-vis their comfort with technology), for the most part they are not recognized as having much to do with the literacy skills schools admire. If we are to have any realistic approach to assessing these skills, then we need to understand how they are acquired and what they actually mean. We need to be able to understand the *reading trajectory processes* which students undergo to read digital texts. Moorman and Horton (2007) maintain that "(Millennial) adolescents read and write more, have a more realistic and broader view of the world, and are more accomplished socially, and process information in fundamentally different ways than previous generations" (p. 2). The challenge for educators is to include texts in the classrooms which represent their students' real life engagements. The students' authored reading trajectory is a very real facet of their literate engagements.

So how to do we assess this in a fashion acceptable to the powerful societal forces that emphasize less ephemeral results, like standardized testing and teaching? As teachers, we must:

1. Begin to recognize the reality of students' engagements online and other technological engagements.
2. Research and develop meaningful ways and means of observing students' authored reading trajectories; for example, encourage students to create

"wikis," jointly authored online informational sites, create class-based web sites where students can be encouraged to contribute and build their own pages, or create classroom projects that require students to demonstrate a multiplicity of online and traditional skills (i.e., interactive displays or PowerPoints which embrace multiple technologies). These projects might not necessarily provide easily quantifiable measurements, but they would provide a platform on which educators could make observations, which in itself would be an enormous step forward.

3. Train and enhance the ability of educators to recognize that student literacy does not end at the bottom of the printed page, and instead extends far into the electronic world—and, therefore, that educators' assessment practices and requirements must follow them into this new frontier.

Although technology has informed the communication and literate engagements of many of our students, we need to think about what that means in practice and how we engage and include new literacies as a part of our curriculum. We need to think about what new literacies actually mean and how defining and assessing them according to past understandings neglects the nature, practicality, and implementation of such real literate experiences for the children in our schools. Reading books and reading screens are not the same experience, though they may share elements in common. Much our students' lives are based on digital literacies, new literacies which are fundamental to many of their activities, pursuits, and the informal parts of their education. Our traditional definitions of literacy have not included these literacies. Through conversations like these, we may begin to see past the technology, to the actual learning and meaning making which is occurring in the lives of youth.

REFERENCES

Alvermann, D. (2002). *Adolescents and literacies in a digital world*. New York: Peter Lang.

Barton, D., & Hamilton, M. (1998). *Local literacies: Reading and writing in one community*. London: Routledge.

Bearne, E. (2003). Rethinking literacy: Communication, representation and text. In UKLA *Reading literacy and language* (pp. 98–105). London: Blackwell Publishing.

Bearne, E., Clark, C., Johnson, A., Manford, P., Mottram, M., & Wolstencroft, H. (2007). *Reading on the screen*. Leicester: United Kingdom Literacy Association.

Bearne, E., Ellis, S., Graham, L., Humes, P., & Merchant, G. (2004). *More than words: Mulitmodal texts in the classroom*. London: Qualifications and Curriculum Authority.

Bearne, E., Ellis, S., Graham, et al. (2005). *More than words 2: Creating stories on page and screen*. London: Qualifications and Curriculum Authority.

Bearne, E., & Kress, G. (2001). Editorial. *Literacy, 35*(3), 89–93.

Black, P., Harrison, C., Lee, C., Marshall, B., & Wiliam, D. (2003). *Assessment for learning*. New York : Open University Press.

Black, P., & Wiliam, D. (1998). Assessment and classroom learning. *Assessment in Education 5*, 7–74.

Black, R.W. (2005). Access and affiliation: The literacy composition practices of English language learners in an online fanfiction community. *Journal of Adult and Adolescent Literacy, 49*(2), 118–128.

Black, R.W. (2007). Digital design: English language learners and reader reviews in online fiction. In M. Knobel & C. Lankshear (Eds.), *A new literacies sampler* (pp. 115–136). New York: Peter Lang.

Burke, A. (2005). Literacy as design. *Orbit, 33*, 16–25.

Burke, A., & Rowsell, J. (2005). From screen to print: Publishing multiliteracies pedagogy. *The International Journal of Learning*. Victoria, AU: Common Ground Publishers. Retrieved on June 14, 2008 from www.Learning-Journal.com

Burke, A., & Rowsell, J. (2007). Assessing multimodal practice. In R. Hammett, M. Mackey, & J.K. McClay, (Eds.), *Assessment and new literacies*. *e-Learning*. Retrieved on October 30, 2008 from http://www.wwwords.co.uk/elea/content/pdfs/4/issue4_3.asp

Burke, A., & Rowsell, J. (2008). Screen pedagogy: Challenging perceptions of digital reading practice. *Changing English, 15*(4), 445–457.

Carrington, V. (2005). New textual landscapes, information and early literacy. In J. Marsh (Ed.) *Popular culture, new media, and digital literacy in early childhood* (pp. 3–27). London: Routledge Falmer.

Chandler-Olcott, K., & Mahar, D. (2003). "Tech-savviness" meets multiliteracies: Exploring adolescent girls' technology-mediated literacy practices. *Reading Research Quarterly, 38*(3), 356–385.

Coiro, J. (2005). Making sense of online text. *Educational Leadership, 63*(2), 30–35.

Coiro, J., & Dobler, E. (2007). Exploring the on-line reading comprehension strategies used by sixth-grade skilled readers to search for and locate information on the Internet. *Reading Research Quarterly, 42*(2), 214–257.

Cope, B., & Kalantzis, M. (n.d.). *Putting multiliteracies to the test*. Retrieved on February 20, 2004 from www.alea.edu.au/multilit.htm

Cope, B., & Kalantzis, M. (2000). (Eds.). *Multiliteracies: Literacy learning and the design of social futures*. London: Routledge.

Delpit, L. (2006). *Other people's children: Cultural conflict in the classroom*. New York: The New Press.

Gee, J.P. (1996). *Social linguistics and literacies: Ideology in discourses* (2nd ed.). London: Falmer Press.

Gee, J.P. (2003). *What video games have to teach us about learning and literacy*. New York: Palgrave Macmillan.

Gee, J.P. (2004a). New times and new literacies: Themes for a changing world. In A.F. Ball & S.W. Freedman (Eds.), *Bakhtinian perspectives on language, literacy, and learning* (pp. 279–306). Cambridge: Cambridge University Press.

Gee, J.P. (2004b). *Situated language and learning: A critique of traditional schooling.* New York: Routledge.

Government of Canada, Industry Canada (2005). *Media Awareness Network. Young Canadians in a wired world* . ERIN Research Inc. Retrieved on April 30, 2008 from www.media-awareness.ca

Jewitt, C., & Kress, G. (2003). *Multimodal literacy.* New York: Peter Lang.

Johnson, D., & Kress, G. (2003). Globalization, literacy and society: Redesigning pedagogy and assessement. *Assessment in Education, 10,* 5–14.

Knobel, M., & Lankshear, C. (2006). Weblog worlds and constructions of effective and powerful writing: Cross with care and only where signs permit. In K. Pahl & J. Rowsell's (Eds.), *Travel notes from the new literacy studies* (pp. 72–92). Clevedon, UK: Multilingual Matters.

Kress, G. (2003). *Literacy in the new media age.* London: Routledge.

Kress, G. (2006). What is English for? *English in Education, 40*(1), 1–4.

Kress, G., & Van Leeuwen, T. (1996). *Reading images: The grammar of visual design.* London: Routledge.

Lankshear, C., & Knobel, M. (2003). *New literacies: Changing knowledge and classroom learning.* Philadelphia, PA: Open University Press.

Lankshear, C., & Knobel, M. (2006). *New literacies: Everyday practices and classroom learning.* New York: McGraw-Hill; Open University Press.

Lankshear. C., & Knobel, M. (2007). Sampling "the new" in new literacies. In M. Knobel & C. Lankshear (Eds.), *A new literacies sampler* (pp. 25–48). New York: Peter Lang.

Leander, K. (2003). Writing travellers' tales on new literacyscapes. *Reading Research Quarterly. 38*(3), 392–397.

Leander, K., & M. Sheehy (2004). *Spatializing literacy research and practice.* New York: Peter Lang.

Lenhart, A., Madden, M., MacGill, A.R., & Smith, A. (2007, December). *Teens and social media. PEW Internet and American Life Project.* Washington, DC: Pew Charitable Trusts. Retrieved on April 6, 2008 from www.pewinternet.org

Leu, D.J. (2000). Literacy and technology: Deictic consequences for literacy education in an Information age. In M.L. Kamil, P. Mosenthal, P.D. Pearson, & R. Barr (Eds.), *Handbook of Reading Research*, 3 (pp. 743–770) Mahwah, NJ: Erlbaum.

Leu, D.J. (2000). Our children's future: Changing the focus of literacy and literacy instruction. *The Reading Teacher, 53*(3), 424–429.

Leu, D.J., Kinzer, C.K., Coiro, J.L., & Cammack, D.W. (2004). Toward a theory of new literacies emerging from the Internet and other information and communication technologies. In R.B. Ruddell & N.J. Unrau (Eds.), *Theoretical models and processes of reading* (5th ed., pp. 1570–1613). Newark, DE: International Reading Association.

Mackey, M. (2004). Playing the text. In T. Grainger (Ed.), *The RoutledgeFalmer reader in language and literacy* (pp. 237–249). London: Routledge.

Mathewman, S., Blight, A., & Davies, C. (2004). What does multimodality mean for English? Creative tensions in teaching new texts and new literacies. *Education, Communication and Information, 4*(1), 153–176.

Merriam, S. (1998). *Qualitative research and case study applications in education* (2nd ed). San Francisco, CA: Jossey-Bass.

Moorman, G., & Horton, J. (2007). Millennials and how to teach them. In J. Lewis & G. Moorman (Eds.), *Adolescent literacy instruction : Policies and promising practice* (pp. 263–286). Newark, DE: International Reading Association.

NCLB (2001). *No Child Left Behind Act of 2001, S. Number, 107.* Retrieved on April 12, 2007 from http://www.ed.gov/nclb/landing.jhtml?src=pb

Prensky, M. (2001). Digital natives, digital immigrants. Part 1. *On the Horizon, 9*(5), 1–6.

Ross, J.A., Rolheiser, C., & Hogaboam-Gray, A. (2002). Influences on student cognitions about evaluation. *Assessment in Education, 9*, 81–95.

Rowsell, J., & Burke, A. (In press) Reading by design: Two case studies of digital deading practices. *Journal of Adolescent and Adult Literacy.*

Scribner, S., & Cole, M. (1981). *The psychology of literacy.* Cambridge, MA: Harvard University Press.

Snyder, I. (1998). *Page to screen: Taking literacy into the electronic era.* London: Routledge.

Snyder, I. (2001). *Silicon literacies: Communication, innovation and education in the electronic age.* London: Routledge.

Stanat, P., Artelt, C., Baumert, J., Klieme, E., Neubrand, M., Prenzel, M., Schiefele, U., Schneider, W., Schümer, G., Tillmann, K.-J., & Weiss, M. (2002). *PISA 2000: Overview of the study, design, method and results.* Max Planck Institute for Human Development, Berlin.

Street, B. (1995). *Social literacies: Critical approaches to literacy in development, ethnography and education.* London: Longman.

Thomas, A. (2007). Blurring and breaking through the boundaries of narrative, literacy and identity in adolescent fan fiction. In M. Knobel & C. Lankshear (Eds.), *A new literacies sampler* (pp. 137–167). New York: Peter Lang.

United Kingdom Literacy Association (2007). *Reading on the Screen Research Report.* Leicester: UK.

United Kingdom Literacy Association/Qualifications and Assessment Authority (2007). *More than words 2: Creating stories on page and screen.* London: QCA. Retrieved on September 16, 2008 from http://www.qca.org.uk/qca_5743.aspx

United Kingdom Literacy Association/Qualifications and Curriculum Authority (2004). *More than words: Multimodal texts in the classroom.* London: QCA. Retrieved on March 30, 2009 from http://www.qca.org.uk

United Kingdom Literacy Association/Qualifications and Curriculum Authority (2005). *More than words 2: Creating stories on page and screen.* London: QCA. Retrieved on March 30, 2009 from http://www.qca.org.uk

Making THE Invisible Visible: Assessing THE Visual AS Spaces OF Learning

MAUREEN KENDRICK, ROBERTA McKAY, AND HARRIET MUTONYI

INTRODUCTION

One of the most distinctive features of the 21st century is the dominance of the visual. Human experience is more visual and visualized than ever before (Mirzoeff, 2000). Visual communication is becoming less the domain of specialists, and more and more crucial in the domains of public communication (Kress & van Leeuwen, 1996), particularly as dominant modes of communication shift from page to screen (Snyder, 1997). The visual is not just part of everyday life, it has *become* everyday life (Mirzoeff, 2000). Yet visual modes as spaces of learning, although integral to the early years of schooling, are not developed and built on in classrooms as tools for future communication use (Kress, 1997). Moreover, generating information about students' knowledge and perceptions of their own learning typically involves language-based modes of assessment, which may not build access to the multiple layers and complexities of students' knowing. Visual representations such as drawings have been utilized by researchers in various fields such as psychology and anthropology to learn more about participants' constructions of their worlds (e.g., Adler, 1982; Dennis, 1966, 1970; Diem-Wille, 2001; Koppitz, 1984). In literacy teaching and research, however, the development of methods that utilize a variety of forms of representation as a means of examining what students know and understand remains largely unexplored despite the

fact that a growing number of literacy researchers (e.g., Anning, 2003; Berghoff, Cousin, & Martens, 1998; Gee, 2005; Kress, 1997, 2000; Siegel, 2006) recognize that students make use of the multiple sign systems available to them in the culture to construct and express meaning.

In this chapter, we argue that students' visual representations of their knowledge and experience are complex narratives that have unrealized potential for classroom pedagogy and assessment. We draw from examples across our various research studies over the past 10 years. These include research on children's images of literacy, which was undertaken by Kendrick and McKay in Canada in the late 1990s. This research addressed how young children use drawing as an alternative mode for conceptualizing literacy in their lives (see, for example, Kendrick & McKay, 2003, 2004, 2009). Also see Bearne's chapter in this volume. In 2003, we had an opportunity to extend our research to school contexts in New Zealand in order to assess uses of the visual as a mode of representation in other cultural contexts. This study involved a diverse population of students, including many with Pacific Island and Maori ancestry. We also incorporate examples from research undertaken by Kendrick[1] in 2003 investigating the literacy ecology of three Ugandan communities, and from work done by Mutonyi and Kendrick, in 2006, which examined the use of cartoons for conceptualizing health literacy. For the purposes of this chapter, we focus on six examples from the three cultural contexts: four primary students' visual representations of literacy in Canada, New Zealand and Uganda, and two secondary students' visual representations of health literacy, specifically HIV/AIDS knowledge, in Uganda.

A MULTIMODAL STANCE

We view literacy as a social practice rooted in conceptions of knowledge, identity, and being (Street, 2003); more specifically, we think of literacy as "the ways language learners understand themselves, their social surroundings, their histories, and their possibilities for the future" (Norton & Toohey, 2003, p. 1). In the age of multimedia, we also recognize that literacy practices are necessarily changing and multiple, "where the textual is also related to the visual, the audio, the spatial, the behavioural... Meaning is made in ways that are increasingly multimodal in which written-linguistic modes of meaning are part and parcel of visual, audio, and spatial patterns of meaning" (Cope & Kalantzis, 2000, p. 6). From this perspective, we argue that both literacy learning, teaching, and research require the development of a semiotic/multimodal toolkit (Dyson, 2001; Jewitt & Kress, 2003; New London Group, 1996) that builds access to the complexity of literacy

practices and discourse resources that constitute the contemporary social landscape (Luke, 2000).

When students are asked about their understandings of particular topics, ideas, and concepts, they respond by presenting *representations* (Bruner, 1964). Gilbert and Boulter (2000) refer to such representations as mental models— personal cognitive representations held by an individual. The only way to understand students' mental model of a particular phenomenon is by eliciting one or more of their expressed models of that phenomenon (Reiss, Boulter, & Tunnicliffe, 2007). Although there are multiple ways of generating information about students' understandings of a particular phenomenon, the vast majority of these methods rely on speaking or writing alone. Instead, we take seriously Kress's argument (2000) for the need to take a completely fresh look at multiple modes of representation in theories of communication and to reevaluate how we use different symbol systems to represent meaning. We draw on social semiotics, which, according to Kress and van Leeuwen (1996), is an attempt to explain and understand how signs are used to produce and communicate meanings across social settings from families to institutions. Signs created through visual representations such as drawings simultaneously communicate the here and now of a social context while representing the resources individuals have "to hand" from the world around them (Kress, 1997; Vygotsky, 1978). The meanings encoded in visual representations also reflect reality as imagined by sign-makers and influenced by their beliefs, values, and biases.

Taking a multimodal/social semiotic theoretical stance to understanding literacy (Kress, 1997, 2000; Pahl, 2003; Stein, 2003) necessitates a methodology that goes beyond traditional language-based approaches. Our literacy research uses a qualitative, interpretative, image-based methodology (Prosser, 1998; Rose, 2001; van Leeuwen & Jewitt, 2001). Image-based research includes moving forms such as films and videos, as well as still images such as photographs, drawings, graffiti, and cartoons (Prosser, 1998). Prosser suggests that it has only been within the last 30 years that qualitative researchers have given serious consideration to the use of images with words to enhance understanding of the human condition. Images offer us, as researchers (and teachers), data that are ordered differently and that allow us to perceive that data in different ways. The production of the images (e.g., drawings and cartoons) also provides the students with a different mode to create and express what they know, which may be quite different from what they express in words. Given the opportunity, students are highly capable of demonstrating their awareness that "there are 'best ways' of representing meanings: in some circumstances language may be the best medium; in some drawing may be; in others colour may be the most apt medium for expression" (Kress, 1997, p. 38). We contend that as the visual gains

more prominence in classrooms and in the lives of students, and as researchers and teachers work toward developing productive means of assessing the visual, it may be possible to move beyond the general assumption that language is a fully adequate communication and representation medium for expressing anything that we think, feel, or sense.

From a research perspective, visual anthropology also broadly informs our understanding of multiple modes of representation within specific social and cultural settings such as Canada, New Zealand, and Uganda. Visual anthropologists contend: "much that is observable, much that can be learned about a culture can be recorded most effectively and comprehensively through film, photography or by drawing" (Morphy & Banks, 1997, p. 14). They also argue that neglecting visual data may be a reflection of Western bias (the privileging of the intellectual over the experiential or phenomenological) or neglecting the importance of visual phenomena across cultures. We would add that neglecting visual data may also be a reflection of an adult communication bias, which typically privileges written modes over visual. Traditionally, researchers rather than research participants have used visual modes for recording culture. We view our participants as co-researchers and put the visual tools of pencils, crayons, and felts in their hands to enhance our understanding of their conceptualizations of complex topics such as literacy and HIV/AIDS.

SITES OF MEANING-MAKING

Although students' visual representations may be collected with relative ease, they are more difficult to analyze due to their complexity, richness, simultaneity and multilayered nature. Rose (2001) points out that although there is substantial academic work being published in the social sciences on "things visual, there are remarkably few guides to possible methods of interpretation and even fewer explanations of how to do those methods" (p. 2). In the interdisciplinary field of visual analysis, interpreters of visual images broadly agree that there are three sites at which the meanings of an image are made: the site of production, the site of the image itself, and the site of viewing (Rose, 2001). Many of the theoretical disagreements about visual interpretation relate to disputes over which of these sites is most important and why. In relation to the research reported here, it is our position that the three sites at which meanings are made are inextricably connected and recursively relational to each other. We elaborate on this relationship and our adaptation of Rose's interpretive framework as a productive means of assessing students' learning and knowledge construction through the visual modes of drawing and cartooning.

PRIMARY STUDENTS' DRAWINGS OF LITERACY

Method and Procedures

In this first set of examples, we focus on four visual representations of literacy: two from a Canadian context (Kendrick & McKay, 2003, 2009), one from New Zealand (Kendrick & McKay, 2003, 2004, 2009), and one from Uganda (Kendrick & Jones, 2008). Across these contexts, we explore the broad question, "How do students use drawing to represent the literacy practices in their lives?" The procedure we followed in soliciting visual representations of literacy involved group discussions followed by a drawing task. The participating students met in groups with a research assistant or one of the researchers for approximately 60 minutes to discuss and draw pictures of their ideas about literacy in their lives in school, outside of school, and in the future. The groups ranged in size from 4 to 21 children, with the average group size being 17 children. Because our goal was to explore children's images and ideas as evident in their drawings, the questions outlined below were used to guide the discussions rather than rigidly format them.

1. What kind of reading/writing do you do in school/outside of school?
2. Why do you read/write in school/outside of school?
3. Where do you read/write in school/outside of school?
4. How is reading/writing in school both similar and different from reading/writing outside of school?
5. How do you think you will use reading/writing in the future, as you grow older?
6. Draw a picture of reading or writing. It can be a picture of reading or writing that you do now or that you think you might do when you're older.

Following the discussion and drawing session, the students were asked to provide an explanation of their drawings. Some were able to write explanations on the back of their drawings, whereas others dictated to one of the researchers. We assess what the drawings as signs might mean within each particular socio-cultural context across the three sites of meaning-making (Rose, 2001). We also use an adaptation of Dyer's (1982) checklist for exploring what the drawings as signs might mean within each particular socio-cultural context. Specifically, the drawings were coded and analyzed according to the following: representations of bodies (age, male/female, race, hair, body, size, looks), representations of manner (expression, eye contact, pose), representations of activity (touch, body movement, positional communication), and representations of props and setting. We concentrate first on a description of the visual, then try to establish a narrative thread

that weaves together other elements and layers of meaning in the drawing that link to the broader contexts of the participants' lives. The four selected drawings were either most typical or most atypical of the data set as a whole.

Examples of Literacy Drawings

Brandy and Melody

Brandy is a 6-year-old Canadian girl. Her drawing, which depicts letter writing with her father, highlights the role of literacy in maintaining emotional ties and relationships with absent family members. During the drawing activity, she talked about writing a letter to her father, who did not live in the same household and worked for long periods outside of the city in which she lived. The drawing includes a pencil and a letter that reads, "Dear Dad How are you doing Love Brandy" (see Figure 4.1). On the reverse side, she drew her father and his written response to her letter: "Dear Brandy. I love you very much" (see Figure 4.2).

For Melody, a 7-year-old from New Zealand, reading and writing at home are strongly associated with her family's religious practices. In her drawing, she is sitting on her bed surrounded by multiple copies of prayer books (see Figure 4.3). She writes: *"I am getting a book of prayers at home. I am reading the book of prayers at home. It is cool reading the book of prayers. It was fun. I love reading at home. I am 7 yrs old. I love reading and writing. I love reading prayers."*

Figure 4.1. Brandy writing letters with her father

Figure 4.2. Brandy's father's response

Figure 4.3. Reading the book of prayers

Both Brandy's and Melody's depictions of literacy focus not on reading and writing as activities in and of themselves, but rather, what motivates their individual desire to read and write. Brandy associated writing with communicating with her father when he was away. For Melody, reading was associated with practicing

her prayers. Drawing provides a space for young learners like Brandy and Melody to make sense of the literacy practices embedded in the personal relationships they have with members of their families and communities. Both drawings are more representative of human relationships and beliefs than literacy itself; this message is a powerful reminder that literacy is not a prepackaged set of skills to be learned, but rather, it is something that takes hold in children's lives in ways that are uniquely meaningful to them. What these two children represent in their images of literacy brings to the forefront of literacy learning the human relationships that are most salient in their lives as young learners.

As researchers, we serve as a public audience for these images. As Collier explains, "Analysis of visual records of human experience is a search for pattern and meaning, complicated by our inescapable role as participants in that experience" (2001, p. 35). How we assess the patterns and meanings evident in the drawings must be contextualized in relation to our own associations, experiences, and ways of valuing literacy, which have in turn influenced the very nature of how we solicited the students' drawings. In other words, the drawings are co-constructions that involve both researchers' and children's understandings of literacy.

Dustin

Dustin is a 10-year-old Canadian student. His drawing of literacy illuminates how visual representations can reveal complex literacy narratives that may not be readily evident. He wrote the following on the front of his drawing: *I shot my first buck with a doble barel shotgut. It is at my grapernts farm. My dad Helped me.* As the text indicates, his drawing was of a freshly killed buck, hanging upside down, blood dripping from its neck (see Figure 4.4). Dustin, rifle in hand, is drawn beside the buck. It would have been easy for us as researchers to overlook Dustin's drawing or assess its content based on low achievement or disinterest in reading and writing. By revisiting Dustin's drawing, as he interpreted it for us within the context

Figure 4.4. Dustin's drawing

of his life both inside and outside the classroom, we were able to tap into his own perception of the multiple layers of meaning embedded in his drawing. Dustin engaged in the drawing activity with considerable secrecy, assessing the expectation by asking questions such as: "Can we draw anything we want about reading and writing?" and "Does our teacher get to see it?" Once reassured that he was free to draw what he chose, and that his teacher would not see the drawing without his permission, he set to work with quiet determination.

We suspected from his secrecy that guns and hunting were not topics that he thought would meet his language arts teacher's approval; they were topics that, according to him, constituted "violence," something he said he was "not allowed to write about." An interview with Dustin's teacher confirmed that guns, blood, and dismemberment were banned from classroom drawing, writing, and reading as part of the school's "zero tolerance" policy on violence. Dustin's drawing is a powerful representation of what he was not allowed to write about in his classroom. His interpretation of his school's policy was also evident in his blank journal; when he was told on the Monday mornings following his weekend hunting trips with his father and grandfather to write about his weekend, he sat in silent resistance. Drawings such as Dustin's have unrealized potential for helping uncover the scripts or "literacy narratives" (Gallas & Smagorinsky, 2002, p. 58) students bring to school and that they use to make sense of reading and writing. These literacy narratives comprise students' perceptions and interpretations of their social interactions, and the cultural materials and experiences to which they are exposed both inside and outside school. Schooled notions of what counts as literacy ignore Dustin's unrealized potential.

Hannah

Hannah is an 11-year-old primary school student living in rural Uganda. Her parents are subsistence farmers who struggle to provide the basics for their children, let alone luxuries such as school supplies, uniforms, and books. For many parents such as Hannah's, there is considerable uncertainty about whether they will be able to afford to send their children to secondary school. Hannah's drawing is a self-portrait in which she is attired formally, wearing a dress and shoes not typical of her school uniform (see Figure 4.5). Secondary school girls in this area typically dress in this manner when they are traveling home from boarding school on weekends or holidays. Her manner of dress may also be reflective of a desired future lifestyle that affords her material goods such as fashionable clothing, which she does not currently possess.

The bench situated under the tree appears to be a study environment. A spot under a tree is a common place to read, especially during examinations when there are no classes and students are preparing at home. Hannah's solitary positioning

Figure 4.5. Hannah

outdoors lends the impression that she has claimed a private space away from the distractions and responsibilities she most likely faces at home. Studying in private is often indicative of someone who takes schoolwork seriously; the aura of a serious student is also communicated by Hannah's concentrated facial expression and upright posture. She clearly labels her reading material *Young Talk*, which is a monthly national newspaper about HIV/AIDS and other sexual health issues targeted at youth. Reading this newspaper requires a high level of English language ability, which most likely reflects her desire to become a part of the English literacy community because of the increased life opportunities it will afford her. As explained in her writing, she is reading *Young Talk* "to know about the [English] words."

The narrative Hannah composes in the drawing is about a young woman who is well dressed, literate in English, and possibly also knowledgeable about issues such as HIV/AIDS and early sexual involvement, which are both potential barriers to attaining her future lifestyle and educational goals. This image of herself, real or imagined, represents her "imagined freedoms" in relation to economics, education, and her status in society. Hannah's positioning of self in the image simultaneously reflects her social history and surroundings as well as how she understands herself and her imagined possibilities for the future. As Norton and Toohey (2003)

contend, knowledge of students' imagined communities and identities may be a critical component of assessing how and why they engage or do not engage in particular literacy practices (Norton & Toohey, 2003).

Drawings of Literacy: Patterns of Meaning

Both art and language provide a means of encoding experience, whether real or imagined (Baron, 1984). As Kress argues, the two modes—art and language—are "embedded in distinct ways of conceptualising, thinking, and communicating" (2000, p. 195). Drawings in particular, he explains, show an astonishing conceptual understanding and imagination that cannot be expressed through language, even language in narrative format. By making visible what is hidden in their mind's eye, the students reveal who they imagine they are allowed to become within the realm of their social and cultural contexts. Assessments of their social and material choices about how to construct literacy constitute, in Willis's words, "the organization of self in relation to the future" (1977, p. 172). Inextricably linked to these choices are the human relationships and the imagined worlds children associate with literacy. Each of these image-based texts represents a unique literacy narrative that reveals the students' complex understandings of how they assess the contexts to represent self and others in relation to literacy.

SECONDARY STUDENTS' VISUAL REPRESENTATIONS OF HEALTH LITERACY IN UGANDAN CLASSROOMS

Method and Procedures

In these two examples, we examine and assess the use of drawing as a tool for understanding students' health literacy, in particular, their conceptualizations of HIV/AIDS knowledge. Specifically, we address the question: "How do Ugandan Senior Three Students use cartoons to represent their knowledge of HIV/AIDS?" The research is an interpretive qualitative case study (Gallagher & Tobin, 1991; Merriam, 1998; Stake, 1995, 1998; Yin, 2003) involving Senior 3 biology classes from four Eastern Ugandan high schools (Mutonyi, 2005; Mutonyi & Kendrick, in press). The four schools varied in status and represented typical public high schools in Uganda; that is, girls-only boarding, boys-only boarding, mixed-boarding and mixed-day schools. Senior Three classes were selected because HIV/AIDS is part of the Senior 3 biology curriculum and, more importantly, this age group is considered highly at risk of contracting HIV/AIDS (Uganda AIDS Commission, 2002).

On a questionnaire, students were asked to simultaneously use text and drawing to convey their understanding of HIV/AIDS. The students were asked to create "cartoons" rather than drawings because of the context. Specifically, the students indicated they associate the word drawing with "artistic" drawing and they were not "talented" in this way. Cartooning, on the other hand, allowed them to draw what they call "stick images" without paying special attention to positioning and spatial relationships from a purely aesthetic perspective. For all of these secondary students, cartooning was a familiar mode of communication used extensively in public education campaigns that target youth. As such, the students did not have preconceived notions of school-sanctioned standards for how cartoons should look or how they should function. We present two illustrative examples that exemplify the kinds of visual narratives this group of students constructed.

We use an adaptation of Warburton's (1996) analytic framework to assess and explore what the cartoons as mediated images might mean. Our interpretation of the images traverses the sites of viewing and production in relation to the image itself (Rose, 2001). The students' own voices, evident in their written text, were critical to our interpretive process. We begin with an *initial description* of the image itself (What visual and textual material is contained within the cartoon? Who and what are represented?) and focus on *immediate connotation* (What does the cartoon count for publicly? What does the image/text signify?), then *systemic connotation* (What is the place and status of the cartoon with respect to the communication system or systems it is part of? What are the connotations of the image/text?). Finally, in this descriptive/assessment framework we *establish narrative threads* (For what/whom was the cartoon intended? What is the relationship between the cartoon and broader discourses on HIV/AIDS?), which provide a synthesis across the three sites of meaning-making.

To extend this analysis and assessment, we also use Jewitt and Oyama's (2001) framework for analyzing health related visual images, focusing particularly on the underlying assumptions of gender representations that can be deduced from the cartoon drawings. In this analysis, we include general concepts of narrative visual analysis in relation to participants (e.g., represented/non-represented and interactive participants) (Jewitt & Oyama, 2001; Kress & van Leeuwen, 1996). The combination of descriptive frameworks used in the analysis allowed us to uncover a visual narrative that was not initially evident. These narratives helped us raise questions about the possible meanings of the cartoons in relation to broader theories and discourses on health literacy and public and cultural constructions of HIV/AIDS.

Examples of Health Literacy Cartoons

Tolophina

Tolophina, a Ugandan Senior 3 (Grade 12) secondary student, drew a series of pictures linked to the narrative captions: "I am worried my friend Susan have HIV/AIDS" and "Susan on streets with other men b'se she had arrived at Kampala." On the left side of the picture, two people—Susan and a man—are depicted engaged in a sexual transaction (see Figure 4.6). "How much are you going to pay me?" is written in Susan's speech bubble; her extended arm directed toward the man communicates her active role in soliciting the interaction. The man's body is positioned away from Susan, which indicates a more passive role in the interaction. In the second frame of the cartoon, Susan's body positioning extends our understanding of the text. Her gestural movement creates a direct line to George, the boy, which reinforces her active role in the interaction. George's body directed away from the girl adds to our assessment of the visual narrative, the possibility of the involvement of someone or something that is not represented in the picture. In the final frame of the cartoon, Susan is represented in a position of power over George. The representation of Susan in an active role in initiating transactional relationships to earn money and maintaining romantic relationships with the lure of money emphasizes the vulnerability of those who solicit prostitutes rather than the vulnerability of the prostitutes themselves. This notion of vulnerability is further emphasized by the unknown in relation to George's gaze and body positioning in both the second and third sequence of the narrative. These visual texts provide opportunities for extending meaning making, both through and in tandem with modes such as gestural, spatial, and aural. These modes operate simultaneously as a holistic text that informs our understanding of Tolophina's drawing and her knowledge of literacy and HIV/AIDS.

Figure 4.6. Tolophina

The narrative portrayed in Tolophina's cartoon also represents the link between socioeconomic status and HIV/AIDS, and how HIV gets spread among urban and rural people in Uganda. The narrative indicates that George and Susan had been friends in the village but Susan ends up going to Kampala to work as a prostitute. Often, girls from poor families might resort to prostitution to survive, which may very well be the case with Susan. The cartoonist makes reference to Kampala because of the status it most likely carries in the conversation with George, who may never have been to the city. Prostitution in Uganda is most predominant in Kampala. Because of these circumstances, Tolophina is concerned Susan has been exposed to possible HIV infection. George, on the other hand, is portrayed as innocent and in love with Susan, who takes advantage of his trust. He happily accepts the money possibly because he is also poor. Despite the central messages of sexual faithfulness in the Ugandan HIV campaign, this cartoon portrays some of the circumstances under which partners may be unfaithful. Tolophina depicts the girl as the actor rather than the more typical victim. She also portrays the rural male as vulnerable to the city-savvy female.

Opondo

Opondo is also a Ugandan Senior 3 (Grade 12) secondary student. His cartoon is set outdoors amidst a heavy downpour (see Figure 4.7). There are three people: one wrapped in a condom, sheltered from the storm, the other two standing side by side in the rain without protection. The cartoonist uses metaphor to convey his message on HIV/AIDS prevention. The rain is labeled AIDS/HIV; the person wrapped in the condom is labeled "protected sex" whereas the unsheltered people are labeled "unprotected sex." The accompanying text reads, "To stay safe from HIV/AIDS simply abstain from sex or use condoms." Opondo's visual representation is a highly effective visual metaphor comprised of multiple sign systems that work simultaneously to communicate his intended meaning. Our assessment

Figure 4.7. Opondo

required reading the image as a whole text and understanding how the various sign systems work in relation to each other, that is, as fused with the visual rather than as separate systems.

Opondo demonstrates that he knows that condoms prevent HIV/AIDS and that unprotected sex makes one vulnerable to infection. The person wrapped in the condom does not appear wet while the ones without shelter are soaked, signifying their vulnerability to infection. The cartoonist respects the cultural approach to educating people about condom use without being explicit about it. Specifically, he uses rain to represent body fluid and a human life instead of a phallic object (e.g., a banana) to communicate how condoms protect against HIV/AIDS. This cartoon shows a high level of creativity and cultural sensitivity in a message that moves beyond more common media messages.

Health Literacy Cartoons: Patterns of Meaning

Cartoons, Warburton and Saunders argue, are unique cultural artifacts that "rely on the communication of stereotypes. These synthesize and amplify cultural narratives" (1996, p. 307). In the hands of these students, cartoons as cultural artifacts have considerable potential for HIV/AIDS education in schools and beyond. These visual representations of HIV/AIDS knowledge are an intermingling of cultural and personal narratives told to both public and private audiences that allow for the expression of a much fuller range of human emotion and experience than spoken or written communication alone (Kress & van Leeuwen, 1996). This is of particular importance when assessing how the cartoons serve to acknowledge the limits of language by simultaneously integrating and transcending taboo cultural practices around discussions of sexuality and condom use. Our findings raise important questions regarding the potentials and limitations of visual and other modes of representation for HIV/AIDS curriculum design and implementation in schools, and in particular, for understanding the relationship between students' own social histories and identities and their interpretation of HIV/AIDS messages. Assessing the diversity of ways in which these students "see" HIV/AIDS demonstrates that cartoons have considerable potential as an untapped pedagogical resource for health literacy and HIV/AIDS education in particular.

Assessing the Affordances of Visual Representations: Implications for Classrooms

Until recently, there has been little interest in investigating and assessing students' perspectives about aspects of their own learning (Dyer, 2002; Filippini & Vecchi, 2000). Arguably, students' perspectives of their own experiences and learning

have the potential to inform educational policy, assessment, and the evolution of practices that are designed to involve them (Harste, Woodward, & Burke, 1984; Nutbrown & Hannon, 2003). From both a research and pedagogical perspective, however, accessing and understanding students' views can be methodologically challenging. In examining how individuals construct narratives of their own lives and experiences, Welty (1983) makes the distinction between listening *for* a story and listening *to* a story, noting that the former requires a much more engaged and dynamic form of listening. The students' visual representations through drawing and cartooning allowed us to listen for a story, and assess and come to understand how students attach meaning to their learning across the various sites of meaning-making.

At the site of production, the students' own voices and interpretations of their images, whether written or scribed, were paramount in understanding their meaning-making process. In assessing and interpreting the image itself, we see the words and pictures as inextricably linked, as a kind of continuous visual narrative text whereby language and image are fused and cannot be separated. The students' meanings, however, are not something inherent in the visual text alone; rather, meanings are co-constructed and collaboratively negotiated by producers and viewers. As such, we recognize that our assessments of these visual texts can only ever point to meaning potentials or possible meanings as opposed to discovering the "one true meaning" of the text. The images, as interpreted across the sites of meaning-making, make visible aspects of students' lives and literacies that are typically invisible when more traditional modes such as speaking or writing alone are used in classroom pedagogies and assessment practices. As multimodal texts, the visual allows students to bring together in highly effective ways multiple sign systems such as spatial, gestural, linguistic, and aural to represent and communicate what they think, feel, and sense.

The visual as a space of learning has a unique set of affordances that go beyond what can be communicated through spoken or written language alone. The students' visual narratives are foremost spaces of authoring/figuring out identity and relationships that are integral to their learning. Visual and other modes have affordances that students make expert use of to represent their knowledge. The images provide windows on the students' imagined communities and identities (Norton, 2000) and imagined "freedoms" (Kendrick & Jones, 2008). As Norton (2000) argues, investment in literacy practices must be understood within this context. Unlike language-based communication, the visual allows students to invert the existing social order in order to explore new social positionings in relation to their literacy knowledge and experience. Bakhtin (1984) equated this inversion process with the carnivalesque. With its masks, monsters, games, dramas, and processions, carnival juxtaposes, mixes, and confronts the spiritual and

material, young and old, male and female, daily identity and festive mask, serious convention and parody, in a "temporary suspension of all hierarchic distinctions and barriers…and of the prohibitions of usual life" (Bakhtin, 1984, p. 15). In this way, our assessment of the visual text demonstrates that the visual both integrates and transcends cultural practices, permitting students to "talk what others think you can't talk" (participant comment, 2004).

Visual representations as opposed to written representations of students' knowledge and experience have considerable potential as spaces of learning in schools and beyond. They provide an alternative method of accessing and assessing students' constructions of literacies in their lives by making visible the kinds of "invisible" knowledge, experience, and emotion that for personal, social, and cultural reasons, students may have difficulty expressing through language alone. They also illuminate the acute vulnerabilities that may prevent students from investing in classroom literacy practices or from applying their knowledge of particular topics such as HIV/AIDS. By responding to these vulnerabilities, teachers, educators, and community leaders can take further steps toward helping students. In assessing these visual texts we see the interface between students' identities, social histories, and literacies. The diversity of ways in which students portray this interface provides insight into how to validate students' literacies, experiences, cultures, and preferred modes of representation in classroom and community contexts.

CONCLUSION

The drawings and cartoons are student-centered spaces of learning that allow for the expression of a much fuller range of human emotions and experiences (Kress & van Leeuwen, 1996) that are not predetermined by the school system. Each text as a visual narrative opens a door to students' worlds that helps us as researchers and teachers understand their constructions and critique of social reality. We see the texts as co-constructed, multilayered, and authentic accounts of students' knowledge, abilities, lives, and literacies. They epitomize what Freire (1990) referred to as a pedagogical method that "while not rejecting the demands of rigour, gives scope to spontaneity, emotion, and adopts as its point of departure what I might call the pupils' perceptual, historical and social here and now." In other words, including the visual as a space of learning in classrooms responds to the current question of how to validate students' literacies, experiences, cultures, and preferred modes of representation. Moreover, because visual texts have the potential to include multiple modes such as spatial, gestural, and aural, they offer more opportunities for making visible that which

is often invisible in traditional school-sanctioned methods of assessing and valuing students' learning and knowledge.

NOTE

1. Along with Bonny Norton and a team of PhD students at the University of British Columbia which included Harriet Mutonyi, Shelley Jones, and Juliet Tembe.

REFERENCES

Adler, L.L. (1982). Children's drawings as an indicator of individual preferences reflecting group values: A programmatic study. In L.L. Adler (Ed.), *Cross-cultural research at issue* (pp. 71–98). New York: Academic Press.

Anning, A. (2003). Pathways to the graphicacy club: The crossroad of home and pre-school. *Journal of Early Childhood Literacy, 3,* 5–35.

Bakhtin, M. (1984). *Rabelais and his world* (H. Iswolsky, Trans.). Bloomington: Indiana University Press.

Baron, N.S. (1984). Speech, sight, and signs: The role of iconicity in language and art. *Semiotica, 52–53,* 197–211.

Berghoff, B., Cousin, P.T., & Martens, P. (1998). Multiple sign systems and reading. *Reading Teacher, 51,* 520–523.

Bruner, J.S. (1964). The course of cognitive growth. *American Psychologist, 19,* 1–15.

Collier, M. (2001). Approaches to analysis in visual anthropology. In T. van Leeuwen & C. Jewitt (Eds.), *Handbook of visual analysis* (pp. 35–60). London, UK: Sage.

Cope, B., & Kalantzis, M. (2000). Introduction. In B. Cope & M. Kalantzis (Eds.), *Multiliteracies: Learning and the design of social futures* (pp. 3–8). London: Routledge.

Dennis, W. (1966). *Group values through children's drawings.* New York: John Wiley & Sons, inc.

Dennis, W. (1970). Goodenough scores, art experience and modernization. In I. Al-Issas & W. Dennis (Eds.), *Cross-cultural studies of behavior* (pp. 134–152). New York: Holt, Rinehart & Winston.

Diem-Wille, G. (2001). A therapeutic perspective: The use of drawings in child psychoanalysis and social science. In T. van Leeuwen & C. Jewitt (Eds.), *Handbook of visual analysis* (pp. 119–133). London: Sage.

Dyer, G. (1982). *Advertising as communication.* London, UK: Routledge.

Dyer, P. (2002). A box full of feelings: Emotional literacy in a nursery class. In C. Nutbrown (Ed.), *Research studies in early childhood education* (pp. 67–76). Stoke-on-Trent: Trentham.

Dyson, A.H. (2001). Where are the childhoods in childhood literacy?: An exploration in outer (school) space. *Journal of Early Childhood Literacy, 1*(1), 9–39.

Dyson, A.H. (2004). Diversity as a "handful": Toward retheorizing the basics. *Research in the Teaching of English, 39*(2), 210–214.

Dyson, A.H., & Genishi, C. (1994). Introduction: The need for story. In A. Haas Dyson & C. Genishi (Eds.), *The need for story: Cultural diversity in classroom and community* (pp. 1–7). Urbana, IL: National Council of Teachers of English.

Freire, P. (1990). Reading the world—interview with Brazilian educator Paulo Freire. *UNESCO Courier*, Dec, 1990, by Marcio D'Olne Campo. Retrieved on July 8, 2008 from: http://findarticles.com/p/articles/mi_m1310/is_1990_Dec/ai_9339028

Filippini, T., & Vecchi, V. (Eds.) (2000). *The hundred languages of children: Exhibition catalogue.* Reggio Emilia: Reggio Children.

Gallagher, J.J., & Tobin, K.G. (1991). Reporting interpretive research. In J. Gallagher (Ed.), *Interpretive research in science education* (National Association of Research in Science Teaching Monograph No. 4, pp. 85–95). Manhattan, KS: NARST.

Gallas, K., & Smagorinsky, P. (2002). Approaching texts in school. *The Reading Teacher, 56*, 54–61.

Gee, J. (2005). Learning by design: Good video games as learning machines. *E-Learning, 2*(1), 5–15.

Gilbert, J.K., & Boulter, C. (Eds.) 2000. *Developing models in science education.* Boston: Kluwer.

Harste, J.C., Woodward, V.A., & Burke, C.L. (1984). *Language stories and literacy lessons.* Portsmouth, NH: Heinemann.

Jewitt, C., & Kress, G. (Eds.) (2003). *Multimodal literacy.* New York: Peter Lang.

Jewitt, C., & Oyama, R. (2001). Visual meaning: A social semiotic approach. In T. van Leeuwen & C. Jewitt (Eds.), *Handbook of visual analysis* (pp. 134–156). London, UK: Sage.

Kendrick, M., & Jones, S. (2008). Girls' visual representations of literacy in a rural Ugandan community. *Canadian Journal of Education, 31*(2), 371–402.

Kendrick, M., & McKay, R. (2003). Uncovering literacy narratives through children's drawings: An illustrative example. *Canadian Journal of Education, 27*(1), 45–60.

Kendrick, M., & McKay, R. (2004). Drawing as an alternative way of understanding young children's constructions of literacy. *Journal of Early Childhood Literacy, 4*(1), 109–128.

Kendrick, M., & McKay, R. (2009). Researching literacy with young children's drawings. In M. Narey (Ed.), *Making meaning: Construction multimodal perspectives of language, literacy, and learning in arts-based early childhood education* (pp. 51–68). New York: Springer.

Koppitz, E.M. (1984). *Psychological evaluation of human figure drawings by middle school pupils.* Orlando, Fl: Grune & Stratton, Inc.

Kress, G. (1997). *Before writing: Rethinking the paths to literacy.* London, UK: Routledge.

Kress, G. (2000). Multimodality. In B. Cope & M. Kalantzis (Eds.), *Multiliteracies: Literacy learning and the design of social futures* (pp. 182–202). London: Routledge.

Kress, G., & Jewitt, C., (2003). Introduction. In C. Jewitt & G. Kress (Eds.), *Multimodal literacy* (pp. 1–18). New York: Peter Lang.

Kress, G., & van Leeuwen, T. (1996). *Reading images: The grammar of visual design.* London: Routledge.

Luke, A. (2000). Critical literacy in Australia. *Journal of Adolescent and Adult Literacies, 43*(5), 448–461.

Merriam, S.B. (1998). *Case study research in education.* San Francisco, CA: Jossey-Bass.

Mirzoeff, N. (2000). *An introduction to visual culture.* London, UK: Routledge.

Morphy, H., & Banks, M. (1997). Introduction. In M. Banks & H. Morphy (Eds.), *Rethinking visual anthropology* (pp. 1–35). New Haven, CT: Yale University Press.

Mutonyi, H. (2005). *Students' Conceptions of HIV/AIDS and Learning.* Unpublished Master's Thesis, University of British Columbia.

Mutonyi, H., & Kendrick, M. (in press). Ugandan students' visual representation of health literacies: A focus on HIV/AIDS knowledge. Clevedon, UK: Multilingual Matters.

New London Group. (1996). A pedagogy of multiliteracies: Designing social futures. *Harvard Educational Review, 66,* 60–92.

Norton, B. (2000). *Identity and language learning: Gender, ethnicity, and educational change.* London: Pearson Education.

Norton, B., & Toohey, K. (2003). Introduction. In B. Norton & K. Toohey (Eds.), *Critical pedagogies and language learning* (pp. 1–17). Cambridge, MA: Cambridge University Press.

Nutbrown, C., & Hannon, P. (2003). Children's perspectives on family literacy: Methodological issues, findings and implications for practice. *Journal of Early Childhood Literacy, 3*(2), 115–145.

Pahl, K. (2003). Children's text-making at home: Transforming meaning across modes. In C. Jewitt & G. Kress (Eds.), *Multimodal literacy* (pp. 139–154). New York: Peter Lang.

Prosser, J. (1998). *Image-based research.* London: Falmer Press.

Reiss, M., Boulter, C., & Tunnicliffe, S.D. (2007). See the natural world: A tension between pupils' diverse conceptions as revealed by their visual representations and monolithic science lessons. *Visual Communication, 6*(1), 99–114.

Rose, G. (2001). *Visual methodologies.* London, UK: Sage.

Siegel, M. (2006). Rereading the signs: Multimodal transformations in the field of literacy education. *Language Arts, 84*(1), 65–77.

Snyder, I. (Ed.) (1997). *Page to screen: Taking literacy into the electronic era.* Melbourne: Allen & Unwin.

Stake, R. (1995). *The art of case study research.* Thousand Oaks, CA: Sage.

Stake, R. (1998). Case studies. In N.K. Denzin & Y.L. Lincoln (Eds.), *Strategies of qualitative inquiry* (pp. 86–109). Thousand Oaks, CA: Sage.

Stein, P. (2003). The olifantsvlei fresh stories project: Multimodality, creativity, and fixing in the semiotic chain. In C. Jewitt & G. Kress (Eds.), *Multimodal literacy* (pp. 123–138). New York: Peter Lang.

Street, B. (2003). What's "new" in the new literacy studies? Critical approaches to literacy in theory and practice. *Current Issues in Comparative Education, 5*(2), 77–91.

Uganda AIDS Commission (2002). *Combating HIV/AIDS in Uganda report.* Retrieved on November 23, 2003 from http//www.aidsuganda.org/aids/html

van Leeuwen, Y., & Jewitt, C. (2001) (Eds.) *Handbook of visual analysis.* London: Sage.

Vygotsky, L. (1978). *Mind in society: The development of higher psychological processes.* Cambridge, MA: Harvard University Press.

Warburton, T. (1998). Cartoons and teachers: Mediated visual images as data. In J. Prosser (Ed.), *Image-based research: A sourcebook for qualitative researchers* (pp. 252–262). London, UK: Routledge.

Warburton, T., & Saunders, M. (1996). Representing teachers' professional culture through cartoons. *British Journal of Educational Studies, 44*(3), 307–325.

Welty, E. (1983). *One writer's beginnings.* Cambridge, MA: Harvard University Press.

Willis, P. (1977). *Learning to labor: How working class kids get working class jobs.* New York: Columbia University Press.

Yin, R.K. (2003). *Case study research: Design and methods.* Thousand Oaks, CA: Sage.

New Literacies AND Assessments IN Middle School Social Studies Content Area Instruction: Issues FOR Classroom Practices

MARGARET C. HAGOOD, EMILY N. SKINNER, MELISSA VENTERS, AND BENJAMIN YELM

Adolescents' engagement in literacy practices that extend beyond the page to incorporate multimodal texts in out-of-school contexts is not new terrain. Research on adolescents' new literacies practices outside of school has shown that they read and utilize texts that demonstrate their competencies as engaged, literate citizens (Alvermann, Hagood, Heron, Hughes, Williams, & Yoon, 2007; Black, 2005; Guzzetti & Gamboa, 2004; Knobel, 2001; Lewis & Fabos, 2005; Mackey, 2003; Mahiri, 2004; O'Brien, 2003; Skinner, 2007a; Vasudevan, 2006). Many of these literacies involve accessing popular culture; using visual and digital technologies such as zines, instant messaging, and fanfiction; creating documentaries; and analyzing television. Most of this research is predicated on the assumption that literacy is no longer singular and print bound; instead the iconic and digital demands of the 21st century have opened up literacies that require transversals across print and nonprint-based formats.

Although literacy practices outside of school demand engagement of an array of multimodalities, school-based literacy competencies in the United States continue to be determined by end-of-year statewide assessments of content that examine students' proficiencies of functional and autonomous literacies (Hull & Schultz, 2002; Street, 1995), which include solely the decoding and encoding of reading and writing print-based texts usually from the standpoint of receiving an author's message. All the while, research continues to reveal that adolescents,

especially those who struggle with academic literacies in schools, are more apt to engage with and to realize the relevancy of traditional academic content when teachers make connections between out-of-school and in-school literacies and adolescents' lives (Hobbs & Frost, 2003; Mahar, 2001; Morrell, 2002).

Even as adolescents engage in new literacies and show competencies with multimodal texts, other indicators such as Annual Yearly Progress (AYP) scores determined by end-of-year assessments and federal initiatives to assist underserved students with literacy improvements in schools suggest that many adolescents continue to struggle with engagement and success on school-based content area literacies. This inconsistency between out-of-school and in-school achievement with respect to literacies practices is felt throughout the United States, and little research has examined the transferal of adolescents' new literacies skills to traditional academic learning of content. Perhaps the dearth of research in this area results from the false dichotomy that separates out-of-school and in-school contexts, and from various groups' interests in keeping these literacies separate. It is this very transversal between engaging new literacies and learning across contexts that we take up in this chapter.

Drawing upon studies of using popular culture and new literacies to engage students in learning (Alvermann, Moon, & Hagood, 1999; Hagood, 2007; Skinner, 2007b), we examine the connections between instruction and assessment of two middle school teachers' pedagogical implementation of new literacies using students' out-of-school interests and texts to further their understanding of social studies content. The work presented here stems from a larger research study of implementing new literacies strategies in content areas (e.g., social studies, science) in underperforming middle schools (Hagood, Provost, Skinner, & Egelson, 2008). In this chapter, we look at how these teachers—who were part of a two-year implementation of new literacies strategies in their respective schools—designed instruction that addressed state standards for social studies using new literacies strategies. From observational data of teaching, individual interviews on the teachers' instructional practices and views of literacies, and student artifacts, we examine how the teachers worked to engage students in social studies content and literacy objectives through incorporations of new literacies. We also show how students demonstrated competencies on these standards through a variety of assessments. Finally, we scrutinize the connections between identities, instruction, assessment, and student outcomes on performance and formative assessments of social studies content when using new literacies.

MEET THE TEACHERS

Ben and Melissa are European Americans in their mid-twenties, and are energetic middle school teachers, working in two underperforming Title One middle

schools (Grades 6 to 8) populated by a majority of African American students and a minority of Latino, Asian and White American students. Both schools have been rated "unsatisfactory" on the South Carolina Report Card, which reflects students' statewide assessment scores. Both schools were selected by the school district to participate in a two-year implementation of new literacies teaching strategies, and all English language arts and social studies teachers in the schools were mandated to participate. Over the two years, these two teachers, along with other teachers from their schools, attended four two-day Institutes on using new literacies strategies and participated in bimonthly grade level meetings to reflect upon their implementation of new literacies strategies, learning how to connect their students' out-of-school and in-school literacies for improved engagement and performance. As part of this research, they implemented these strategies in their social studies classrooms and studied their students' content engagement and academic performance.

Ben has an undergraduate degree in secondary education/Social Studies (Grades 7 to 12). Because he taught three years of middle school prior to South Carolina teaching level certification policy changes, he was grandfathered under previous policy that allows him to teach any grade level in middle school. Ben recently completed a Masters degree in Technology Education. Also, for the past two years, Ben has participated with a group of 13 educators to prepare for a Fulbright funded five-week trip to Sierra Leone and Guinea to learn about West African culture and to make connections between West African culture and local Gullah and Geechee cultures, to which many of his students relate.

Ben has taught sixth and seventh grade classes for over four years, all at Northside Middle School (a pseudonym). The Northside administration puts a significant emphasis on preparing for the statewide assessment, the Palmetto Achievement Challenge Test (PACT), illustrated recently during a faculty meeting when the principal announced that the school planned to have a community pep rally for teachers to ride around in a bus on a Saturday afternoon hyping up the community about the upcoming test. In the past, students at Northside had scored the lowest on the social studies portion of the PACT. However, for the past couple of years, students at Northside have scored highest on the social studies portion of the PACT, an achievement that Ben and his social studies teaching colleagues are proud. Like all teachers at Northside, Ben spends a substantial amount of time during the "PACT Push" (50 day countdown prior to the beginning of PACT), preparing his students for the test with activities such as reviewing big ideas, making PowerPoint presentations about historical figures and events, playing Jeopardy review games, answering daily review questions, and reviewing *unitedstreaming* (Discovery Communications, 2008) video clips. *Unitedstreaming* is an on-demand digital

online service provided by Discovery Education that provides teachers with a multitude of video clips related to content area curriculum (e.g. social studies, science, math, health, language arts, etc.).

During the time of this research, Ben taught three sections of 6th grade and one section of 7th grade social studies for general education students. The previous three years he exclusively taught 7th grade social studies, but received a new placement for the current year based on a shift in grade level student enrollment numbers. Sixth grade social studies standards in South Carolina include world history content from early humans to the 1600s and the Age of Exploration.

Melissa has an undergraduate degree in history and secondary education, and is currently working during the summer on a graduate degree in Social Studies. She has taught for three years, all at Westside Middle School (a pseudonym). Because of Westside's "unsatisfactory" rating, teachers feel pressure from the administration to raise end-of-year test scores. Therefore, much of Melissa's classroom instruction includes coupling new literacies with course content so that students understand content and are prepared for state testing.

As an 8th grade social studies teacher, Melissa teaches all social studies courses (honors, general, resource, and self-contained). Middle school students in the district that Melissa and Ben work in are tracked into all academic classes (math, science, social studies and English language arts) dependent on their math proficiency. Math is the only course that has different standards for the different tracks, whereas in the other content areas teachers address the same standards at all levels, but generally modify their instruction and expectations based on their students' track placement.

At the beginning of the academic year, Melissa knew she had her work cut out for her when she learned that approximately half her current students scored "Below Basic" on the social studies portion of the PACT state testing as 7th graders. She resolved to assist students in making connections from out-of-school to in-school literacies to engage them in learning and to prepare them for the year-end assessment. In an interview about new literacies and history, she said, "History is boring to kids; I am always looking for ways to connect their lives to what I am teaching. Using new literacies helps to make things relevant to students because it's connecting what they are already comfortable with, with new information. I also think that using new literacies strategies will help my students be more engaged with content. As an 8th grade teacher, I teach only South Carolina history. To make connections for students using their literacies brings the content to life and improves their engagement with it, and hopefully their retention of the information."

THE NEW LITERACIES CLASSROOM IMPLEMENTATIONS

Drawing upon research that makes connections between adolescents' out-of-school literacies and in-school academic content (Morrell, 2002; O'Brien, 2003; Skinner, 2007b) and between new literacies and academic literacies (Hagood, 2007), our approach to new literacies professional development during the past two years has been to provide a repertoire of new literacies teaching strategies for teachers, such as comic strip writing (Bitz, 2007), digital storytelling, and blended narratives (Harris, 2007), that they could then draw from to address specific academic content area standards. In selecting new literacies strategies, we asked teachers to consider the academic literacy areas (e.g., vocabulary, writing process, fluency, applying comprehension strategies, grammar, decoding, reading/writing connections, understanding text genre and structure, etc.) that their students struggle with as identified by their classroom observations as well as by their review of district assessment scores.

It is our view that new literacies strategies can be implemented during any or all stages of content area reading instruction (before, during, and after) (Hagood, 2007) and of writing process instruction (Skinner, 2007b). New literacies strategies also can be used to address any stage (e.g. pre-unit, as unit, post-unit) of content area unit plan implementation. In the following two sections, we show how Ben engaged students in a new literacies project using visual literacies and digital technologies at the beginning of a unit, and Melissa utilized visual literacies within new literacies strategies through students' comic strip creation at the end of a unit in order to build upon students' facilities with new literacies formats and to improve their competencies with academic content.

USING DIGITAL STORYTELLING TO BUILD PRIOR KNOWLEDGE ABOUT CLASSICAL ROMAN CIVILIZATION: NEW LITERACIES AS INTRODUCTION TO CONTENT

Ben frequently drew upon new literacies strategies, projects, and references in his teaching. He often stated that in comparison to the English language arts teachers participating in our new literacies professional development and research, social studies teachers had much more freedom to assess new literacies. During a grade level meeting where teachers discussed their implementation of new literacies strategies and assessments, Ben commented, "All we have to do to assess is [evaluate] are they addressing content? Can they spell? We don't care. We have so much stuff—we cover 30,000 years of history. For us to take time out to work on that stuff is unrealistic. It's unrealistic to teach them to be fluent [readers and writers]."

And yet, during our observations of Ben's teaching, we found that he explicitly incorporated literacy teaching into social studies content area teaching.

In this section, we describe how Ben developed, implemented and assessed a digital storytelling project at the beginning of a unit of study that addressed the sixth grade world history standard, "Summarize the significant political and cultural features of classical Roman civilization, including its concept of citizenship, law, and government: its contribution to literature and the arts; and its innovations in architecture and engineering such as roads, arches, keystones, and aqueducts" (Charleston County School District, 2007a). At the same time, he fluidly integrated literacy instruction into the digital storytelling project through addressing multiple sixth grade language arts state standards regarding writing process, reading comprehension, reading response, communication and research skills, and assessed the organization component of a *6 + 1 Traits* (Culham, 2003) district-wide writing initiative that Ben noted was "just commonsense."

In preparation for this project, Ben used the online resource, *filamentality* (Knowledge Network Explorer, 2008) to develop a home page where his students could gather images of Roman architecture, historical icons, art, maps, and government (see http://www.kn.att.com/wired/fil/pages/listromansbe1.html). This step of the project development proved crucial in providing students with access to online images, a task that had been challenging for one of Ben's English language arts colleagues who had previously implemented digital storytelling with his students and run into challenges regarding the district's internet filter, which teachers characterized as blocking out all websites recognized as used for social networking (and thus excluded Flickr.com, among others).

Using Ben's *filamentality* home page, his students worked online to immerse themselves in print-based and visual texts related to Rome, selected images they planned to present in their digital stories on Roman architecture, and then imported these images to their personal district network folders. Concurrently, Ben taught students how to use the free download software, *Photostory* (Microsoft, 2008), a program that allows users to design digital stories using still images, narration, music, subtitles, motion, and transitions.

Ben modeled how to use *Photostory* in whole class minilessons that included: importing images, adding motion to images, writing and recording narration, and adding music. He also individualized instruction regarding many of these digital literacy skills as students worked their way through developing their photostories noting that because this was the students' first experience with this particular software, he had to re-teach each skill to about half of the students, who then re-taught the skills to the other half. In addition, Ben developed a photostory model that students used as a mentor text when developing their own photostories. Also, Ben developed a rubric for evaluating students' photostories (see Table 5.1).

Table 5.1. *Photostory* Project Grading Rubric

Score Criteria	Below Average: 70% or lower	Average: 70%–85%	Excellent: 86%–100%
Photos	Less than 75% of photos used do not have to do with Roman history or culture.	75%–95% of all photos have to do with Roman history or culture.	All photos have to do with Roman history or culture.
Captions	Over 50% of captions are difficult to understand or have nothing to do with the photos.	Less than 50% of captions are difficult to understand or have nothing to do with the photos.	All captions are easy to understand and deal with the photos they were placed on.
Narration	Narration is confusing/off topic.	Narration is not confusing, but not completely on topic.	Narration is easy to understand and completely on topic.

In reviewing students' photostories, we found that their projects all integrated multiple images of ancient Roman architecture and engineering (e.g., roads, arches, keystones, and aqueducts). In addition, students' projects included a diversity of other Roman images such as current architecture, ancient and modern day geographical and political maps, and historical Roman leaders and gods. Along with the images, students designated captions for each image included (e.g., Roman aqueducts, theatre of Marcellus, Roman arch, etc.). At the beginning of their photostories, students introduced their photostories using the narration tool.

In order to modify instruction for the variety of learners in his classes related to English language oral fluency and reading and writing competencies, Ben offered his students a variety of options for narrating their photostories, including composing their own narration, reading their narration from their social studies text book, and providing background music in lieu of narration (following the introduction that all students were required to record). Students' chosen background music included popular hip-hop (e.g., Beyonce, Soldier Boy, Alicia Keyes) and Latina (e.g., Shakira, Esperanza) music that provided viewers with clues as to the cultural identities of the *Photostory* designers in relation to age, race, ethnicity and gender.

At the culmination of the week-long project, students presented their photostories to their classmates. Then, having facilitated students' building of prior knowledge about classical Roman civilization through digital literacy practices, during the following weeks Ben facilitated direct whole group teaching of classical Roman civilization content, presenting activities such as having students draw

diagrams of Rome's bridges and roads, reading a variety of short shared texts including comics and short stories, viewing parts of the Hollywood-produced movie, *Julius Caesar* (2004), and completing worksheets on content. Ben framed these activities with interactive PowerPoint lectures and notes that purposefully included many of the images students had used in their photostories so that they would recognize the images as part of their prior knowledge and be interested in learning more about the content.

Ben observed that during the Roman architecture digital storytelling unit students took ownership over their projects, learned a lot about Rome, and were extremely engaged. He noted that for months after the project's completion they viewed it as one of their most memorable experiences from 6th grade. At the end of the academic year, Ben said his students still recalled the pictures they had included and the songs they had selected. Ben recognized that working on this project for a week's time was so engaging and inviting that, "for some of them, it got them to school that day, and that got them to math and science…" (Yelm, 2008). He further elaborated on a particular student who had been retained twice and regularly missed school, and yet during the week of this project's implementation was present every day and additionally showed up at his classroom door during lunch to work on her Roman architecture photostory.

Ben also concluded that the project worked well for English language learners, a conclusion that he had likewise drawn when implementing a new literacies comic strip project that drew upon visual literacies earlier in the year. Ben delineated the teaching challenges inherent in the project, including the necessity that teachers both develop a depth of knowledge of *Photostory* and then are able to offer their students substantial individual assistance in order to complete their individual photostories.

USING COMIC STRIPS TO STUDY SOUTH CAROLINA'S HISTORY: NEW LITERACIES AS CULMINATION OF CONTENT

Most of the South Carolina 8th grade social studies standards address issues of slavery and race relations. Working in a predominantly African American school, Melissa wanted to make the content real to the students and to connect their contemporary lives with the academic standards relevant to life in the state 300 years ago. Melissa drew upon the predominant standard that students must "draw conclusions about how sectionalism arose from events or circumstances of racial tension, internal population shifts, and political conflicts, including the Denmark Vesey Plot, slave codes, and the African American population majority" (Charleston County School District, 2007b, p. 20) in order to weave

together the main ideas of race relations and tensions that led to stricter state laws. She used several school and out-of-school sources to cover this standard. These texts included primary source documents such as those provided by the curriculum guide (Charleston County School District, 2007b), the section on Denmark Vesey provided in the district-wide 8th grade social studies text, *The History of South Carolina in the Building of the Nation* (Huff, 2006), and other websites and information she found online that she included in her classroom discussions.

Melissa decided to use the case of Denmark Vesey as a central point of discussion and to connect his story through new literacies strategies as a culmination activity so as to improve students' engagement with the content and retention of information of the larger theme of slavery, race relations, and repercussions in the law as a result of whites' concerns for slave uprisings. A brief history of Denmark Vesey (1767–1822) shows how students would be drawn to his story. Melissa explained to the students, through their readings and discussions, how Denmark Vesey was a unique and interesting man. A West Indian slave, he won the lottery in Charleston, and then used the $1,500 prize money to buy his freedom and to help found the African Methodist Episcopal Church (AME). According to *The History of South Carolina in the Building of the Nation* (Huff, 2006), Vesey believed God spoke to him and told him to be the Moses of his people, and with approximately 9,000 supporters he plotted a slave revolt in 1822. Peter Prioleau, another slave, told his master what Denmark planned. The revolt was squelched, and Vesey and others were hanged. Outcomes of the attempted revolt resulted in stricter slave codes in South Carolina, tightening slaves' few privileges, taxing free blacks, and strengthening the Whites' pro-slavery stance.

Melissa worked with her students on this topic for a week, covering content, vocabulary, main ideas, and making inferences. Students first read the textbook selection on Denmark Vesey as a class and picked out the main points. Then, they summarized these points on the whiteboard in a whole group discussion, and students copied this information down in their notebooks. To conclude the unit of study, Melissa wanted students to demonstrate their knowledge of content and vocabulary. She planned to have students critique the Wikipedia entry of Vesey and to add their own information to the site during a review of the unit of study, but due to the school's cyber-patrol system, the students were blocked from making any additions to the entry on Denmark Vesey on the Wikipedia site. Instead, Melissa chose to use a comic strip, one of the new literacies strategies she learned about during one of the New Literacies Institutes. First she reviewed the key information with the students. The following transcript shows how Melissa engaged in the method of Initiate, Respond, and Evaluate (IRE) (Mehan, 1979) to quickly

review content with the students and to set the stage for comic creation:

> *Melissa*: Where did Vesey live?
>
> *Student 1*: Charleston
>
> *Melissa*: He was a slave and brought here from the West Indies. How did he get his freedom?
>
> *Student 2*: He won the lottery.
>
> *Melissa*: How much did he win?
>
> *Student 3*: $1,500
>
> *Melissa*: How much did he pay for his freedom?
>
> *Student 1*: $600
>
> *Melissa*: Who did he pay?
>
> *Student 4*: The slave owner.
>
> *Melissa*: Then he founds a church. Which one?
>
> *Student 5*: AME
>
> *Melissa*: What was his job?
>
> *Student 3*: He was a carpenter.
>
> *Melissa*: His house was near the College of Charleston. He thought he was the Moses of his people. What does he plan? Recall, we got mad at your social studies text because it calls it the "Vesey Insurrection." Why shouldn't we call it that?
>
> *Student 5*: Because it never happened.
>
> *Melissa*: Why?
>
> *Student 4*: Because they were caught before it.
>
> *Melissa*: Right. Vesey and other leaders were hanged. Some others were enslaved and because of what Vesey does they are re-enslaved. How is that?
>
> *Student 1*: The slave code was put into effect after the other rebellion.
>
> *Melissa*: Yes, what was the name of that one?
>
> *Student 6*: The Stono Rebellion.
>
> *Melissa*: Okay so two plots had occurred before this one. The Stono Rebellion is where slaves were trying to get free in 1739 in south Florida. Was the rebellion successful?
>
> *Students (most of class)*: No!
>
> *Melissa*: So that resulted in stricter slave codes and blacks had to wear negro cloth— certain kinds of clothing.

[The other plot occurred in Santo Domingo in 1791 and was successful.]

> *Melissa*: So you need to create a 6 slide comic that would teach 3rd graders about Denmark Vesey. You have to summarize what happens to him. You need to include words and pictures. If you can't draw people, that's okay, but try to make it colorful and use the background to show the setting. You have markers, colored pencils, rulers. You have until the end of class [40 minutes] to create your comic.

Then, students eagerly engaged and completed this assignment in the allotted time frame. Examples of their work are presented in Figures 5.1 and 5.2.

After completing this assignment, students shared their work with each other, summarizing the result of the Vesey-led attempted revolt and critiquing

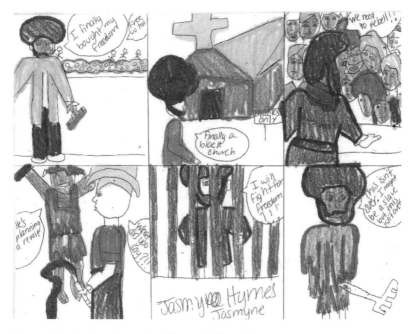

Figure 5.1. Student 1 Comic of Denmark Vesey Revolt

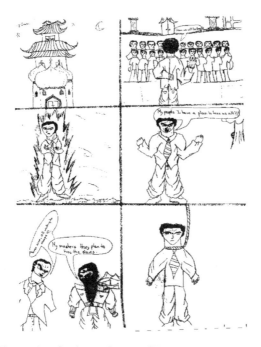

Figure 5.2. Student 2 Comic of Denmark Vesey Revolt

each others' comics related to content and presentation. In this exercise, Melissa attempted to have students transfer their uses of visual literacies and new literacies creations of comic strips into a more formalized academic literacy. Using the comic strips as a form of prewriting, Melissa had students write essays summarizing the outcome of the Vesey plot, explaining the tightened slave laws that ensued, and discussing the historical significance of these events on South Carolina history.

Finally, in an end-of-unit test, Melissa had students discuss in an essay question the story of Denmark Vesey, including the result (stricter slave codes). She explained, "What I really wanted students to gain from the comic was the result of the plot, and I even showed them actual examples of South Carolina slave codes from the 1840s. As a PACT review question, I asked students the multiple choice question, 'What was the result of the Denmark Vesey plot?' This was five months later, and most students got the answer to the question correct."

DISCUSSION

Finally, we scrutinize the connections between identities, content area instruction, assessment, and student outcomes on performance and formative assessments of social studies content. In implementing the *Photostory* project, Ben did not regard himself as a literacy teacher; instead he viewed his primary purpose as to teach his students social studies content. He recognized the difficulty for social studies teachers to hang back and to involve their students in inquiry-based learning, as he had done with the *Photostory* project, stating, "Social studies teachers know everything and we want to teach you everything we know."

And yet, Ben's *Photostory* project implementation allowed students to build prior knowledge about ancient Roman civilization *before* he indulged in telling his students, whom he assessed as knowing very little about ancient Roman civilization, everything *he* knew about Roman ancient civilization. Furthermore, Ben explicitly addressed social studies curriculum standards while at the same time integrating numerous English language arts state standards including: reading comprehension, writing process, reading response, communication (speaking, viewing and listening), and research skills (gathering, preparing and presenting information). In addition, the rubric Ben developed to evaluate students' projects addressed writing organization, one of three *6 + 1 Traits* (Culham, 2003) areas his administrators had selected for school wide focus across the content areas.

Melissa, unlike Ben, did not initially see the connections between social studies and the teaching of literacy. Like many other middle school teachers, Melissa's undergraduate program did not prepare her to be a literacy teacher in a social studies classroom. Speaking to this issue of identity and teaching, she said,

"I don't know about all of those terms you use with literacy. No one ever explicitly taught me in my undergrad program how to teach students how to read the text. We were just taught how to teach the content." Seeing herself as an outsider to literacy instruction and her role in the classroom solely as one of history content transmission, she used new literacies to break down the content so as to assist students in comprehending the difficult aspects. Drawing upon what she taught them with key vocabulary, main ideas, summarizing, and inferencing, she completed the unit of study with students' creation of a six slide comic. Students were able to visually display their understanding of the ideas and connected this visual aid to their construction of an essay that demonstrated their understanding of content in more academic representation.

Ben and Melissa's teaching illustrates that sometimes new literacies strategies build upon foundational, academic literacies. Ben's work with augmenting students' schema at the beginning of a unit of study and Melissa's use of new literacies as a culmination to solidify main ideas and inferences illustrate the intricate coupling of foundational/academic and new literacies practices in the classroom. Through incorporations of new literacies, Ben and Melissa validated their students' engagement as crucial to content area learning and their students' development and display of multimodal competencies (Siegel, 2006) as legitimate sources for performance-based assessments of social studies content area learning. Furthermore, both Ben and Melissa integrated English language arts standards and important foundational literacy components into their teaching and assessment. Melissa, in particular, worked to assist students' transferal of content from the creation of visual, new literacies texts to more traditional essay format assessments.

Because students were able to work first from their areas of interest and expertise with comic creation, Melissa felt that they understood better the content and were more willing to do the work to translate and to transfer their understanding to a more traditional form of assessment, the writing of a brief essay. The essays made it apparent to Melissa that the students understood both the main ideas and the details of the Vesey case, as well as the nuances of the race relations that were exacerbated from the outcome of the slave revolt that never occurred.

CONCLUSION

Through incorporating new literacies instruction and content assessment into their pedagogy, teachers like Ben and Melissa can assert their intersecting identities as knowledgeable content area teachers and sophisticated new literacies practitioners, an assertion that maximizes students' engagement and furthers

students' acquisition of competencies. Melissa often critiqued the structure within her school that subtracted her contact time with students and replaced it with *Read 180* (*Scholastic*, n.d.), a reading intervention software program targeted for below-grade-level readers that focuses on decoding drills to improve students' print-based reading skill.

Relatedly, Ben highlighted that students at Northside (where they were also pulled out in 7th and 8th grade for *Read 180*) were doing better on the social studies PACT than any other area. Perhaps, if schools and districts recognized and supported teachers such as Ben and Melissa's competencies in integrating social studies content with literacy teaching objectives through new literacies projects, students in "unsatisfactory" schools might have more opportunities to display their own competencies while at the same time extending their content area knowledge and raising their literacy achievement. Moreover, as literacy practices change to reflect multimodalities and new literacies, appropriate assessments must follow suit. Assessments must allow for students to demonstrate their competencies within new literacies, but students must also be able to show those competencies in more traditional formats and high stakes statewide assessments such as the PACT.

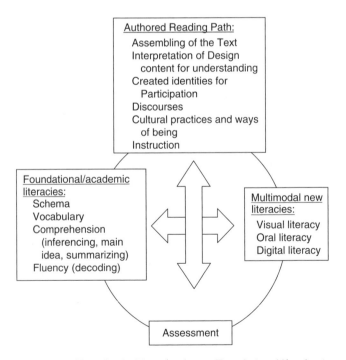

Figure 5.3. Transferal of Content Across Foundational/Academic and New Literacies in School

Instead of dichotomizing literacies— separating new literacies from academic literacies, content literacies from each other, and performance assessment from formative assessments—we need to find spaces to meld these forms of literacies to aid in both instruction and assessments in classrooms. To keep literacies separated marginalizes new literacies to continue to be the "hook" that gets students involved and fails to recognize the necessity to teach and assess students' new literacies in order to prepare students to be competent literacy users in the 21st century (Johnson & Kress, 2003; Kalantzis, Cope, & Harvey, 2003). Such division between these literacies also precipitates perceptions that students in "unsatisfactory" schools are unsuccessful in academic literacies, when in fact, they are competent.

As illustrated in the model in Figure 5.3, teaching of literacies in the 21st century must incorporate academic and new literacies simultaneously. Efforts must be made to assist students in using new literacies to connect to content and then to loop around so that competencies can be translated into assessments that are current markers of success in school.

Developing and recognizing both students' foundational literacies and new literacies concomitantly is especially important for students and teachers in schools that have been rated as "unsatisfactory," a label that is unfortunately internalized by teachers in these schools (Venters, 2008) and yet neither describes nor defines the depth or breadth of Ben and Melissa's teaching and their students' learning.

REFERENCES

Alvermann, D.E., Hagood, M.C., Heron, A., Hughes, P., Williams, K.B., & Yoon, J. (2007). Telling themselves who they are: What one out-of-school time study revealed about underachieving readers. *Reading Psychology, 28*(1), 31–50.

Alvermann, D.E., Moon, J., & Hagood, M.C. (1999). *Popular culture in the classroom: Teaching and researching critical media literacy.* Newark, DE: International Reading Association and National Reading Conference.

Bitz, M. (2007). The comic book project: Literacy outside and inside the box. In J. Flood, S. Brice-Heath, & D. Lapp (Eds.), *Handbook of research on teaching literacy through the communicative and visual arts* (Vol. II, pp. 229–237). New York: Routledge.

Black, R.W. (2005). Access and affiliation: The literacy and composition practices of English-language learners in an online fanfiction community. *Journal of Adolescent and Adult Literacy, 49*(2), 118–128.

Charleston County School District. (2007a). *Social Studies: Grade 6 coherent curriculum.* Charleston, SC.

Charleston County School District. (2007b). *Social Studies: Grade 8 coherent curriculum.* Charleston, SC.

Culham, R. (2003). *6 + 1 traits of writing the complete guide (Grades 3 and up)*. New York: Scholastic.

Discovery Communications, LLC (2008). *Unitedstreaming*. Retrieved on May 16, 2008 from http://www.streaming.discoveryeducation.com/index.cfm

Guzzetti, B.J., & Gamboa, M. (2004). Zines for social justice: Adolescent girls writing on their own. *Reading Research Quarterly, 39*(4), 408–436.

Hagood, M.C. (2007). Linking popular culture to literacy learning and teaching in the 21st century. In B.J. Guzzetti (Ed.), *Literacy for the new millennium: Adolescent literacy* (Vol. 3, pp. 223–238). Westport, CT: Praeger.

Hagood, M.C., Provost, M., Skinner, E., & Egelson, P. (2008). Teachers' and students' literacy performance in and engagement with new literacies strategies in underperforming middle schools. *Middle Grades Research Journal, 3*(3), 57–95.

Harris, R. (2007). Blending narratives: A storytelling strategy for social studies. *Social Studies, 98*(3), 111–116.

Hobbs, R., & Frost, R. (2003). Measuring the acquisition of media-literacy skills. *Reading Research Quarterly, 38*, 330–355.

Huff, A.V. (2006). *The history of South Carolina in the building of the nation*. Columbia, SC: Capital City Publishing Enterprises.

Hull, G., & Schultz, K. (Eds.) (2002). *School's out: Bridging out-of-school literacies with classroom practice*. New York: Teachers College Press.

Johnson, D. & Kress, G. (2003). Globalisation, literacy and society: Redesigning pedagogy and assessment. *Assessment in Education, 10*, 5–14.

Julius Caesar [Television mini-series] (2004). New York: Good Times Video.

Kalantzis, M., Cope, B., & Harvey, A. (2003). Assessing multiliteracies and the new basics. *Assessment in Education, 10*, 15–26.

Knobel, M. (2001). "I'm not a pencil man": How one student challenges our notions of literacy "failure" in school. *Journal of Adolescent and Adult Literacy, 44*(5), 404–414.

Knowledge Network Explorer. (2008). *Filamentality*. Retrieved on May 16, 2008 from http://www.kn.att.com/wired/fil

Lewis, C., & Fabos, B. (2005). Instant messaging, literacies, and social identities. *Reading Research Quarterly, 40*(4), 470–501.

Mackey, M. (2003). Television and the teenage literate: Discourses of *Felicity*. *College English, 65*(4), 389–410.

Mahar, D. (2001). Bringing the outside in: One teacher's ride on the Animé highway. *Language Arts, 81*(2), 110–117.

Mahiri, J. (2004). Street scripts: African American youth writing about crime and violence. In J. Mahiri (Ed.), *What they don't learn in school: Literacy in the lives of urban youth*, (pp. 19–42). New York: Peter Lang.

Mehan, H. (1979). *Learning lessons: Social organization in the classroom*. Cambridge, MA: Harvard University Press.

Microsoft. (2008). *Photostory*. Retrieved on May 16, 2008 from http://www.microsoft.com/windowsxp/using/digitalphotography/*Photostory*/default.mspx

Morrell, E. (2002). Promoting academic literacy with urban youth through engaging hip-hop culture. *English Journal, 91*(6), 88–92.

O'Brien, D. (2003, March). Juxtaposing traditional and intermedial literacies to redefine the competence of struggling adolescents. *Reading Online, 6*(7). Retrieved on May 15, 2008 from http://www.readingonline.org/newliteracies/lit_index.asp?HREF=obrien2/

Scholastic. (n.d.). *Read 180.* Retrieved on May 16, 2008 from http://teacher.scholastic.com/products/read180

Siegel, M. (2006). Rereading the signs: Multimodal transformations in the field of literacy education. *Language Arts, 84,* 65–77.

Skinner, E.N. (2007a). "Teenage addiction": Adolescent girls drawing upon popular culture texts as mentors for writing in an after-school writing club. In E. Rowe, R. Jimenez, D. Compton, D. Dickinson, Y. Kim, K. Leander, & V. Risco (Eds.), *National Reading Conference Yearbook, 55,* 275–291. Chicago, IL: National Reading Conference.

Skinner, E.N. (2007b). "Teenage addiction": Writing workshop meets critical media literacy. *Voices from the Middle, 15,* 30–39.

Street, B.V. (1995). *Social literacies: Critical approaches to literacy in development, ethnography and education.* London: Longman.

Vasudevan, L. (2006). Looking for angels: Knowing adolescents by engaging with their multimodal literacy practices. *Journal of Adolescent and Adult Literacy, 50*(4), 252–256.

Venters, M. (2008, May 4). *Day of tears: Day of desperation; Using blogging to make literacies engaging and comprehensible.* Session presented at the International Reading Association Conference, Atlanta, GA.

Yelm, B. (2008, May 4). *Using Photostory to teach world history.* Session presented at the International Reading Association Conference, Atlanta, GA.

My Life ON Facebook: Assessing THE Art OF Online Social Networking

JENNIFER ROWSELL

There is irony in the title of this chapter because I do not have a life on Facebook. I tried, with limited success, to represent parts of myself (see Figure 6.1) on the social networking website ubiquitously used by all age groups. There are millions of people who do, however, have a life on Facebook, and they invest a lot of time and energy in updating, communicating through, and mediating their identities online. In this chapter, I look at Facebook and the lives of three Facebookers to interpret the kinds of practices used whilst social networking. To extend the applicability of social networking within a schooling framework, I look at ways of assessing practices used in Facebook. This chapter demonstrates how conventionalized skills such as communicating online can and should be evaluated to open up what we mean by literacy today.

Facebook demands from its users sophisticated skills that have become conventionalized, such as the art of remixing and remediating texts or embedding familiar themes and tropes into profiles. Facebook invokes an appreciation of intertextuality and nesting texts within other genres of texts to speak to an audience: your community. Sophisticated skills such as remixing and remediating texts or embedding familiar tropes have become conventionalized, or, as Bruno Latour (1991) would term it, "blackboxed," through the use of technology and this chapter thinks through ways of assessing these naturalized skills. By "naturalized skills," I mean the kinds of actions that we do online that are second nature

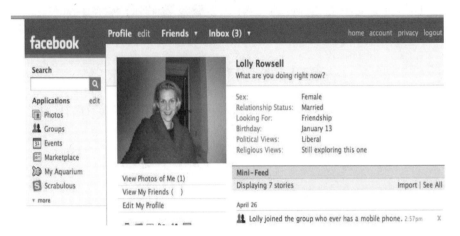

Figure 6.1. Jennifer's Facebook page

to users. For example, regularly contributing to affinity groups and developing a relationship with users in common affinity groups is a naturalized skill.

What motivated me to write a chapter on Facebook for this edited volume was the seemingly "natural" gift millions of people possess that enables them to digitally manifest themselves and their communities online. My epiphany about Facebook made me appreciate how conventionalized practices are, or can become, and how essential it is to uncover naturalized practices in order to understand contemporary literacy practices. Clearly, by digitally mediating our identities, we have more choice in the modalities we use. More to the point, younger generations distinctly prefer identity mediation online to other mediums (e.g., the written word; cf., Burke, Chapter 2 in this volume). In this chapter, I explore the world of Facebook, theorizing its capacity to project and maintain identities and communities of practice in conjunction with looking at three quite different individuals and their lives on Facebook. The argument made in the chapter is that Facebookers engage in valuable literacy practices in their use and understanding of this social networking site. Skills used to "facebook" exhibit an understanding of skills that are critical to reading, writing, and communicating more generally. That is, to create a Facebook profile, you need to have a firm grasp of: (1) What is the purpose of a text? (2) Who is the audience for the text? (3) How do design and content materialize purpose and audience?

A FACEBOOK PROFILE

Founded in 2004, Facebook is what they call on the website, "a social utility" site which helps people communicate with "friends, family, and coworkers." The site was

launched by Mark Zuckerberg for students at Harvard, but actually its history goes further back to Zuckerberg's high school days, when he wanted to create a digital social networking medium for students to get to know their classmates before the beginning of the school year. Within months of creating Facebook, it expanded to all Ivy League schools and then to most universities in the United States and Canada. Facebook has ascended to the sixth most trafficked site in the U.S.—making Facebook the fifth most valuable U.S. company valued at $15 billion.

The site invites you to share different kinds of information about yourself as a form of dialogue. The company prides itself on two main things, one: it allows anyone to create a Facebook page; and two: it is international and as such, you can reach anyone who has been in your life or who might be in your life (as long as they can and like to digitally mediate themselves online). Facebook has habituated a way of talking to people everywhere all of the time—even if you have never met them face-to-face in your life. On the homepage of Facebook, they exhort:

Anyone can join Facebook
Discover the people around you
Do more
Keep it private

From just looking at key headings on the Facebook homepage, there are several aspects of the social networking site that are obvious: it is easy to join; you can find a community and participatory structure immediately; there are different ways to connect; and, most of all I suspect, you have privacy. In creating a page, you realize that all of these features are part of the ecology (Nardi & O'Day, 1999) of Facebook. Yet, there are several practices, habits of mind, and texts that are conventionalized and rendered invisible. For example, you soon realize that most people do not fill out *all* of the personal information. Older generations tend to use Facebook to correspond with friends and family, whilst younger generations use many of the applications to socially connect with friends. There is an increasing trend today for organizations and institutions to create Facebook profiles for their communities to keep abreast with new information and events.

One of the more conventionalized practices within Facebook is textual networks tied to the social networking juggernaut. For example, Microsoft invested $240 million in Facebook in October 2007 and this sponsor of Facebook has become naturalized into the ecology of Facebook. Nardi and O'Day (1999) describe "ecology" as an online environment created out of a holistic fusion of discourses, ideologies, and modalities to give it its own life. Microsoft's interest in Facebook, in all likelihood, derives from the sheer volume of data-mining that can happen through Facebook. There is so much personal information that people put onto Facebook that can serve as valuable information for a computer company about

market trends, personal interests, how they can shape products around interests, and how people use mediated spaces more generally.

Another convention implied by the Microsoft-Facebook merger is the "branding" that happens on Facebook. Facebook actively encourages users to publicly declare their affection for everything from soft drinks to dish soap. You can also send your friends such gifts as a Louis Vuitton purse if you like—therein choosing one brand over another. Such practices as data-mining and endorsing products are blackboxed practices that we, more specifically our students, engage in without giving them a second thought.

METHODOLOGY

To conduct the study, I became a Facebook lurker and interviewed three Facebookers to analyze their relationship with Facebook. Interviews were conducted in person while we looked at their profile pages. One interview was conducted over the phone because the Facebooker lives in Canada and I live in the United States. Each participant volunteered to be a part of my modest study of Facebook. The first participant, Andy (a pseudonym), talked about his Facebook time in one of my teacher education classes and when I mentioned that I was going to write a chapter on Facebook during a class discussion, he volunteered to be interviewed. The second participant, Lara (a pseudonym), works with me and after discussing Facebook, she suggested that we look at her page and agreed to be interviewed. Finally, Oscar (a pseudonym) is an old friend from high school who is what I fondly call "a techie" who gracefully agreed to discuss the role of Facebook in his life after many exchanges on Facebook with me (he is one of my grand total of 14 Facebook friends). The same set of questions were given to each participant:

(1) When did you first use Facebook?
(2) What do you like about Facebook?
(3) What thought went into creating your profile?
(4) Who do you chat with on Facebook?
(5) What purpose does it serve in your life?
(6) What sorts of applications do you use?
(7) When do you go on Facebook?

The interviews offered me "thick description" (Geertz, 1993) of not only participant Facebook pages (content and visuals), but also what motivated each one to be on a social networking site. Each interview was transcribed and analyzed by looking at recurrent themes.

To analyze interview data, I applied a constant comparison approach wherein I looked at common strands that ran across all three interview dialogues. Alongside interview data, each participant shared parts of their profile (with personal information blurred for anonymity). Looking at the visual in conjunction with interview talk helped me to piece together how individuals mapped out their own dispositions, interests, habits of mind and beliefs onto the visual communication of their practices.

THREE CASE STUDIES OF FACEBOOKERS

The three Facebookers presented in this chapter agreed to be participants and to share their respective Facebook profiles with readers. I use pseudonyms to protect their identities. Participants are at different stages in their lives, and there is a degree of cultural diversity in representing three individuals as telling case studies of rhetorical and multimodal mediation of identities. I derive my definition of "case study" from the work of Denscombe who provides a helpful insight into case study research by explaining that "the aim [or a case study] is to illuminate the general by looking at the particular" (Denscombe, 1998, p. 30). Golby (1994) has made clear that case studies are not a study of uniqueness, but of particularity, which well suits my purpose here. Golby (1994) argues that to make understanding "particular," connections to other cases need to be made, and an acute awareness of how understanding is reached is required. In research on facebooking as a literacy practice, I take an "analytic generalization" from the data to offer some insight into how we can begin to embed an understanding of facebooking and build it into a literacy program and our ways of assessing students who invest a lot of time in social networking.

Although I look at three adults sitting in different age groups as indicative of social networking practice, I acknowledge that the practices and remediaton of identity is subject to the subjectivities and habitus (Bourdieu & Wacquant, 1992) of the user. In a different project with thirty high school students in New Jersey (Rowsell, 2009), each one of them uses Facebook as a fundamental part of their vernacular literacies inside (and, indeed, outside of) school.

DIGITAL IDENTITY MEDIATION

To make meaning in web space entails not only an understanding of audiences and people but also what audiences will do and where they will go in web space. Bourdieu's notion of habitus (Bourdieu, 1980; Bourdieu & Wacquant, 1992) can be helpful in exploring what we choose to foreground when we mediate ourselves

online. Bourdieu's habitus takes account of our unconscious dispositions that we improvise in everyday practices such as creating an online identity. Social networking sites are simultaneously an engagement of habitus working within and improvising within the Bourdieuian notion of field. Field signifies the environments in which we engage in everyday practice, and Facebook is as much an environment to make meaning as a high school classroom. There are aspects of our personalities that we consciously and subconsciously want to foreground and we materialize these aspects through our choice of modalities in Facebook. Sherry Turkle (1997) speaks of using "computational objects" to think with and for settling into ways of being with others. That is, computational objects like Facebook are not only ways of thinking about and understanding texts, but also, they allow us to mediate identities in diverse networks (i.e., experiment with different identities in different communities). Turkle talks about how cyberspace enables individuals to play with identity (Turkle, 1997). Rheingold goes one step further, viewing meaning making online as virtual communities from which people derive identities:

> In cyberspace, we chat and argue, engage in intellectual intercourse, perform acts of commerce, exchange knowledge, share emotional support, make plans, brainstorm, gossip, feud, fall in love, find friends and lose them, play games and metagames, flirt, create a little high art and a lot of idle talk. We do everything people do when they get together, but we do it with words on computer screens, leaving our bodies behind. Millions of us have already built communities where our identities commingle and interact electronically, independent of local time or location. (Rheingold 1993, p. 414)

In this way, Facebooking practices foregrounded later in this chapter serve as mediating practices that shape understandings of users and foster certain kinds of learning and thinking patterns. There is a lot to think about in this formulation of cyberspace; points essential for my purpose are: (1) there are epistemologies promoted in online texts that are fundamentally different from print-based texts; (2) there are practices called upon and honed in the use of online texts; and, (3) there are relationships and communities created that are simultaneously local and global and that shape our own identities and sense of belonging. As Latour says, "technology is society made durable" (Latour, 1991). When we create an identity on Facebook, we cast an image of ourselves textually that our community interprets and responds to in kind.

CREATING CULTURAL STORIES

To discuss Facebook as a literacy practice, I need to unpack what sits beneath such a claim. First of all, in the chapter, literacy is regarded as a social practice (Street,

1984) which is shaped by the contexts in which literacy takes place. Digital environments such as Facebook require repertoires of practice that exhibit skills a Facebooker can transfer from one context to another (e.g., school learning).

Implicit to using and understanding Facebook is the skill of choosing modalities for their affordances in showcasing a certain kind of message and materializing this message in a Facebook profile. Kress and Van Leeuwen (2001) talk about the notion of "provenance" as the movement of a discourse or an image or sound into another context and recontextualizing these discourses and images into a new text. Building a Facebook profile is a form of "provenance" or "bricolage" because it involves cobbling together a portrait of self through pictures, background information, communities of practice (Lave & Wenger, 1991), and preferred applications. This act of producing and sustaining a Facebook profile implies a set of conventionalized practices that can be assessed. Along similar lines, the way in which we adjust our Facebook page makes a statement to our community. Do I want a picture with my daughter? Or, do I want a posed picture that exudes independence? There are other issues implicit to choosing modalities such as privacy and security; for instance, you may not want to feature your child on Facebook if there is wide access to your profile.

There are several theoretical notions sitting beneath the surface of an analysis of Facebooking. First of all, to Facebook is to create a cultural story about "you" through interpersonal and rhetorical devices. In his book about Edison and the invention of the lightbulb, Charles Bazerman (2001) talks about how Edison forged rhetorical networks by placing advertisements about his invention in strategic newspapers with a matching spin to his invention. For example, in magazines with a large female audience, he would place lightbulbs in with flowers to spread a perception of what a lightbulb can do and be for different individuals. Similarly, images Facebookers choose to display signal parts of themselves they want visitors to know and to associate with their identities. Choices in how we materialize ourselves tell us important information about our pathway into literacy (Kress, 1997). Take Lara's comment as indicative of creating a cultural story about herself through composition and rhetorical devices on Facebook,

> I wanted my profile to reflect what I consider my eccentricities to be—to be a bit weird and left-field. I only have a small group of friends that know about my page, and they know what I am really like and seem to enjoy when I put a funny picture of, say, of Colonel Sanders [the "face" of the Kentucky Fried Chicken fast food chain] as my profile picture with a quippy comment attached. (May 3, 2008)

Each of the Facebookers presented in this chapter make deliberate choices in modalities, which tell their cultural story. There is a distinct logic to making

a Facebook profile—you need to assemble semiotic aggregates that collectively create a message about you and your community. You might choose a photo or an associative text such as Lara's Colonel Sanders advertisement to rhetorically represent yourself.

An interesting aspect of mediating your identity multimodally on Facebook is that your community or Friends page carries timescales (Lemke, 2000) that are variable and as such, makes choosing words, pictures, and audio tricky in that some friends you have known for a long time and who will understand nuances of meaning, whilst others have shorter timescales (often a friend of a friend whom you meet on Facebook as opposed to in person). In Lemke's discussion of timescale, he talks about how certain texts carry longer, more embedded relevance because of the amount of time invested in the text. On Facebook, choosing words, pictures, and sounds is tied to timescales (i.e., you have known them for a long time), whilst others you have known for a comparatively shorter amount of time. Lemke talks about how objects have histories that carry more or less relevance and Facebook throws timescale into relief because, to sustain a profile, you need to pitch the register at communities who have shorter and longer timescales.

NATURALIZED LITERACY PRACTICES

Fundamental to Facebook are naturalized practices that I came to understand in using the social networking site for myself. The art of spin, register, pitch are all honed in sustaining a Facebook profile. For example, writing on someone's wall is reserved for lighter, dialogic conversations whereas sending a message to an inbox deals with personal information. Given that the wall is a collective text—read by someone's community—the register is different, looser and less directly personal. Yet another Facebook convention is to obfuscate personal information on the profile information pages. I was quite literal when I filled in the information about my political leanings, my favourite movie, my hobbies and such, only to realize that most people falsify information for reasons of privacy and safety so that they do not appear as an open book. These sorts of practices become naturalized with use and Facebookers can probably tell a novice from a veteran Facebooker when they read these telltale signs of conventionalized Facebook practice. Bruno Latour (1991) claims that technology "blackboxes" practices that become accepted and naturalized without a meta-understanding of what these actions do and how they can be remediated in other situations and contexts.

When we look across the three case studies featured below, what we see are three very different takes on what a profile does and how to visually mediate it.

OSCAR, FACEBOOKER #1

The first Facebooker is Oscar, who has been on Facebook for over a year now. The appeal of Facebook for Oscar is that he can keep up with friends who are further afield. Oscar lives in Calgary, Alberta, and has friends around the world whom he connects with through Facebook. Oscar is 39, Maltese-Canadian and he is a software engineer involved with the biofuels industry. Oscar describes his production of a Facebook profile as:

> I wanted to show that I am outdoorsy. I try to keep my professional life and business life out of my personal life, so there's not really anything on there that depicts anything I do for a living in bio fuels…I just say in general it really is who I am in terms of what I do with my spare time so if you had to go to my Facebook profile, it's all about outdoors like snowshoeing and canoeing and whatever.

What you see in his profile (see Figure 6.2) is a photograph of him on top of a mountain that he has climbed, which is a clear foregrounding of his abiding

Figure 6.2. Oscar's Facebook page

passion for the outdoors and climbing. Upon reading his profile (having known him for a long time), I see that he obfuscates personal details for readers. You see humour in his profile, such as one of his interests being "growing mushrooms." What stands out is that he wants to connect with his community, but he reserves the right to share more personal information in a different forum—such as exchanging messages through his Inbox.

LARA, FACEBOOKER #2

Lara (pseudonym) is a 28-year-old who has been using Facebook for a year now. The appeal of Facebook for Lara is how private it is "and that no weirdos could contact you." She had been on MySpace and found that there was not enough screening and privacy, so she moved over to Facebook. The greatest benefit of Facebook is that Lara can keep up with people whom she does not see very often. Her main dialogues take place with people who are farther away and she prefers to use the phone with people who live close by because "if you care enough, you will find a way to personally talk to someone."

Lara's Facebook profile is far more polemical than Oscar's profile. Lara wants to exude an image through a text—rather than placing a photograph of herself to represent her identity (see Figure 6.3). Lara wants her community to infer the

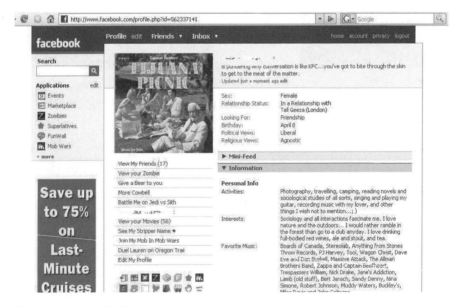

Figure 6.3. Lara's Facebook page

kind of online identity that she wants to portray as key aspects of her personality. Although Oscar's profile carries timescales, Lara opts to speak to parts of her community who know her well through history or closeness in relationship. Oscar's profile, on the other hand, speaks across timescales to old friends, new friends, rekindled friends, and co-workers. As such, he pitches his register at a further distance than Lara. Is this a generational difference? It could well be, given that Oscar is far more invested in his career at this point in his life, whereas Lara is still seeking out a career that matches her interests.

ANDY, FACEBOOKER #3

Andy is 21 and is completing a degree in English Education. Andy has used Facebook for several years now to connect with his community. Like Lara, Andy has habituated Facebook as a part of his daily routine—he checks his Facebook profile in the morning and in the evening. Andy's Facebook page features him blowing out candles for his birthday (see Figure 6.4). It is a familiar text within his community because many of them attended his birthday. Andy is very involved in theatre at his university and Facebook provides a vehicle to connect with university friends and friends farther away on a daily basis.

Like Oscar, Andy falsified information on the profile pages and provided comical responses to Facebook questions: what is your favourite movie? To which he said Face-Off. What is your favourite book? To which he said Face-off. In other words, all of his responses had to do with the movie, Face-Off. The Face-Off allusions became an ongoing trope on Andy's wall.

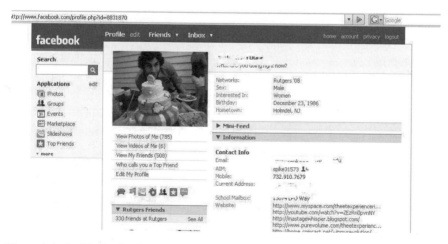

Figure 6.4. Andy's Facebook page

MATERIALIZING IDENTITIES ONLINE

What you see in each profile is an effort to manifest an identity online. Oscar presents himself as an outdoorsy guy who likes to speak across his community. He achieves this image through his choice of photograph, comments in his profile, and conversations on his wall. Lara is more subversive and edgy in presenting herself on Facebook. She seeks out people who understand her humour and she does so through intertextuality. Through political quips and ironic images, Lara speaks to key individuals who know and appreciate her humour. Andy likes to speak across his community like Oscar, but tends to speak more regularly to his Facebooking friends. Each participant materializes a certain identity, both consciously and perhaps unconsciously, guided by age, stage, subjectivities, and motivations in using Facebook. A Facebook user can choose from a variety of semiotic resources to create an image and forge a relationship such as sending a fish to a friend or embedding music or video into their profile. One can even manifest and materialize an identity through networks that users are involved in and that appear as part of their community.

Based on my small sampling of Facebookers, I note a difference in materializing online identities and practices between men and women. As Lara notes,

> My impression is that with men, they don't want applications and frou-frou girly stuff like flowery language and tests as much. They tend to enjoy online games that you can have embedded in your page. Men talk linearly. Women open up more candidly on their pages. It's interesting, socially, you can tell what people want in the way they set-up their profile. *Facebook is like mirror reality... you're just able to delete things that you don't want to see or think about anymore.*

There is so much in Lara's comments about ways of rhetorically materializing oneself. To begin with, the gender divide in terms of register and linguistic features and the practices used for Facebook is interesting in itself. Her awareness of gendered habits of mind and how they are rhetorically realized is an interesting finding. I have italicized a section of our interview that is particularly germane in terms of skills that Facebook carries: "Facebook is like mirror reality." The phrase consolidates a central message of the chapter, which is the degree of multimodal and rhetorical skill that it takes to maintain a Facebook world. Controlling discourse, shifting the register, mediating the visuals and sounds, and intertextual ties to texts such as YouTube—all point to strong literacy skills. Andy talked about online gender difference as part of his reflection about the world of Facebook:

> Whenever I get a message from a female it's always more like she might want something from me...it's like "how have you been, haven't talk to you for a while..." Guys

usually message each other when they have a purpose, you know, like I lost my phone recently and I had to get phone numbers from people.

Once again, we see a pattern of meta-linguistic awareness on Facebook along-side ways of mediating multimodally and linguistically to speak to different audiences.

STALKING AND GAWKING

Facebook is a sprawling web of family, coworkers, friends, and acquaintances all jostling for attention. Upon using Facebook, I became acquainted with old feel-ings of inadequacy from high school—that is, a syndrome known as "Facebook envy." You talk to people who have 257 friends on Facebook. Facebook is like a neighbourhood with lots of convivial interactions, sprinkled in with moments of jealousy, gossiping, exhibitionism, and even voyeurism. Lara was the most vocif-erous in viewing Facebook as increasingly about voyeurism.

The act of Facebook is all about gawking and at times stalking people on Facebook. What all of the interviewees talked about was the "nosy neighbour" syndrome that Facebook has spawned. As Oscar explains,

> Because I guess it's kind of a common space in a way. It's like, "come and see what everybody is doing," almost like "Mr. Nosey Neighbour." I think that it brings in this real world. People aren't necessarily getting to know their neighbours all that well and so it has become, what's John doing? It has that element.

There is a definite sense of stalking and gawking individuals on Facebook to track how they are feeling today or what they are doing today or what is absorbing their attention. In my observations of Facebook, users talk about how they are feeling and what they are doing on their walls and their inboxes are reserved for personal correspondence. Lara's big complaint about MySpace is precisely this "nosy neigh-bour" syndrome, which is much less in Facebook because of efforts to make profiles private:

> I found that MySpace started out as a really cool social networking grassroots kind of site. I enjoyed it at first…I loved that you could express yourself on a webpage…it did get out of hand and became a popularity contest—profile counters, trackers, groups, and e-stalking.

In her interview, Lara discussed how Facebook used to be far more private and that, slowly, the stalking and gawking syndrome is encroaching on Facebook pages.

CREATING COMMUNITIES

A key point about Facebook, especially for younger generations, that has not been addressed yet is that it is a hub and comfortable meeting place for so many people. With public spaces such as malls becoming policed and curfewed, digital spaces have become relatively safe for millions of people, especially younger people. Oscar, Lara, and Andy, to greater and lesser extents, have gravitated toward Facebook because they can make themselves how they see fit and they can carve out a community for themselves. Lest we forget, communities and identities forged on Facebook absorb far more time than the brief windows of literacy teaching and learning that our students experience in school. To create communities and to mediate identities is no easy feat; indeed, it requires such skilled practices as:

1. An ability to create and identify rhetorical networks.
2. An awareness of sound, visual, and animated texts that express more than written words.
3. Intertextual abilities—tying a Facebook profile to other, disparate texts such as YouTube.
4. Building tropes as familiar concepts remixed in other, related formats or situations.
5. Shifting registers given the nature of the speaker.
6. Foregrounding parts of characters through multiple modes.

Each of the above skills has been blackboxed in Facebook the past few years.

ASSESSING THE ART OF FACEBOOKING

Now, how can these unrelated skills be tied to schooling? Facebook relates strongly to many of the skills developed in school literacy such as synthesizing information; finding the right register to a particular genre; using visuals and formatting to enhance text content; using short, pithy text to send across a message. There are new skills derived from using Facebook. For instance, mediating identities through multiple modes and applications. Or, shaping written text and visuals around diverse audiences that have shorter and longer timescales.

Then, how do we remediate these skills in school? Switching registers as you do on Facebook could be remediated in school literacy to promote an understanding of genre. Such instances of conventionalized practices should become far more explicit and invoked in the kinds of activities that we do in high school English

class (just as an example). The point of writing such a chapter about a ubiquitous set of practices is that they can be assessed. In other work, I explore the notion of "production" as a more accurate way of describing what literacy is today. That is, Sheridan-Rabideau and I (Sheridan-Rabideau & Rowsell, 2007) talked to producers of digital, film, and printed texts to find out how texts such as Facebook are made and used by their subscribers. Production as an epistemology plays a key role in shaping students' use of social networking sites. That is, *how* an individual chooses to present himself or herself through visuals, applications, animation, sound, and written text deals with multimodal composition. What resources does the user pull on? Why these resources and not others?

Traditionally, and indeed presently, school literacy relies on summative assessments such as standardized tests to assess students' understandings of alphabetic texts despite incessant reminders of multimodal texts in students' lives. There is a need for new questions shaped around such conventionalized, widespread practices as Facebooking. Such questions would get at the heart of valuing and understanding of visual texts of all shapes and sizes. Table 6.1 outlines questions that could be applied to genres of texts read, used, understood, and created in literacy learning.

Facebook is like an online yearbook. Once you join, a page called your profile pops up and a white box for a picture of you. From that point forward, every mode you choose to present your identity is controlled by you. With Table 6.1's set of questions in mind, what modes does Oscar choose to represent himself in a particular way? What colours give Lara's profile its distinct and polemical character? What rhetorical devices does Andy use to evoke a particular statement? I can answer all of these questions in light of interview and profile analysis.

Interviewing and analyzing Facebook profiles offered me a detailed picture of not only three peoples' lives, but also sophisticated practices that are quite unique to each one (i.e., I would not have known about any of these skills if I had not probed their Facebook worlds). Imagine what we would glean in talking to students about their Facebook lives.

In assessing student writing, we need to apply such questioning not only to canonical texts, but also and importantly, to incorporate new forms of texts that are made through such programs as Adobe Photoshop, Dreamweaver, iMovie, Garageband, among others. Admittedly, all of our students do not have access to such programs, but the fact is that most people today use these programs to produce texts. Many students will not have access to such programs and software, but the key point is that our communicational landscape is made with these programs in mind and, as such, they control our meaning-making epistemologies and need to be accounted for in our assessment measures. We exist in a convergence culture—a convergence of information through multiple modalities that have been chosen for their particular effect. This is a contemporary picture of literacy.

Table 6.1. Assessing Rhetorical Uses of Multimodality

Questions applied to all genres of texts.

Multimodal Impact/Statement:
- What modes are chosen to give a particular effect?
- What is the effect?
- What modes are especially useful in creating a particular effect?
- What colours give an effect?
- What details have been chosen to create an effect?
- What message is the text telling its audience? How do you know?
- What rhetorical devices are used to evoke a statement?

Multimodal Organization:
- What is the text layout? Why is it this one and not another?
- What other medium could the author have used? How would it be different?
- Is there a dominant mode? If so, what is it?
- Where does the most important information sit on the page?
- What information is put in the background and why?

Multimodal Salience:
- What mode is privileged? How do you know?
- What mode is obscured? Why?
- What is darker and what is lighter? What is the significance of shading to the content?
- Where are major elements positioned?
- Where are the viewer's eyes directed?

Multimodal Coherence:
- Do elements work in unison or at odds with each other?
- Are there patterns in the design or content? What are they?
- How is coherence created?
- Are major elements balanced or not balanced?
- Is there juxtaposition, overlapping, or proximity in the text?

Source: Adapted from Cynthia Selfe's framework, 2007.

If we return to Facebook profiles as a coda to the chapter, the questions offered earlier could be easily answered and easily assessed if we could all sit with our students as they presented their digital worlds (see Table 6.2 for participant cross-case analysis). We need to apply these kinds of questions to keep in step with texts that are being used (all of the time). We want our students to take advantage of their honed "funds of knowledge" (Gonzales, Moll & Amanti, 2005) and to use all available means of communication to teach literacy. To do so, we need to cast a wider, more radical assessment that rethinks what digital texts do.

I may never be a Facebooker, but I have a deep appreciation for individuals who have the modal flexibility to project themselves through a series of images, sounds, written texts, or short films to their community.

Table 6.2. Use of Rhetorical Devices

Case Study	Oscar	Lara	Andy
Chosen modes	Posed photo for effect, humorous written text, occasional visual of friends.	No photographs, rhetorical visuals for effect, long and subversive written text to spark responses, lots of material on her Wall—mostly written.	Photographs, short, humorous written text, truncated texts that are meaningful to regular visitors, lots of dialogue amongst common group of friends on his Wall.
Rhetorical Effect	Focus on career and interests—multimodal effects blur personal information to speak to a larger audience.	Desire to be political and edgy and to instigate conversations with close friends and loved ones. There is a hint of irony and cynicism in her use of Facebook which materializes through visuals.	Creation of community with lots of different people contributing to dialogues and the modalities transmit a regularity and familiarity with communication.
Dominant Mode	50% Visuals–50% written word.	80% Written words and 20% visuals.	60% Written words and 40% visuals.
Inventory of skills acquired through Facebook	Visual communication of image.	Visual communication of identity.	Selecting frequent visuals that capture a phase in his life.
	Composing written narratives around perceived image.	Composing written text that is subversive, edgy, and tries to achieve an effect.	Speaking to the collective—his Wall community.
	Choosing modes that transmit governing message.	Choosing a voice and visual shaped around particular views.	Creating humorous updates for his profile information pages.
	Speaking across audiences and choosing appropriate narrative structures and rhetorical devices to do so.	Writing short, quippy text for her Wall.	Exchanging emails with different kinds of friends and family through his Inbox.
	Awareness of written word conventions—grammar, syntax, spelling.		Frequent checking throughout the day.
	Awareness of when to genre switch—that is, move to Inbox when dealing with more private dialogues.		

REFERENCES

Bazerman, C. (2002). *The languages of Edison's light.* Cambridge, MA: MIT Press.

Bourdieu, P. (1990). *The logic of practice.* Cambridge: Polity Press.

Bourdieu, P., & Wacquant, L. (1992). *An invitation to reflexive sociology.* Chicago, IL: University of Chicago Press.

Denscombe, M. (1998). *The good research guide.* Buckingham: Open University Press.

Geertz, C. (1993). *Thick description: Toward an interpretative theory of culture.* New York: Fontana Press.

Golby, M. (1994). *Case studies as educational research.* Exeter: Research Support Unit, University of Exeter.

Gonzalez, N., Moll, L., & Amanti C. (Eds.) (2005). *Funds of knowledge: Theorizing practices in households, communities and classrooms.* Mahwah, NJ: Lawrence Erlbaum.

Kress, G. (1997). *Before writing.* London: Routledge.

Kress, G., & van Leeuwen, T. (2001). *Multimodal discourse: The modes and media of contemporary communication.* New York: Oxford University Press.

Latour, B. (1991). Where are the missing masses? The sociology of a few mundane artifacts. In Bijker & Law (Eds.), *Shaping technology/building society studies in sociotechnical change* (pp. 225–258). Cambridge, MA: MIT Press.

Lave, J., & Wenger, E. (1991). *Situated learning: Legitimate peripheral participation.* Cambridge: Cambridge University Press.

Lemke, J. (2000). Across the scales of time: Artifacts, activities, and meanings in ecosocial systems. *Mind, Culture, and Activity, 7*(4), 273–290.

Nardi, B., & O'Day, V. (1999). *Information ecologies: Using technology with heart.* Cambridge, MA: MIT Press.

Rheingold, H. (1993). *The virtual community.* Boston, MA: MIT Press.

Rowsell, (2009). Artifactual literacy: Objects telling stories. In M. Hagood (Ed.), *Learning from youth in out-of-school and in-school contexts.* New York: Peter Lang.

Rowsell, J., & Sheridan-Rabideau, M. (2009). Education by the backdoor: A pedagogy of innovation. Paper given at the International Multimodal Conference. London, UK.

Selfe, C. (2007). Assessing multimodality. In A. Wysocki, J. Johnson-Eilola, C. Selfe, & G. Sirc (Eds.) *Writing new media: Theory and applications for expanding the teaching of composition* (pp. 29–40). Logan, UT: Utah State University Press.

Sheridan-Rabideau, M., & Rowsell, J. (June 7, 2007). *Before the black box: Profile on new media producers.* Paper given at the Multimodality and Creativity Conference at the Institute of Education, London.

Street, B.V. (1984). *Literacy in theory and practice.* Cambridge, UK: Cambridge University Press.

Turkle, S. (1997). *Life on the screen.* New York: Touchstone Press.

Distributed Assessment IN OurSpace: This Is Not A Rubric

JILL KEDERSHA McCLAY AND MARGARET MACKEY

Adam is six years old. He knows the difference between reading a page in a book (left to right, top to bottom) and reading a screen: "Sometimes it goes in different directions...side to side, lists, touch and drag, sometimes there are different colours to change your voice when you're reading the words" (Bearne, Clark, Johnston, Manford, Mottram & Wolstencroft with Anderson, Gamble & Overall, 2007, p. 12).

What do Adam's perceptions have to do with received ideas about "the basics"? Learning to decode remains a necessary challenge for children like Adam, but they must obviously also learn much more in order to function in the textual world he describes, and those who work with such children must find new ways of evaluating whether they know enough to make critical sense of their textual surroundings. Reading was never the monolith of simple decoding that sentimental popular memory would make it out to be, but the new pluralism of literate behaviours raises complicated questions for assessment. How do Adam's teachers realistically establish benchmarks for observing his progress?

This snapshot of Adam reveals a child who is comfortable with the plural possibilities of the screen in front of him. Adam is coming soon to a classroom near you, if he isn't already there. With his elastic capacity to respond to novelty in productive and experimental ways, he represents a fearless generation who don't know what they don't know, but know there is probably a way to figure it out. The

challenge of teaching these young people is intimidating enough for many teachers; the idea of finding fair and constructive ways to assess their work is sometimes very overwhelming indeed.

A very different snapshot of literate practices develops from a national study of the teaching of writing in contemporary middle-level Canadian classrooms (McClay & Peterson, 2008). Approximately 200 teachers discussed, in telephone interviews, their contexts and practices for teaching writing. Canadian provincial curricula for English Language Arts education require, explicitly or implicitly, some focus on digital literacy, learning with digital media, and representing learning in multimodal ways; however, the teachers who responded in this study were not, by and large, taking up the mandate. Teachers commented on the lack of reliable access to necessary equipment, their fears of the real and perceived dangers inherent in social networking and digital engagement, and the testing cultures that restrict their consideration of curriculum and literacy. For the most part, teachers were using computers as typewriters rather than as composition tools, having children key a word processed "good copy" after writing the actual draft in longhand. PowerPoint, rather than networked affordances, served for multimedia composition and presentations in classrooms. This picture of teaching and learning in contemporary classrooms provides much evidence of teachers who consider their teaching deeply and with professional awareness, but it does not establish that teachers generally acknowledge or exploit Web 2.0 practices.

A third snapshot brings into focus a number of teachers who *have* taken up the challenge to teach with attention to newer literacy environments. Such teachers are evident within the national study, as well as within our other research in recent years (McClay et al., 2007; McClay, 2006), and their examples are invigorating and encouraging. These teachers speak with enthusiasm and obvious pride in their work and in the engagement with literate practices that they see among their students. Andrew, a Grade 6 teacher, developed a class blog when one of his students made a family visit to Vietnam for an extended period during the school year. The blog project grew, as Andrew expanded his initial intention—to have the student keep in contact with schoolmates and to keep a journal of his travels—and developed into an interactive site for the remaining class members to learn about Vietnam and to provide the travelling student with genuine questions and investigative work so that all students would benefit from one student's overseas visit. When questioned about whether this project was a departure from the mandated Grade 6 curriculum on which students would write a provincial exam later in the year, Andrew spoke expansively about the broader and deeper educative value of such work in terms of the social studies program overall. He noted that the writing, thinking, and inquiry skills that the students developed from such work were

indeed well within the scope of the grade 6 curriculum, and he had confidence that his students would do well on provincial examinations.

When children like Adam sit in classrooms where they are told to compose first with pen or pencil and then use the computer for "the good copy," what sense can they make of their schooling? When computer facilities are inadequate and the results of standardized exams are published in the local newspaper, how can teachers be blamed for a narrow field of vision regarding the teaching of writing? And, very importantly, how do teachers enlarge their vision, as did Andrew, keeping real learning and real world literacy opportunities in mind as they teach and assess students' work?

In this chapter, we will explore some of the issues that arise out of the need for teachers to find ways of assessing what we (educators and researchers alike) don't completely understand ourselves. As new media and new formats proliferate, we must find ways to explore them with our students or risk our classrooms becoming uninteresting to our children's present lives and irrelevant to their futures. We need to attend carefully to teachers who report innovative ways of teaching with digital affordances, because such teachers also teach in provinces in which a testing culture is dominant, but they do not seem cowed by this constraint (McClay, 2006). Classrooms do not exist in a vacuum; teachers must take account of the priorities of the educational establishment, and they must also recognize the world of proliferating literacies in which their students live.

Current assessment measures are part of the problem. Carey Jewitt says, "If learning is multimodal and assessment is restricted to the modes of speech and writing the assessment will ignore (and in the process negate) much of what is learnt" (2003, 84). Templates, rubrics, and provincial examinations do not offer us the flexibility we need to explore new ways of thinking, composing and critiquing; we must find a way of assessing work that is innovative and responsive to the opportunities offered in new literary environments. Where on earth do we even start?

In this chapter, we raise several of the many weighty questions concerning assessment and work toward answers that respect and take account of teachers, students, and the digital environment in which we live. We will discuss teaching at length because we cannot talk about assessment without talking about how a teacher presents himself or herself as a learner and as an authority in the classroom. Indeed, assessment becomes malformed and malfunctioning when educators make assessment decisions without thinking simultaneously about teaching. We will next consider characteristics of knowledge in the contemporary world, as assessment always implies a vision of what counts as knowledge and what knowledge ought to be assessed. We will propose distributed assessment as an appropriate and authentic approach to assessment in new literacies, detailing several ways of

creating distributed assessment strategies in classrooms. We conclude by raising challenges that new literacies teaching and assessment pose for educators, considering how these challenges can be met both in "ideal" and "real" classrooms.

TEACHING IN AN EXPANDED ZONE OF PROXIMAL DEVELOPMENT

We begin by considering Vygotsky's much-revered concept of "the zone of proximal development (ZPD)," which has been a staple of learning theory among teachers for many years. Vygotsky defined the ZPD as "the distance between the actual developmental level as determined by independent problem solving and the level of potential development as determined through problem solving under adult guidance or in collaboration with more capable peers" (1978, p. 86). We believe that an expanded vision of the ZPD is an important starting point for aligning good teaching with good assessment; and it is also essential to consider the implication of this expanded ZPD for the stance and authority of teachers.

Nobody who knows the tumultuous history of Russia in the early twentieth century would say that Lev Vygotsky lived in a smoothly ordered world. Yet in his famous definition of the zone of proximal development, one given remains unquestioned. In Vygotsky's world, adults know more than children do. Children learn by working with adults or more competent peers. Vygotsky does not mention the idea of adults learning from more competent juniors, but most adults today are familiar with that phenomenon, and many teachers are made uncomfortable by it. When it comes to discomfort, the idea of assessing work in a situation where the teacher is actually the learner does have a certain paradoxical confusion to it.

In an English language arts classroom where work with new media is conducted, the role of designing becomes more important. University of California information specialist Philip Agre offers a useful picture of design at work:

> As media proliferate and change, the task of designers becomes more difficult. By *designers* I mean to include everyone—authors, composers, performers, public speakers, letter writers, editors, and others—who make decisions about the format and content of communications media, whether for others' purposes or their own. More indirectly I also mean to include the people—librarians, publishers, book sellers, programmers, critics, anthologists, and others—who operate the distribution channels that connect the producers and the users of media products. Designing for media, and particularly for new media in which stable conventions have yet to be established, requires many kinds of effort—research, experimentation, rational choice, iteration of prototypes, and learning from the work of others. Many skills enter into the process (1998, p. 70).

Agre does not mention teachers in his long list of knowledge workers, but his chapter is a revised version of a manifesto for an undergraduate university course, so teachers have at least an implied role in this scenario. In some ways, the key sentence is the last in this quotation: "Many skills enter into the process"—and in the world he describes, with its distributed understanding of new media, not all the skills have been previously mastered by the teacher before they are put to work. The zone of proximal development is multi-directional, with teachers helping students and students helping teachers, and everyone performing at a higher level than they could manage unassisted.

Applebee notes that teachers must develop "knowledge-in-action"; he sees the difficulty of the stance of teacher-as-learner, but he also solves the dilemma:

> The paradox of knowledge-in-action is that in order to learn something new, one must do what one doesn't yet know how to do. The way out of this paradox is to realize that learning is a social process: We can learn to do new things by doing them with others (1996, p. 108).

In classrooms where teachers truly understand and embrace the multi-directionality of the ZPD, the role of co-learner and co-constructor of knowledge enables teachers, paradoxically, to establish more, rather than less, authority and credibility. McClay's previous research in classrooms with a multiliteracies focus (McClay, 2006; McClay & Weeks, 2004) confirmed that teachers enjoyed impressive credibility with their students for such work; students in these classrooms regarded their teachers as fellow learners. When middle-grades students were asked what their teachers could do to improve upon a given project the following year, they most often noted that their teacher would certainly vary even a successful project. A typical student comment, repeated in a number of variations, was that the teacher "would want to try something new, so he won't get bored." Students understood that if the teacher was indeed a learner, then he or she would continue to learn in the coming years, shaping classroom projects for new interests and new students rather than delivering a "canned" curriculum. Teachers who share authority with their students take genuine risks, but such risks are often rewarded by students demonstrating noticeably responsible attitudes (see McClay, 2006, for a fuller discussion of this idea). Respect, like the ZPD, is multi-directional and synergistic. What results is a classroom that feels like "OurSpace" rather than the teacher's space.

KNOWLEDGE, LEARNING, AND ASSESSMENT IN OURSPACE

What kind of "knowledge-in-action" (Applebee, 1996) do teachers need to develop and co-construct with students? Kalantzis, Cope and Harvey suggest that

"knowledge today is distinguished by three characteristics: it is highly situated; rapidly changing; and more diverse than ever before" (2003, p. 16). Knowledge, they say, is more specialized now than in the past, and the

> sheer range of alternatives and life-wide settings severely limits the effectiveness of any curriculum focused around empirically right and wrong answers, or of any assessment techniques which seek only to measure knowledge within this narrow context (2003, pp. 16–17).

We need learners who are "flexible, autonomous, and able to work with cultural and linguistic diversity" (Kalantzis et al., 2003, p. 18), and who show evidence of collaborative and problem-solving skills. Kalantzis et al. point out that we need assessment techniques appropriate for "measuring the attributes of persons who will be most effective in the new economy and most valuable as citizens" (Kalantzis et al., 2003, p. 24); they call for "a broad range of assessment strategies," focused on the following:

- the performance of tasks;
- the planning and completion of projects;
- group work; and
- the presentation of portfolio work (Kalantzis et al., 2003, p. 25).

We will return to these useful points later.

Although the portrait of learning issues that Kalantzis et al. present is somewhat intimidating, teachers are accustomed to meeting broad-ranging challenges. Two decades ago, John Goodlad (1984) noted that teachers need to be able to work in rapidly changing contexts characterized by much ambiguity and by conflicts in values. This description of constant change is truer than ever today, and now the changing contexts include the literacy world itself. Yet even in the most idealized version of the cooperative classroom, the teacher remains the agent responsible for assessment and accountability. How does assessment proceed in an environment where knowledge is distributed? In part, at least, the answer lies in distributed assessment.

Distributed Assessment

If teachers and students are to collaborate to construct knowledge, so too must they collaborate to assess. We see distributed assessment as a sharing and dividing of assessment responsibilities that serve to help teachers and students alike to develop metacognitive and critical awareness of the work under consideration. Distributed assessment entails principled negotiations of purposes, tools, and appraisals, and

it offers opportunities for developing knowledge-in-action both for teachers and students. We will discuss peer-to-peer learning networks and sideshadowing as two approaches to develop distributed assessment. Both of these approaches can proceed fluently from reading and writing workshops, as they focus upon aspects of peer response and attention to process that are important aspects of workshop approaches.

Peer-to-peer learning networks. It is often noted, usually with frustration, that assessment drives teaching practice. If that is the case, and we believe it is, then teachers will do well to explore assessment practices in the online environments that children frequent outside of school hours. Ito (2008) focuses on the learning that is supported among creators and responders in various online communities, such as those for anime music videos and fan fiction. She characterizes three noteworthy qualities of the learning in such peer-driven networked communities:

- Very little explicit instruction is provided, and what is provided is offered on an as-needed basis;
- Participants specialize in particular, often narrow niches, rather than aiming for overall mastery; and
- Ongoing feedback, review, and critique are internal to the process and provide encouragement to participants throughout the process.

Teachers who already work within a process approach to writing instruction will see possibilities within Ito's characterization of these peer-to-peer networks. The provision of "just-in-time" mini-lessons and constructive feedback during the composition process achieves many of the same ends. More difficult to frame within school contexts, however, is Ito's recognition of specialization rather than mastery of particular skills and techniques.

Teachers, after all, are obligated to work on a critical process of disembedding some of the specialist tactics and subject knowledge that students bring to the classroom. Many students develop digital skills and "niche knowledge" in their recreational literacy practices; teachers can and should prompt them to consider critical and ethical issues with regard to these literacy practices. The development of critical sophistication is best fostered by teachers who are at least aware of common practices in new literacy environments. Teachers can learn a great deal from respectful conversations with their students about their recreational literacies. Aidan Chambers (1993) reminds us of the power of the simple phrase, "Tell me." Relating those specialist skills to the broader world of literacy is an ongoing conversation that enriches both students' and teachers' understanding and critical awareness.

Sideshadowing. In our work exploring the thinking of young people who engage in composition and game play in newer digital environments, we have developed sideshadowing protocols that are productive for uncovering literate thinking and sensibilities (McClay, Mackey, Carbonaro, Szafron & Schaeffer, 2007; McClay, 2002; Mackey, 1999). Based on Morson's (1994) term, and Welch's (1998) application of it in the teaching of writing, sideshadowing is a helpful construct for uncovering a person's appraisals and intentions in his/her own literate work. In sideshadowing, we ask individuals to consider a work in progress, a completed work, or the video of game play or other online activity. We ask the individual to talk about what options he or she saw and considered at each step of the way, why he or she opted for particular choices and rejected others, and what appraisal he or she makes of the work to date. Such sideshadowing helps composers of text, image, and action to expand the narrative possibilities under consideration. It enables the individual to consider other ways that the composition or game could have developed, rather than simply to justify the way he or she actually did develop it. Used as a teaching tool, sideshadowing can heighten the metacognitive value of any creative activity that students engage in, and assist them in considering potential avenues for future creation.

Teachers cannot spend lengthy periods of time with each student for sideshadowing; they must teach students to assist each other, to talk through such a protocol, and to develop their own ways of working with sideshadowing to explore narrative and rhetorical possibilities as students create fiction and nonfiction in forms that are emerging and for which no clear conventions have yet been established. Moving through a world of changing literacies as they do, students need (and also develop) critical and metacognitive skills; work with sideshadowing can help them to articulate their own tacit understanding as well as enabling them to assist their peers.

As practical routes to distributed assessment, both peer-to-peer networks and sideshadowing protocols enrich such activities as performance of tasks, planning and completion of projects, group work, and presentation of portfolio work, as Kalantzis et al. (2003) advocate.

Assessing Development as Well as Achievement

Assessment must proceed from an explicit understanding of what constitutes development and how development is manifested in students' work, behaviour, and metacognitive reflection. Eve Bearne and Helen Wolstencroft offer a fine-grained template for considering multimodal work. They offer descriptors for multimodal text creation in four stages of development—"in the early stages"; "increasingly assured"; "more experienced and often independent"; and "assured, experienced

and independent" (2007, pp. 173–176). In a detailed table, they provide accounts of how this creator of a multimodal text at each level does the following:

- makes decisions about mode and content for specific purpose and audience;
- structures texts;
- uses technical features for effect;
- reflects on the whole process (2007, p. 173).

This list of descriptors could usefully be applied to tasks, projects, group work, and portfolios. Such a step would make a start on providing accountability with the kind of detail and granularity that illuminates student accomplishment as well as areas where progress is needed. It is interesting (and not accidental) that this list is as useful for the assessment of writing as it is for the evaluation of multimodal forms of communication.

CHALLENGES IN TEACHING AND ASSESSMENT

In assessing contemporary multimodality, we need to think large as well as fine-grained. Henry Jenkins and a group of colleagues (Jenkins, Purushotma, Clinton, Weigel, & Robinson, 2006) provide a different kind of lens for looking at the broader issues. They set out to explore the chief challenges of digital media literacy in the 21st century and recognized three main concerns: participation, transparency, and ethics. Teachers must attend to these challenges, which also have important implications for thinking about assessment.

The participation gap. Young people arrive in school with varying degrees of exposure to, experience with, and expertise in different media. Often their expertise is highly specialist, even narrow. It is difficult or impossible to establish a level playing field for the assessment of three different kinds of student: those with a broad sophistication involving many forms of digital competence, those with a specific hobby or interest that develops particular skills at the expense of others, and those with little access to or interest in digital media and a correspondingly low level of skill and high level of intimidation. The zone of proximal development gets a workout in classrooms where those with greater skill have the opportunity to assist those with less, but such activity does not necessarily stretch or challenge the most expert, nor does it readily solve assessment problems.

The transparency problem. Jenkins et al. note "the challenges young people face in learning to see clearly the ways that media shape perceptions of the world" (2006, p. 3). Whatever level of skill and experience young people bring into the

classroom, they can all benefit from having their critical antennae made more sensitive and rigorous. A lifetime of exposure to advertisements may make young media users merely cynical; social networking may appear to offer a more honest and personal economy of information. But just because I learn something from an Internet buddy whose credentials I think I understand does not necessarily make that information reliable or disinterested. The imprimatur of a personal acquaintance, online or in real life, is not sufficient to establish authority. Nor is the filter of many such personal perspectives on the world necessarily rigorous enough to create reliability. Critical digital literacy involves finding ways to question many forms of information: the personal, as in Facebook entries, blogs, chatroom discussion and so forth; the collective, as in Wikipedia or Amazon book recommendations ("other customers who bought X were interested in Y"); the commercial, as in viral marketing, click-through campaigns, and product placement; and the institutional, as in official websites of one kind and another. One of the major challenges for educators of the early 21st century will be for teachers to find ways to develop such critical awareness—and then to assess it.

The ethics challenge. Jenkins et al. define the ethics challenge as "the breakdown of traditional forms of professional training and socialization that might prepare young people for their increasingly public roles as media makers and community participants" (2006, p. 3). The world of Web 2.0 ensures that many students in contemporary classrooms are producers of online information as well as recipients. A critical understanding is important, and an ethical attitude is essential. Cruelty and ignorance do not change their spots by going digital. Enhancing students' awareness of their responsibilities online is a difficult and important task; assessing the success of such efforts will call for collective intelligence on many levels.

IMAGINING CLASSROOMS IDEAL AND REAL

To explore the very broad range of issues we have raised so far, we first imagine an idealized teaching situation, after which we will make a reality check. Ideally, what would it take to support teaching that enabled assessment of the performance of tasks, the planning and completion of projects, the successful coordination of group work and the presentation of portfolio work (Kalantzis et al., 2003, p. 25), creating a framework in which students moved through Bearne and Wolstencroft's four stages of development (early; increasingly assured; more experienced and often independent; assured, experienced and independent) while taking account of the three major teaching challenges raised by Jenkins et al.? We use Jenkins' challenges as headings for our discussion below.

An Ideal Framework

Participation: In an ideal framework, there would be enough computers (not necessarily one per student on every occasion), and technical teaching and support as needed. Teachers would feel secure to learn alongside students, confident that productive learning will take place if they participate as fellow learners in a community. Students would work on a task they understood, were interested and invested in, and had to stretch themselves to complete. In such an environment, students would be able to make "pure" decisions about mode and content in terms of specific purposes and audiences, without being constrained by the limitations of equipment and so forth. If this scenario sounds completely fantastical, it is worth remembering that students sometimes may actually come much closer to realizing this power to concentrate exclusively on purpose and audience when they work with pencil and paper, a situation in which the technological requirements are taken completely for granted.

Transparency: In an ideal framework, students would become increasingly aware that any choice offers certain affordances and particular constraints. Their attention would not be distracted by the need to make do with whatever second-best choice is actually available; they would learn that some constraints actually engender creative response and other constraints simply constrain. They would have the luxury of learning to structure texts for their own clear purposes and to reflect and critique within that context. Their capacity to structure texts would be limited by their creative powers, not by the limits of the available technology.

Ethics: In an ideal situation, students would not be struggling with each other for access to limited equipment. There would be no status issues about who owns the coolest tools, and work would not have to be sent home with the group member who has the best domestic computer. Teachers would be free to focus on the real questions of working together: treating each other fairly online and offline, pulling your weight, considering the real-world consequences of decisions, citing work correctly and respectfully, and so forth.

In the Real World

Obviously we do not live in an ideal world. One contradiction that teachers have long noted and contended with is the contradiction between the rhetoric of good practice, as exemplified in curriculum documents, and the reality of narrowly defined standardized exams. While programs of studies in English Language Arts and Social Studies have extolled the merits of collaborative and cooperative learning, Canadian standardized exams at the provincial and district levels have focused entirely on individual achievement. In this respect, as in so many others, teachers

will need to enter the social and political debates, even though most teachers prefer not to see their teaching as a political activity. We do well to remember that accountability is a two-way street, however, and educators will have to help restore balance to a severely overbalanced system of standardized testing.

Teachers are equally entitled to hold governments, parents and other citizens accountable for the impoverished technological settings in which many of them teach. When they are asked to apply business standards of efficiency and effectiveness, their reply might emphasize the level of resources that commercial enterprises take for granted. Given, however, that, for the foreseeable future, school technology is likely to lag behind the home technology of many students, what elements of the ideal situation described above could be applied to the real world?

McClay and Peterson's (2008) study of the teaching of writing in early 21st century Canada suggests that in some real-world classrooms, the computer is used only as a glorified typewriter, and PowerPoint stands in for all other forms of multimodality. Such practice represents the lowest common denominator of minimalist technology use, and it seems only fair that teachers should similarly be held accountable for such reductive practices. Surely it is more productive to move into an expanded Zone of Proximal Development and remember that adults can learn from the students in their care, and that schools can piggyback on the technological capacities developed at home. Teachers who restrict everybody's use of computers because of inequality in home provision of technology do not level the playing field; they simply ensure that those students who can't learn about computers at home can't learn about them at school either, and so make a bad situation worse.

Given the need to compromise with our ideal scenario above, what ways could we make progress under Jenkins' three headings? For the purposes of this "real-life" discussion we will list his points in reverse order.

Ethics: Performing tasks, planning and completing projects, participating in group work and presenting portfolios are all challenges that require an ethical approach. How students treat each other online and off, how they cite their sources and respect the work of others, how they pull their weight in group projects and deal with real-world consequences—all these significant questions need to be assessed within a strong ethical framework that all students understand. There is nothing essentially digital about these issues, but working in virtual settings does affect the dynamics of ethical relationships and students need the opportunity to consider, discuss, and perform what is ethically appropriate.

Transparency: The difference between the ideal and the real-life scenario is not so great when it comes to developing critical thinking. A teacher's own analytical capacities and ingenuity can open any materials and texts to critical

examination. PowerPoint will do some things well, but for other tasks, it is restrictive and reductive; a class that works largely in PowerPoint can still critique those possibilities and limitations. In any kind of classroom, children can learn to reflect on their own work, and also to question and critique information they glean from other sources. They can learn that criticism is both positive and negative, and that it gains credibility for being grounded in detailed attention both to the material being critiqued and also to the authority that informs such material.

Participation: In the real world, students are at differential levels of exposure, experience and comfort with particular media and digital technologies. Rather than stifling everybody's contribution, it makes more sense to leverage the assets in the classroom. Finding ways to work collaboratively with distributed equipment and know-how calls for creative approaches, but students do need to learn to support each other in a variety of ethical and critical ways. The need to find a task that genuinely stimulates and stretches students remains exactly the same as in our ideal scenario. The challenge is to create a cooperative classroom, to make best use of what technologies are available and work collectively to improve on what may be on offer within the school. If a classroom is perceived as "OurSpace," then wringing the best use out of technology may be perceived as "OurChallenge" rather than just the teacher's.

Assets are better leveraged when they are recognized, and one step towards creating a participatory classroom is to audit what print, media and technology strengths are in the collective. The first need is for better information about the strengths and weaknesses of the students in a particular group. One of us has written extensively (Mackey, 2002; Robinson & Mackey, 2006) on the importance of an asset model, as opposed to a deficit model of new literacies. An asset model can be converted into a form of simple audit that both supplies basic information and also raises questions for discussion. (See the Appendix for a current version of this asset model.)

There are at least two ways of using the asset model audit. One approach has the virtue of speed and simplicity: simply supply a list of literate activities (including print, image and digital options) to a group and ask them to circle the ones they are completely at home with, underline the ones they have some limited acquaintance with, and leave blank those that mean nothing to them. Follow-up discussion after the form is completed is usually lively.

The second approach is slightly more time-consuming: provide an initial list and ask the group to participate in refining it, bringing it up to date (always an issue!) and establishing which activities can be most usefully grouped together. Once the audit list is edited to the group's satisfaction, then it can be filled in as above. This approach has several virtues. Since any list of contemporary literacy

activities is ever-increasing, the discussion surrounding what to include and what to omit is in itself an educational opportunity. The audit is more likely to be comprehensive when many minds collaborate on its composition. And even in the preliminary sorting out of the questions, teachers may learn a great deal about the recreational literacies of their students.

It is essential that any such audit designed for class use should include "old" as well as new literacies. Nobody should be faced with the necessity of leaving every category blank! But it is also salutary for those filling in the asset model (including the teacher) to recognize that almost nobody is equally at home in all our contemporary modes of communication.

It is important to think about this model as a form of audit rather than assessment. It is hard to imagine anyone thinking it a good idea to "mark" such an audit, but it can certainly provide useful baseline information from which to assess gains over the course of a semester or a year. As Bearne and Wolstencroft remind us, "Describing progress is part of record keeping" (2007, p. 143), and a set of audits taken every four or six months could certainly become part of a portfolio.

OURSPACE: ARRIVING AT CLASSROOMS NOW

We have discussed teaching and teachers' attitudes at length because assessment in new literacies—and in traditional forms of literacy—must proceed from and be coherent with teaching, as well as with externally imposed curriculum and assessment. We have highlighted some of the political and social dimensions that teachers must contend with, as we recognize that classroom walls are porous; teachers cannot simply begin to assess students' learning in new literacies without considering the realities of the educational culture and larger society in which they teach. We have looked both to the fine-grained and to the broader sweep of the canvas in considering productive approaches to assessment.

With an expanded conception of the Zone of Proximal Development, teachers are able to feel comfortable as learners in their classrooms, an essential starting point for appropriate assessment work in new literacies. Kalantzis et al.'s (2003) three characteristics of knowledge—that it is highly situated, rapidly changing, and more diverse than ever—suggest radical action for educators. Teachers must insist that, although they work with "outcomes-based" curricula, their classrooms must provide space for the very real, immediate learning that comes with genuine creation of knowledge. Real learning involves surprise, serendipity, improvisation, and discovery, and it cannot entirely be codified in pre-ordained statements of learning outcomes. Classrooms are places of genuine learning when children

and teachers can consider the classroom to be OurSpace. This ownership of space includes negotiation of assessment practices and standards.

Just as assessment of students' work in new literacies must involve negotiation among students and teachers, so too must frameworks for assessment and larger attempts to delineate development involve negotiation among teachers and other educators. Working with teachers from Essex, England, Bearne and Wolstencroft (2007) developed a framework for describing progress in multi-modal work. They note that students can demonstrate progress and increasing sophistication as they decide on mode and content for specific purpose(s) and audience(s); structure texts; use technical features for effect, and reflect on process and achievement.

Fostering disciplined, ethical, and engaging classroom communities, teachers can provoke and assess student progress in these abilities by developing strategies for distributed assessment. Peer-to-peer online networks, as described above, demonstrate some possibilities for teachers and students to consider the creation of texts in critical and insightful ways. Sideshadowing offers a process for reflection, as students can encourage each other to consider their intentions for creation, appraisals of work, and understandings of genres, modes, and audiences. Teachers and students can use asset inventories to remind themselves of the changing nature of the literacy environment and of their own developing literate practices.

We conclude with a reminder that balance remains important. New forms of work and evaluation will not completely take over the English language arts classroom. Traditional literacies still remain potent, and tried and true methods of evaluation still have their place. The mutual respect necessary between teachers and students has its parallel in respect for older as well as newer media and forms of literacy. Children will only respect old media if their teachers respect new media. The portrayal of classrooms as OurSpace offers teachers and students respectful and productive ways to engage in literate practices and literacy learning.

REFERENCES

Agre, P. (1998). Designing genres for new media: Social, economic, and political contexts. In S. Jones (Ed.), *CyberSociety 2.0: Revisiting computer-mediated communication and community* (pp. 69–99). Thousand Oaks, CA: Sage.

Applebee, A.N. (1996). *Curriculum as conversation: Transforming traditions of teaching and learning.* Chicago, IL: University of Chicago Press.

Bearne, E., Clark, C., Johnston, A., Manford, P., Mottram, M., & Wolstencroft H., with Anderson, R., Gamble, N., & Overall, L. (2007). *Reading on screen.* Leicester: United Kingdom Literacy Association.

Bearne, E., & Wolstencroft, H. (2007). *Visual approaches to teaching writing.* London: Paul Chapman/UKLA.

Chambers, A. (1993). *Tell me: Children, reading and talk.* Lockwood, England: The Thimble Press.

Goodlad, J.I. (1984). *A place called school: Prospects for the future.* New York: McGraw-Hill Book Company.

Ito, M. (2008, March 28). *Amateur cultural production and peer-to-peer learning.* Paper presented at the American Educational Research Association Annual Conference. New York City.

Jenkins, H., Purushotma, R., Clinton, K., Weigel, M., & Robinson, A.J. (2006). *Confronting the challenges of participatory culture: Media education for the 21st century.* Retrieved on April 2, 2007 from http://www.digitallearning.macfound.org/atf/cf/%7B7E45C7E0-A3E0-4B89-AC9C-E807E1B0AE4E%7D/JENKINS_WHITE_PAPER.PDF

Jewitt, C. (2003). Re-thinking assessment: Multimodality, literacy and computer-mediated learning. *Assessment in Education, 10*(1), 83–102.

Kalantzis, M., Cope, B., & Harvey, A. (2003). Assessing multiliteracies and the new basics. *Assessment in Education, 10*(1), 15–26.

Mackey, M. (1999). Playing in the phase space: Contemporary forms of fictional pleasure. *Signal: Approaches to Children's Books, 88,* 16–33.

Mackey, M. (2002). An asset model of new literacies: A conceptual and strategic approach to change. In R.F. Hammett & B.R.C. Barrell (Eds.), *Digital expressions* (pp. 199–217). Calgary: Detselig.

McClay, J.K. (2002). Hidden "Treasure": New genres, new media, and the teaching of writing. *English in Education, 36*(1), 43–52.

McClay, J.K. (2006). Collaborating with teachers and students in multiliteracies research: "Se hace camino al andar." *Alberta Journal of Educational Research, 52*(3), 182–195.

McClay, J.K., & Peterson, S.S. (2008, March 28). *Teaching writing in Canadian schools: Pan-Canadian perspectives on literacy education and curricula.* Paper presented at the American Educational Research Association Annual Conference, New York City.

McClay, J.K., & Weeks, P. (2004). Ensemble improvisation: Chats, mystery, and narrative in a multiliteracy classroom. *The International Journal of Learning, 10* (pp. 1443–1455). Retrieved on September 29, 2008 from http://learningconference.publisher-site.com/

McClay, J.K., Mackey, M., Carbonaro, M., Szafron, D., & Schaeffer, J. (2007). Adolescents composing fiction in digital game and written formats: Tacit, explicit and metacognitive strategies. *E-Learning, 4*(3), 273–284.

Morson, G.S. (1994). *Narrative and freedom: The shadows of time.* New Haven, CT: Yale University Press.

Robinson, M., & Mackey, M. (2006). Assets in the classroom: Comfort and competence with media among teachers present and future. In J. Marsh & E. Millard (Eds.), *Popular literacies, childhood and schooling* (pp. 200–220). London: Routledge.

Vygotsky, L.S. (1978). *Mind in society: The development of higher psychological processes.* Cambridge, MA: Harvard University Press.

Welch, N. (1998). Sideshadowing teacher response. *College English, 60*(4), 374–395.

APPENDIX: AN ASSET MODEL OF CONTEMPORARY LITERACY EXPERIENCES

This version is adapted and updated from previous incarnations of the asset model. The first model was published in 2002 in "An asset model of new literacies: A conceptual and strategic approach to change" by Margaret Mackey, in *Digital expressions: Media literacy and English language arts*, edited by R.F. Hammett and B.R.C. Barrell, Calgary: Detselig, 199–217. A further upgrade of this checklist appeared in 2006 in "Assets in the classroom: Comfort and competence with media among teachers present and future", by Muriel Robinson and Margaret Mackey, in *Popular literacies, childhood and schooling* (pp. 200–220), edited by J. Marsh and E. Millard, London: Routledge.

If you are very familiar and comfortable with an item on this list, circle it. If you are somewhat aware of it but not entirely comfortable, underline it. If you have no experience with it, leave it blank.

Text on Paper

novels
short fiction/poetry/drama
information books/reference books
other non-fiction (e.g., biography, history, science)
newspapers
print magazines
comics
graphic novels
zines
picture books
computer manuals
games manuals/help books
posters
online materials printed off specifically for the purpose of reading
other—specify

Audio

live radio
satellite radio

Internet radio
podcasts
audiocassette/minidisc
CD/DVD audio
MP3, iPod, or other form of digital transfer of sound
other—specify

Audiovisual

movies at the cinema
television
 basic channels
 satellite/cable
 digital cable
 pay-per-view
 Internet access
 cellphone access
VHS
 home-taped TV programs for later or more convenient viewing
 purchased or rented tapes
DVD
personal video recorders (e.g., TiVO)
online (streaming video, YouTube, etc.)

Electronic Text

electronic books (e-books)
PDAs (personal data assistants such as Palm Pilot, Blackberry, etc.)
 with built-in telephone
 with gaming features
 with Internet connection
on-screen readers such as Adobe PDF
CD/DVD-ROM information texts
literary hypertext
online magazines
RSS feeds
e-zines
e-cards

online communication
 email
 social networking sites (Facebook, MySpace, Bebo, etc.)
 instant messaging
 with personally known friends
 with Internet-only friends
 texting
 listservs
 chatrooms, bulletin boards, etc.
 blogs
 reading
 authoring
 creating a website
 personal—e.g. home page
 topic-related
 contributing to other websites
 contributing to collectively-created sites, e.g., Wikipedia
 online game-playing
 online gambling
 other—specify

Electronic Images

digital cameras
 taking, storing pictures for local domestic use
 posting pictures to online sites such as Flickr or YouTube
computer games
 played alone
 played against face-to-face opponent/s on a single computer
 played on a local area network with/against other gamer/s
 played online
 massively multi-player online role-playing games
console games (PlayStation, Nintendo, etc.)
 played alone
 played against face-to-face opponent/s
 played online
hand-held electronic games (GameBoy, etc.)
arcade games
VLTs
other—specify

Mobile Communication

cellphone
 talking
 photos
 video
 texting
 gaming
 accessing the Internet
 info updates (e.g., sports)
 timekeeping (using as a clock)
 reading continuous text
 PDA
Blackberry
digital recorder
GPS
other—specify

Digital Life Organization

online commerce
 banking
 shopping
digital calendar/schedule
 personal
 collective
other—specify

Valued Knowledges AND Core Capacities FOR Digital Learners: Claiming Spaces FOR Quality Assessment

KAY KIMBER AND CLAIRE WYATT-SMITH

INTRODUCTION

For many young people today, immersion in a digital culture is part of everyday life. Increasing numbers of online youth have become creators of web content from blogs to social network pages (Lenhart, Madden, Rankin Macgill, & Smith, 2007). Many delight in building online identities, characters and avatars for their online games, blogs and social network sites. Almost as a consequence, public attention varies from amazement to fear whenever young people, new technologies and especially the Internet are considered in tandem.

Carers are often flummoxed by their children's facility with multiple media, frequent multitasking (Prensky, 2001; Wallis, 2006), and use of new media technologies. Research into young people's leisure time social practices with digital media has revealed: the scale and ease of their adoption of new media (Roberts, Foehr, & Rideout, 2005); the significance of mobile phone usage to their lives (Stald, 2008); and the relationship between social networking sites, identity representation and sense of connectivity (Boyd, 2008; Stern, 2008), and the wide popularity of online computer games (Beavis, 2002; Gee, 2003; Sefton-Green, 2003). In each of these instances, young people have developed skills, capabilities and technology-mediated social practices that have often been extended by their peers, not the classroom teacher (Drotner, 2008; Gee, 2004; Jenkins, 2006; Stern,

2008). Other instances have shown young people in pursuit of knowledge about subjects of interest from community experts, not their classroom teachers (Gee, 2004; Jenkins, 2006). Technology-mediated social practices like those outlined here have implications for school curriculum, the envisioning of next-practice pedagogy and the framing of appropriate assessment tools. So, too, do findings from several large-scale studies of young people's technology use in the home.

Valentine, Marsh, and Pattie (2005) identified English children's preference for using home computers rather than those available in school. Interestingly, while home usage was primarily leisure-oriented, the faster speeds of home equipment and the relative freedom of access enjoyed at home, compared with school constraints, were also cited as reasons. An Australian study linked high technological skill and confidence levels with higher levels of home resources, particularly personal ownership of computers (Meredyth et al., 1999). However, a more recent national study (Ministerial Council on Education, Employment, Training and Youth Affairs, 2007), devised an *ICT Literacy Scale* (p. x) to gauge the technological performative levels of 7,500 young people in Grades 6 and 10 drawn from a national sample. Many gendered and state-differentiated analyses were provided, a key insight being that despite the extent of young people's leisure uses of technology, young people were using technology in a limited way. Formal education had not adequately equipped them for critical or imaginative usage. This limitation has also been noted by other writers. Drawing on research studies from several countries into young people's everyday uses of technology, David Buckingham (2007) observed that banality and superficiality rather than critical discrimination characterised much of their technological usage. Amongst findings from the British Educational Communications and Technology Agency (2001) ImpaCT2 study, three observations have direct relevance for this discussion:

1. Evidence from observed lessons in secondary schools suggests that some teachers focus on teaching skills that most pupils already possess.
2. Relatively few teachers are integrating ICT into subject teaching in a way that motivates pupils and enriches learning or stimulates higher-level thinking and reasoning.
3. Classroom observations indicate that when teachers use ICT in lessons (such as English, science or history) they often focus on basic rather than higher-order thinking and reasoning skills (pp. 13–14).

The points raised above suggest that educational/technology debates need to focus on *how* young people are already using technology in and out of school, and more particularly, on *how* teachers can assist in extending this development. It is no longer just the case of integrating technology at a base level of

utility. More pressing is the need to develop pedagogical learning goals and strategies designed to extend young people's critical and creative capacities with new technologies. With clearly articulated capacity priorities, young people's performance within and beyond school settings could be improved and assured greater portability.

In this chapter we explore possibilities for rethinking knowledge boundaries and identify priorities for capacity-building in young people's use of ICTs, whether at home or at school. In Part One, we lay the foundation for our case for moving beyond traditional binaries associated with in- and out-of-school learning. Further we identify four related knowledges that provide a foundation for expanded learning opportunities. In Part Two, we build on this foundation to present a new conceptual framing of *Essential Digital Learnings* (EDLs) and consider their implications for classroom practice and assessment.

PART ONE: IN- AND OUT-OF-SCHOOL LEARNING

In the body of writing on learning and—more specifically—curricular learning, there are long-standing dualisms that centre on the context in which learning occurs. In-school learning has been distinguished traditionally from out-of-school learning, the former tagged as "formal" and given higher value, with the latter tagged as "informal" and accorded lesser value. Qualifying and compartmentalising in these ways cloak the complexities that complicate both spheres. In their *Shared Spaces: Informal Learning and Digital Cultures* report, Buckingham, Sefton-Green and Willett (2003) observed the problematic nature of regarding both formal and informal learning as discrete, given increased child autonomy in informal learning situations. Sefton-Green (2003) suggested that both forms of learning share many characteristics—purposeful learning experiences with external intervention, promoting particular values and expressed in subject-specific language. Accepting that both sites can offer scope for meaningful learning offers a way forward for rethinking the relationship between learning locales, curriculum structure, pedagogy and assessment.

Brown (2002), for example, recognised the co-existence of on-campus and virtual learning communities and consequently advocated the framing of a "new knowledge architecture" to facilitate what he termed "a learning ecology" for university students:

> A framework, or architecture, that unifies these traditionally separate infospheres to produce a new form of a learning ecology—an active place where the virtual and the physical seamlessly and synergistically coexist (p. 80).

In recognising the fluidity between the two spheres, he advocated

> a hybrid model of learning—one that combines the power of passion-based participation in niche communities of practice with a limited core curriculum for teaching the rigorous thinking and argumentation specific to that field (Brown 2006, p. 19).

These concepts resonate with earlier work by Beavis, Nixon and Atkinson (2005), who argued that "the overall ecology of learning" is constituted within the "flows between formal and informal sites and practices" (p. 41). In similar vein, and even earlier still, Macdonald (2003) noted that educators needed to widen their curricular perspectives to embrace those new learning locales of young people: "educators need to recruit and recognise new spaces and places for learning that are effective and engaging, but are beyond formal curriculum planning and reform projects" (p. 145). Here, informal sites are synonymous with community-based learning.

Community-based learning has been described as "passion-based learning" (Brown, 2006, 22) or "affinity spaces" (Gee, 2004, 77) with the power to generate more active, involved learning across time, cultural and age boundaries. Many young people already engage with *community knowledges* through online, special interest networks. Jenkins (2006) deemed such involvement as "a participatory culture" (p. 3) where membership and participation are frequently voluntary, and collegial mentoring assists with individual growth within the community. With greater youth agency and opportunities for involvement, Jenkins believed that participants become empowered and interconnected. He cited several examples of young people whose life and careers as politicians, computer programmers, authors and even film producers have been sparked through online community memberships. Jenkins observed that the kinds of skills acquired by young people, "learning how to campaign and govern; how to read, write, edit, and defend civil liberties; how to program computers and run a business; how to make a movie and get it distributed" (p. 5), have been developed in their fan and/or gaming communities, but not in their schools.

If, as Jenkins (2006) has argued, participatory culture values and fosters peer-to-peer learning, changed attitudes "toward intellectual property, the diversification of cultural expression, the development of skills valued in the modern workplace, and a more empowered conception of citizenship" (p. 3), then it is imperative that ways be found to draw these into the educational discourse and to legitimate them within assessment frameworks. At this point, the discussion is extended from recognising *community knowledges* in school curriculum to consideration of how assessment practices might also include both formal and informal contexts.

Assessment has traditionally been associated with teacher authority, especially as this relates to judgments of quality. We argue that it is timely to call into

question the traditional notion of connoisseurship (Sadler, 1989) in assessment as residing with the teacher. This notion hinges on the assumption that the teacher, by virtue of discipline knowledge and evaluative experience, is best placed to recognise characteristics of quality in performance and assess these against standards. Given the widely reported generational gaps in technological know-how between teachers and students, a rethinking of holders of expertise and what counts as quality performance is warranted.

Throughout history and in all cultures, experts in their field are revered for their substantive knowledge, respected quality of their work and demonstrated skills. By their own executive control of the myriad of dimensions shaping their creation, using, adapting or breaking those dimensions for particular effects, experts reflect the spirit of their time, or even challenge traditional boundaries to the discipline with originality and creativity. Connoisseurs, or those who claim expertise in appreciation of all those fine qualities that distinguish the work, stand as the vanguard of evaluative action. Those individuals who aspire to emulate the expert, usually need to be inducted into the guild or insider knowledge (Sadler, 1989) so they might understand and act with assurance within that guild.

Eisner (1985) and Sadler (1985, 1989, 1998) linked connoisseurship to education, positioning teachers as the custodians of substantive subject discipline knowledge and connoisseurs of knowledge of criteria[1] of quality in performance or production. Sadler also posited that the role of the teacher extended to procedural knowledge for inducting student novices into knowledge of (1) assessment criteria (expected features of quality) by which to judge performance and (2) the rules for applying them. Sadler's interest in assessment and learning led to the key insight that explicit provision of defined criteria played a key role in informing students about expectations of quality and the features of performance against which their work would be assessed. The assumption here is that the teacher has the insider knowledge of what counts as quality. The role of the teacher is to download evaluative experience to the student by making explicit knowledge of relevant criteria and their uses for informing improvement. By construing evaluation "as an agent in learning" (1989, p. 138), Sadler extended teacher expertise to include the ability and willingness not just to induct learners into guild knowledge, but also to facilitate their empowerment, positioning them as would-be experts. But do these constructs still hold true for digital learning?

In their social communities, adolescents typically are already insiders, fully aware of their own norms and values, frequently proficient with new technologies and ready to make judgments of quality. Sadler (1989) noted that "children (certainly in their hours out of school) continually engage in evaluative activity and, if asked, can often produce rudimentary but reasonably sound rationales for

their judgments" (p. 141). While Sadler was not referring to digital activities, evidence of self-inquiry and self-assessment in digital worlds has begun to emerge. For example, young people already have tacit knowledge about what makes them cohere as a group and what constitutes a high quality digital creation (Walsh, 2007). They can already identify their own high performers in digital worlds as in online games (Gee, 2003), set their own goals and seek out more knowledgeable others to help improve their own performance, as in web design (Stern, 2008). In all these ways, the types of shared digital experiences constitute a youth guild where young people are the insiders, if not already the experts and as such, they induct others into their digital practices.

In regard to such digital practices, there has been relatively little research or development of opportunities to explore how traditional authority structures in teacher-student interactions, especially in assessment, might be impacted in the changed relations where the student is recognised as the expert or connoisseur. Some early work exploring the complementarity of out-of-school technology practices and curricular learning has emerged. For example, Walsh (2007) reported how the adolescents worked collaboratively, forming expert teams, with the teacher as novice. Walsh observed that

> teachers can significantly alter their classroom habitus, not in deterministic ways, by allowing students to engage in multimodal design. This in turn offers the possibility of generating a wider repertoire of possible creative design practices and actions, perhaps unavailable in the habitus of progressive workshop classroom (p. 34).

In this study, the young people's involvement extended to entering and winning a *Thinkquest* competition, illustrating their agency not just in the act of creation, but also in initiating their entry, reflecting their confidence in its content, digital proficiency and self-ascertained evidence of quality.

From this discussion, it is possible to visualise a gradation between teacher and youth guild knowledges whereby legitimated instances of young people's out-of-school community learnings could be given high status. Such learnings characteristically draw from knowledges that students have in their communities, both physical and online. The deliberate combining of teacher and youth knowledges could induct teachers into more expert appraisal of digital literacy practices, and learners into more expert appraisal of performance criteria. In these ways the roles and identities of both teacher and learners could be extended, made more robust and less reliant on the pre-existing notion of teacher expertise as all-knowing authority. This revised view of expertise is therefore organic, dynamic and more inclusive of the novice in the field when that field is populated with rapidly changing new technologies.

To this point, our discussion of the desired complementarity of school and community learning introduced the notion that teacher, learner and community expertise might be productively shared. In recognising that "knowledge is inextricably *situated* in the physical and social context of its acquisition and use" (Brown, 2002, p. 65, emphasis in the original), we take up the notion of *curricular* and *community knowledges* as central to student learning in digital contexts. The latter can no longer be ignored or have its significance reduced in the core business of a school in building capacity for students to work in a range of ways to both use and produce knowledge. Additionally, two other forms of knowledge are vital: *curriculum literacies* and *criterial knowledge*. As discussed below, both relate to how students come to understand content and processes. Both require the teacher's explicit articulation of tacit (unstated) features and perceptions of quality.

Australian research on the literacy demands of curriculum in senior schooling has teased out the subtle but important distinction between "curricular knowledges" and "curriculum literacies" in the examination of the literacy-curriculum interface (Cumming & Wyatt-Smith, 2001; Wyatt-Smith & Cumming, 2003). The noun "curriculum" foregrounds the interface between a specific subject curriculum (for example, agricultural studies, design and technology, mathematics) and its subject-specific literacies. The Australian researchers made clear that literacies in the curriculum, or *curriculum literacies*, are those literate capabilities needed to learn in the curriculum. These include the knowledges and capabilities necessary to access and use meaning systems in using and producing knowledge. They made the case that literacy, defined to include reading, writing, listening, speaking, viewing and critical thinking, is a major determinant of success in education. Further, they argued the need for exploring the coherence of literacy demands that students encounter in managing their learning in different contexts and for incorporating these demands explicitly in instruction and assessment. Their conceptualization of curriculum literacies, expanded to include curricular knowledge and epistemological domains, provides an opening for considering multimodal communication online and the mix of modes and channels of communication that are routinely involved in digital technologies. Further, they argue that the concern with making curriculum literacies explicit extends to assessment. As Wyatt-Smith and Cumming (2003) explain that

> our recurrent theme is that to be successful, students need to be able to identify and engage with these curriculum literacies within each subject, not just for learning, but also for successful negotiation of assessment within each subject…Overall student academic success in meeting expected appropriate demonstrations of performance will depend very much on how well the student can manage to understand, participate in and respond to the created intersection of the curriculum-literate environment (pp. 49–50).

The study highlighted the need to make the features of quality performance, framed by curriculum literacies, more explicit. Further, they pointed to the need for teachers "to assist students to understand those expectations so that they can use such knowledge to self-assess and monitor learning over time" (p. 54). The researchers concluded that the literacy environment of school curriculum places highly complex demands on students and reiterated that

> some students succeed in negotiating these, apparently drawing on resources other than those that teachers provide. Others may spend their compulsory years [of schooling] in an environment that is essentially conducted in a foreign language in which they never gain sufficient proficiency. And students need to be fluent, to negotiate the even more demanding literacy-bound assessment requirements successfully.

> ...the role and nature of the curriculum-literacies that are in-built in assessment activities, and which impact upon the students' performances, should be more explicit...Assumptions of student's curriculum literacies is not sufficient. These need to be incorporated in direct instruction (Wyatt-Smith & Cumming, 2003, p. 58).

This conceptualization of curriculum literacies and its contribution to academic success through to assessment points to how students benefit from clearly defined expectations of quality including *criterial knowledge*.

Explicit articulation of *criterial knowledge* has gained increasing recognition as being critically important for learners' academic success. Sadler's (1989) seminal work advocating the deliberate unpacking of criteria and standards for a learner's more clear understanding of the various elements that constitute quality in a piece of work has become an important thread in the assessment for learning literature (Black & Wiliam, 1989; Gibbs & Simpson, 2004; Wyatt-Smith & Cumming, 2003). According to Sadler, when learners are able to identify the specific dimensions of criteria and engage with evidence (or lack thereof) in their own and others' work, criteria play a role in self-monitoring and improvement. As previously discussed, *criterial knowledge* needs to be a collaborative, negotiated process where expertise is shared between teachers and students.

We recognise that designing and sharing assessment criteria can be problematic when teachers regard assessment as being exclusively their responsibility and, in particular, where assessment is tied to a traditional notion of teacher as sole authority in the classroom. With deliberate focus, however, the acquisition of *criterial knowledge* promises to generate greater discrimination in learning—or discerning learning. This is particularly relevant where such knowledge is further illustrated in carefully chosen exemplars with annotations showing evidence of how the criteria requirements are met. From this background, we contend that *criterial knowledge* offers a rich dimension for improving the quality of student learning. Yet few examples of criteria designed to complement multimodal texts are in the literature.

One large Australian study has developed key criteria as indicators of quality in students' digital creations (Wyatt-Smith & Kimber, 2005). E-proficiency, cohesion, content and design were devised as a way of talking about and determining the quality in students' multimodal text creations. "Transmodal operation" was posed to capture the synergistic dynamic of border-crossing between visual, verbal and kinaesthetic modes, and different software applications. It sought to articulate the essence of learners moving within and across different modes as they negotiated meaning and constructed some digital representation of their knowledge. Further development and teacher-student negotiation of these criteria could help inform learner agency, as whenever criteria are openly accessible, students and teachers alike are able to scrutinize and interrogate features of quality in ways that offer great potential for value-adding to the learning experience.

Criterial knowledge is foundational to learner success and integral to informed decision-making in the construction of digital knowledge products. To be able to apply criteria (Sadler, 1985) effectively to one's own production, one needs to be able to develop expertise over time and with regular practice. These understandings are supported by writing on formative assessment with a focus on the provision of timely, pertinent feedback (Black & Wiliam, 1998; Gibbs & Simpson, 2004). Feedback can help to stimulate deeper understanding of assessment criteria as indicators of desired features of performance. In our framing, formative assessment with a focus on student agency in using criteria offers ways to engage students in self-monitoring and improvement strategies.

Thus we propose that *community, curricular* and *criterial knowledges,* and *curriculum literacies* (see Figure 8.1) are jointly foundational to a learner's ability to construct quality performances and products, such knowledge being portable across in- and out-of-school. While these four components are shown as discrete, they are understood to be dynamically interrelated, one with the other.

Currently schools have responsibilities in relation to the presentation of *curricular knowledges,* whatever disciplines are selected in their curriculum offerings. The research discussed above, however, opens the possibility for considering how student learning can be enhanced when explicit provision is made for the teacher and student to engage with the other three elements. Differently, where these

Figure 8.1. Foundational knowledges

knowledges remain implicit in pedagogy and assessment, they can present powerful barriers to student academic success (Wyatt-Smith & Cumming, 2003). In the proposed learning ecology, the challenge for teachers and students alike is to make the knowledges explicit, raising them to consciousness for deeper learning. In what follows we build on the notion of foundational knowledges to discuss what we have previously referred to as *Essential Digital Learnings* (EDLs).

PART TWO: ESSENTIAL DIGITAL LEARNINGS

Taking account of the many claims in published research that young people are "growing up digital" (Tapscott, 1998), there is an urgent need to shift the goal for learners from acquiring facts and content knowledge to becoming more digitally proficient, critical evaluators, creative producers and ethical users of new technologies. With this shift, the focus for learning becomes not so much what subject content is selected, but how to develop the learner's cognitive, metacognitive, performative and transformative capabilities. Traditionally valued literacy skills of reading, writing, communication, comprehension and problem-solving remain important, but other essential learnings are called for. As indicated above, we have named these as *Essential Digital Learnings* (EDLs) which include *e-proficiency*, *e-credibility* and *e-designing*, extending to *metalearning* (see Figure 8.2). These are especially relevant for using and creating knowledge in digital environments.

e-proficiency

Our initial use of the term *"e-proficiency"* reflects the learner's capabilities and repertoires of practice to utilise a variety of digital media in communicating with others. On an operational level, these include basic navigation across the Internet and a variety of software programs as in technological competence. E-proficiency extends well beyond this, however, to being able to choose and use appropriate software applications for particular tasks, competently deploying its associated logics and grammars. Findings from a 2003 to 2007 Griffith University study (Castleton & Wyatt-Smith, 2005; Wyatt-Smith & Elkins, 2008; Wyatt-Smith & Kimber, 2005) indicate that demonstrated levels of student e-proficiency are not as high as would be expected from techno-savvy young people. With e-proficiency as a goal, opportunities are presented for improving learners' facility with software protocols and fine functions. Here e-proficiency involves the notion of "transmodal operation" (Wyatt-Smith & Kimber, 2005) discussed earlier. All these skills enable production as distinct from consumption of digital products and are foundational to any creative design possibilities using digital media.

E-proficiency extends to the selection and informed use of search engines. Being net-savvy begins with the ability to search and locate relevant information. Far too frequently young people launch into their search for information via one search engine only and using basic search terms. Harris (2008) advocated explicit teaching about the resources of the invisible Web, arguing that "[d]igital natives are not necessarily skilled or critical consumers of digital information. Many are still novices when it comes to searching, selecting and assessing the meaning and value of the information they find" (p. 155). A more systematic teaching focus on better search strategies and more critical selection of sources is warranted. Armed with the knowledge of multiple search engines and strategies for mounting discriminating searches, young people can improve their e-proficiency and the quality of their learning process and outcomes. Tandem to a proficient use of search engines is an invaluable cognitive capacity with personal, social and ideological ramifications: *e-credibility*.

e-credibility

Early concern for the way that the Internet raised credibility issues (Brown, 2000; Bruce, 2000; Burbules, 1997a, 1997b, 2001) has shifted to explorations of the parameters, logistics and essentials of credibility evaluation in digital contexts. For some authors, credibility issues have been identified as perhaps the greatest challenge facing a networked society (see Metzger and Flanagin, 2008). People's capacity to evaluate the credibility (or believability) of a source or person has always been integral to human relationships, so it is not surprising to contemplate how the complexity of the Internet has compounded the difficulty of being able to discern indicators of trustworthiness. Digital media developments have magnified the need for more frequent and more astute use of credibility evaluative skills. For these reasons, we prefer to use the term *e-credibility*, drawing on Haas and Wearden's (2003) point that e-credibility entails deliberately and critically discerning "the qualities of trustworthiness, accuracy, completeness and timeliness that entail a sense of 'believability'" (p. 170). We believe that this term foregrounds the potentially powerful impact of digital environments on young people's abilities to make credibility judgments as they negotiate their online worlds.

Trustworthiness and expertise, the two key dimensions of credibility identified by Flanagin and Metzger (2008), both rely on the receiver's ability to decode, discern or accept the reliability of the source in question. Harris (2008) argued that some young people's level of cognitive development, naiveté, lack of real world experience and tendency to "satisfice" (p. 162), or settle for "good enough" rather than optimise their decisions, sets them at a disadvantage when working with information on the Web. The reading and interpretation of informational cues in digital texts

require the reader to locate, organise, consider logically and apply abstract reasoning, all of which are directly linked to developmental changes in cognition (Eastin, 2008). Given the amount of erroneous, misleading and potentially harmful information that sits in the same virtual space as rich, accurate, powerful multimedia texts, young people need to learn to discriminate in more powerful ways. Educators can and must assist young people to develop their capacities and meta-strategies for interrogating texts, seeking corroboration and arriving at informed decisions. Drotner (2008) has argued that young people cannot develop the kinds of evaluation and reflection needed in online environments without explicit instruction.

Some suggestions for helping young people develop their evaluative strategies include "hyperreading", particularly of hyperlinks, to develop a more critical facility for identifying and distinguishing between "misinformation, malinformation, messed-up and mostly useless information" (Burbules, 1997a, 1997b). Harris (2008) recommended going beyond checklists "because evaluation of information is subjective, relative and situational rather than objective, absolute, and universally recognizable" (p. 166). Sundar (2008) offered the MAIN (Modality, Agency, Interactivity and Navigability) model of heuristics to assist students to achieve greater evaluative discrimination of credibility when working with digital texts. When one considers the extent of young people's immersion in their digital lives and how their mobility often means that their point of contact with a range of technological tools and interaction opportunities becomes routinised, then their ability to apply appropriate heuristics for validating, corroborating, using and constructing knowledge in ethical ways becomes even more important.

To achieve valid, discerning, credibility judgments, young people should be able to deploy effective meta-strategies suitable for learning in a digital environment. Consistent and appropriate use could help young people to add their own critical lens to offset reportedly current corroborative practice—almost instantaneous seeking of clarification and support from social networks and recommended sites (Harris, 2008). Flanagin and Metzger (2008) cast this kind of networked corroboration as the new "coin of credibility" which should be challenged by building young people's personal evaluative skills to such a degree that they become "architects of credibility" (p. 18).

This notion of e-credibility is integral to the quality of young people's academic performance and social interactions. Its effectiveness can be identified in the products that they create through *e-designing*.

e-designing

The term, "e-designing," invokes learner agency as the digital learner makes connections between ideas or information for transformation into a digital

representation of understanding. To some extent it offers insight into the way the mind has processed what might be a kaleidoscope of ideas. E-designing captures the active, dynamic act of traversal across mental and virtual spaces in sourcing, navigating, connecting and engaging with ideas or information, and perhaps interacting with others to create new digital artefacts. It encapsulates a blend of creativity, evaluation, e-credibility and e-proficiency. It can reflect the degree of ethical concern or cultural affiliations of the designer. Further, the act of creation could be achieved individually or in collaboration, and entails imagination, multimodal display, reflection and evaluation. When these different perspectives are taken into account, the role of e-designing in value-adding to a digital learning experience can be appreciated. Its desirability as valued learning becomes an imperative when one considers latest research findings that suggest that young people's everyday uses of new technologies are

> characterized not by spectacular forms of innovation and creativity, but by relatively mundane forms of information retrieval…The technologically empowered "cyberkids" of the popular imagination may indeed exist; but even if they do, they are in a minority and they are untypical of young people as a whole (Buckingham, 2007, p. 92).

One explanation for this so-called lack of creativity could be that familiarity with the digital medium has brought complacency or an utilitarian attitude. Elsewhere Buckingham comments that most young people are more concerned with the uses they can make of technology, a view endorsed by Stald (2008) in her research with Danish youths and mobile phones. Yet various empirical studies have confirmed the academic progress and improved performances of students who act as designers of multimodal texts (Chen & McGrath, 2003; Kimber, Pillay, & Richards, 2001; Lehrer, Erickson, & Connell, 1994) including computer games (Beavis, 2002; Prensky, 2007; Watson & Johnson, 2004) and electronic concept maps (Anderson-Inman & Ditson, 1999; Kimber, Pillay, & Richards, 2007). Such studies show growing support for the notion that digital transformations and designing can enhance the process of personal agency in student learning.

Beyond these studies, recent educational and political thinking has concerned ways to foster and sustain the innovative capacities of future workforces in times of technological change. Of particular note is policy focus in the United Kingdom directed towards enhancing the creativity, imagination and futures-oriented thinking of young people. Recommendations from the *All Our Futures: Creativity, Culture and Education* report (Robinson et al., 1999) included a strong focus on the creative arts, but the notion of creativity was cast as fundamental to advancing diverse subject disciplines and the nurturing of innovative, imaginative, future citizens. The report identified four features of creative processes (imaginative thinking, purposeful activity, original creation, value of outcome), similar to The New London

Group's (2000) notions of Designing and the Redesigned. Furthermore, the report encouraged young people's experiencing creative, as distinct from technicist, uses of new technologies. If this latter goal were to be achieved on a much wider basis, Buckingham's (2007) point about mundane, utilitarian uses of technology would be countered by creative, critical, aesthetic and ethical usage, as discussed in the following section. Before this, however, there is at least one critical caveat synonymous with e-designing and the reproduction of web materials.

Several writers have identified the ease with which plagiarism, whether of word, image or music, can occur online in new formulations or "remixing of content" (Keen 2007, p. 24). On this matter, the field is divided. Writers including Gibson (2005) argue that "our culture no longer bothers to use words like *appropriation* or *borrowing*," promoting the idea that "The remix is the very nature of the digital" (p. 1). This idea is mirrored by Keen (2007) who characterised the latest Web 2.0 "remixing" of content and "mashing-up of software and music" as easily accomplished (p. 24), observing that

> cutting and pasting, of course, is child's play on the Web 2.0, enabling a younger generation of intellectual kleptomaniacs, who think their ability to cut or paste a well-phrased thought or opinion makes it their own (p. 25).

Countering this view is Jenkins' (2006) description of "appropriation" as "the ability to meaningfully sample and remix media content…wherein young people build on others' cultural productions through dissecting and rebuilding it in another form" (p. 32). Integral to his notion of digital e-designing is the capacity for "transmedia navigation" (p. 46) which includes not just the ability to read and think across different media, but also the facility to exploit the opportunities and affordances of those different media. But concomitantly, transmedia navigation brings the potential for plagiarism, whether intentional or unintentional. When the fluidity of production entails ease of cut and paste, remixes and mash-ups, all supposedly creating a new genre or a new digital text, then budding e-designers might be easily tempted to take the easy path towards re/production, exemplifying Keen's "intellectual kleptomaniacs" (2007, p. 25). In this situation, it is essential that young people develop a strong measure of ethical responsibility as e-designers to ensure that plagiarism is recognised as misrepresentation. In these ways, e-designing can embody ethical and discerning learning.

To this point we have suggested that *e-proficiency*, *e-credibility* and *e-designing* are significant learnings for today's young people. They interlace the critical, creative, aesthetic and ethical dimensions of learning to develop a new "knowingness" for the digital learner. A feature of such knowingness is its portability across contexts and applications for different purposes. The effectiveness of that portability

lies partly with the learner's ability to internalise and activate those EDLs in new contexts. Thus the ultimate goal for these learning processes is *metalearning,* as discussed next.

Metalearning

The term *"metalearning"* is taken to represent informed application of intentional, metacognitive principles to the learning process. It includes the ability to select from a raft of repertoires and capabilities the most appropriate method and strategy to achieve the desired goal or outcome. It also includes the ability to reflect on learning as it is occurring, especially in terms of the quality of learning and barriers impacting on progress. It encapsulates higher order thinking processes such as evaluative and creative thinking, analysis and synthesis, accomplished abstract reasoning, the ability to create an aesthetic performance and a commitment to ethical consciousness in all spheres of operation, both physical and virtual. As such it intersects with and carries forward the capabilities identified in the EDLs. Above all, *metalearning* connotes the accomplished traversal of complex virtual and real-world spaces to use and construct knowledge, most frequently with digital tools. It also connotes capacities relating to moving between print-based and digital environments, being aware of how the two can be drawn on to generate informed critical insights into the nature of knowledge and how it is represented. As such, *metalearning* is the acme of independent, active, social and strategic learning, and essential for lifelong learning in a complex, rapidly changing world.

In summary, the three EDLs operate in a dynamic, interrelated manner to enable the digital learner. All involve higher order thinking and all are underpinned by the core tenets of *ethical responsibility* and *cultural sensitivity.* Separately and cumulatively they make a significant contribution to the young person's capacity for learning and earning in a digital world. Separately and cumulatively they promise to enhance the critical, creative, aesthetic and ethical dimensions of becoming a contributing twenty-first century citizen who is sensitive to cultural differences. Separately and cumulatively, they support the notion that learning is a process, not just an assessable final product, developed and negotiated through social interactions. This last point in particular impacts on the choice of teaching and assessment to leverage these essential learning traits or goals.

FRAMING THE FOUNDATIONAL KNOWLEDGES AND EDLs

The knowledges and capabilities discussed to this point have been envisaged to match the changing media landscape of the digital world and to equip young

people for effective citizenship and participation. Figure 8.2 graphically combines the foundational knowledges previously presented in Figure 8.1 with the EDLs and related capabilities discussed above. *Metalearning* is intentionally positioned at the apex of the triangle to highlight it as the synthesising goal towards which all teaching and learning should aspire and be directed. Together, all elements are represented as discrete though they are understood to be complementary and inter-related. Together they constitute our framing for how teaching and assessment choices might help to support learning in digital environments.

The upper section and dotted boundaries to all shapes are of significance. The dotted lines partially bound the school-based learning terrains to suggest their potential for fluidity and interconnection. They represent the boundless limits of the Web and possibilities for interactions that can impact on learning and global citizenship. Also of note are the wave-shaped text boxes to represent dynamic, fluid movement and their potential for extending beyond their own space. Immediately above these text boxes, and similarly wave-like, are the ethical, critical, creative and aesthetic dimensions of learning that should underpin the framing of activities and responses. "Ethical responsibility" and "cultural sensitivity" appear as oblique

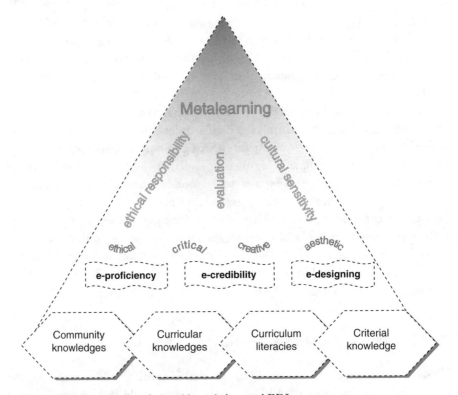

Figure 8.2. Framing foundational knowledges and EDLs

and dynamic waves, bounding the suite as all-embracing social issues that impact on personal identity formation and the scope of social interactions. "Evaluation," the central vertical text, is a core higher-order thinking skill and central to all of the learnings in the suite. Together, these three lines of text represent how they should permeate all learning experiences, especially with digital literacies. Further the design of the figure places evaluation, ethical responsibility and cultural sensitivity as vehicles to draw up and carry forward the learnings into acts of synthesis with the greatest potential for informing problem-solving and realising productive social agency.

The empirical and epistemological literature informing the composition and design of the suite of EDLs (see Figure 8.2) has been drawn from literacy research, digital literacies and Sadler's (1989) theorising of formative assessment. Through these different lenses, emerging and proven ideas about learning in a digital landscape are drawn together, offering scope for considering the potential of the suite for teaching, learning and assessment in the twenty-first century. Specifically we suggest that the shaping of young people as knowledgeable, productive and socially responsible citizens in a global, digital environment rests on three core tenets that could well assist in moving this suite forward into enacted practice.

Firstly, the complementarity between young people's in- and out-of-school learning communities should be recognised as pre-requisite in developing their knowledge bases and performance capabilities. Through valuing and accepting the extent of their learning initiatives in school-based credentialing, impetus is given to the sustainability and portability of learning skills across a lifetime. Similarly, the alignment of *curriculum literacies* and *criterial knowledge* offers teachers direct focus for making explicit those core elements of discipline knowledge or markers of quality that might otherwise remain within the province of teacher guild knowledge. In these ways, positive steps forward in invigorating teaching and assessable opportunities within classroom practice can be made.

Secondly, school curriculum should not only capitalise on young people's digital capabilities but also seek to extend and develop their digital practices in ways that prioritise evaluation, ethical responsibility and cultural sensitivity. This means that due consideration will be given to how young people can be encouraged to evaluate sources and credentials with greater discrimination, and to evaluate the potential implications of their selections, use and transformations of cultural knowledge. To this end, knowledge use and construction should be prioritised over knowledge consumption. Inherent in evaluation is its focus on critical reflection and creativity as indicators of the level of thinking involved in developing the representation of understanding. In all these ways, young people's actions will be guided towards sustainable, portable, futures-oriented, ethical and culturally sensitive practices.

Thirdly, the goal of *metalearning* offers positive direction for teaching and learning. Classroom practices should be directed towards developing young people's metalearning capabilities through a range of activities designed to engage them metacognitively in their enactment of those essential digital learnings outlined earlier. Furthermore, the nature of assessment and assessable opportunities should be widened in scope to involve young people in evaluative consideration of their own and others' processes of working online. In these varied ways, student agency and expertise in applying assessment criteria can be realised.

Our conception of assessment for digital learning is grounded in daily, school-based and technology-mediated practices where assessment is understood as tied to learning and learning improvement. It is different from e-assessment where a multitude of innovative, technological ways of delivering personalised, diagnostic testing, engaging simulations, large scale assessment delivery and instantaneous feedback can enrich classroom experiences. Rather, our view of assessment for digital learning is responsive to learner agency in operation in online communities. It recognises both the processes and products of learning acquired virtually, informally, as well as in the classroom. It could be best activated through adopting an integrated approach that links teaching, learning and assessment via critical inquiry. In all these ways, assessment for digital learning supports and extends learners in their interactions with knowledgeable others, engaging them with feedback and deeper involvement with assessment criteria to enhance learning.

CONCLUSION

Our discussion in this chapter has aimed to claim spaces for new ways of thinking about learning and assessment opportunities in digital environments. What is new in this work is the broad conceptualisation of opportunities designed to take account of the requisite foundational knowledges and Essential Digital Learnings. Our approach has been to explore some connections in diverse fields of research writing as discussed earlier and probe their potential to inform discussions of what counts as valued learning and assessment in the twenty-first century.

The framing of foundational knowledges and Essential Digital Learnings offered in the chapter is taken as provisional, a construct on our part. Clearly it lends itself to interrogation from both theoretical and empirical perspectives. Accordingly we invite readers to consider the possible relevance of the framing to their teaching and assessment contexts. Finally, the approach that we have taken prompts much needed conversations about education futures for young people. At the heart of this matter, we believe, is the recognition that learning is intrinsically social, cultural, value-laden and historic in nature. As such, it

necessarily changes in relation to shifting developments in society, locally and globally. Due to the rapidity of change in new and emerging technologies, there is now potential for rapid change in social and communication practices and processes. The challenge for learning and assessment in schooling is to rethink the nature of knowledge and the demands of learning using technologies. In this way, schools will be able to reassert their relevance and salience for young people in a digital world.

NOTE

1. Drawing on the work of Sadler (1985), this term is taken to refer to those properties, dimensions or characteristics by which student performance is appraised.

REFERENCES

Anderson-Inman, L., & Ditson, L. (1999). Computer-based concept mapping, a tool for negotiating meaning. *Learning and Leading with Technology, 26*(8), 6–13.

Beavis, C. (2002, December 1–5). *RTS and RPGs: New literacies and multiplayer computer games.* Paper presented at the Australian Association for Research in Education Conference, Brisbane.

Beavis, C., Nixon, H., & Atkinson, S. (2005). LAN cafes: Cafes, places of gathering or sites of informal teaching and learning? *Education, Communication & Information, 5*(1), 41–60.

Black, P., & Wiliam, D. (1998). *Inside the black box: Raising standards through classroom assessment.* Kings College London, School of Education. Retrieved on January 12, 2008 from http://academic.sun.ac.za/mathed/174/FormAssess.pdf

Boyd, D. (2008). Why youth ♥ social network sites: The role of networked publics in teenage social life. In D. Buckingham (Ed.), *Youth, identity, and digital media* (pp. 119–142). The John D. and Catherine T. MacArthur Foundation Series on Digital Media and Learning. Cambridge, MA: MIT Press. Retrieved on January 16, 2008 from http://www.mitpressjournals.org/doi/pdfplus/10.1162/dmal.9780262524834.119

British Educational Communications and Technology Agency. (2001). *ImpaCT2—Emerging Findings from the Evaluation of the Impact of Information and Communications Technologies on Pupil Attainment.* Coventry, UK: BECTA. Retrieved on March 30, 2008 from www. becta.org.uk/research/reports/impact2

Brown, J.S. (2000, October 2). look_closely_right_now. The Internet bestows authority on everyone which is exactly the problem (pp. 26–28). *Forbes ASAP.*

Brown, J.S. (2002). *Learning in the digital age.* Paper developed by Maureen Devlin used in Brown's talk at the Aspen Forum (pp. 65–86). Retrieved on March 12, 2008 from http://www.johnseelybrown.com/learning_in_digital_age-aspen.pdf

Brown, J.S. (2006). *New learning environments in the 21st century: Exploring the edge*. Retrieved on March 12, 2008 from http://www.educause.edu/ir/library/pdf/ff0604S.pdf

Bruce, B.C. (2000). Credibility of the Web: Why we need dialectical reading. *Journal of Philosophy of Education, 34*(1), 97–109.

Buckingham, D. (2007). *Beyond technology: Children's learning in the age of digital culture.* Cambridge, UK: Polity Press.

Buckingham, D., Sefton-Green, J., & Willett, R. (2003). *Final report. Shared spaces: Informal learning and digital cultures*. Retrieved on March 12, 2008 from http://www.wac.co.uk/sharedspaces/final_report.pdf

Burbules, N. (1997a). Rhetorics of the Web: Hyperreading and critical literacy. In Snyder (Ed.), *Page to screen: Taking literacy into the electronic era* (pp. 102–122). St Leonards, Australia: Allen & Unwin.

Burbules, N. (1997b). Misinformation, malinformation, messed-up information, and mostly useless information: How to avoid getting tangled up in the 'Net'. In C. Lankshear, C. Bigum, C. Durrant, B. Green, E. Honan, W. Morgan, J. Murray, I. Snyder, & M. Wild (Eds.), *Issues and innovations (Vol. 3). Digital rhetorics: Literacies and technologies in education—current practices and future directions* (pp. 109–120). Brisbane, Australia: QUT Press.

Burbules, N. (2001). Paradoxes of the Web: The ethical dimensions of credibility. *Library Trends, 49*, 441–453.

Castleton, G., & Wyatt-Smith, C. (2005). Investigating digital curricular literacies: Resolving dilemmas of researching multimodal technologically mediated literacy practices. In B. Moloch, J. Hoffman, D. Schallert, C. Fairbanks, & J. Worthy (Eds.), *54th Yearbook of the National Reading Conference* (pp. 144–156). Wisconsin: National Reading Conference.

Chen, P., & McGrath, D. (2003). Knowledge construction and knowledge representation in high school students' design of hypermedia documents. *Journal of Educational Multimedia and Hypermedia, 12*(1), 33–61.

Cumming, J., & Wyatt-Smith, C. (2001). *Literacy and curriculum: Success in senior schooling.* Melbourne: ACER.

Drotner, K. (2008). Leisure is hard work: Digital practices and future competencies. In D. Buckingham (Ed.), *Youth, identity, and digital media* (pp. 167–184). The John D. and Catherine T. MacArthur Foundation Series on Digital Media and Learning, Cambridge, MA: MIT Press. Retrieved on January 16, 2008 from http://www.mitpressjournals.org/doi/pdfplus/10.1162/dmal.9780262524834.167

Eastin, M. (2008). Toward a cognitive developmental approach to youth perceptions of credibility. In M. Metzger & A. Flanagin (Eds.), *Digital media, youth, and credibility* (pp. 29–47). The John D. and Catherine T. MacArthur Foundation Series on Digital Media and Learning, Cambridge, MA: MIT Press. Retrieved on January 16, 2008 from http://www.mitpressjournals.org/doi/pdf/10.1162/dmal.9780262562324.029

Eisner, E. (1985). *The art of educational evaluation: A personal view*. London: Falmer Press.

Flanagin, A., & Metzger, M. (2008). Digital media and youth: Unparalleled opportunity and unprecedented responsibility. In M. Metzger & A. Flanagin (Eds.), *Digital media, youth and credibility* (pp. 5–27). The John D. and Catherine T. MacArthur Foundation Series

on Digital Media and Learning, Cambridge, MA: MIT Press. Retrieved on January 18, 2008 from http://www.mitpressjournals.org/doi/pdf/10.1162/dmal.9780262562324.005

Gee, J.P. (2003). *What video games can teach us about learning and literacy.* New York: Palgrave Macmillan.

Gee, J.P. (2004). *Situated language and learning: A critique of traditional schooling.* New York: Routledge.

Gibbs, G., & Simpson, C. (2004). Conditions under which assessment supports students' learning. *Learning and Teaching in Higher Education, 1,* 3–31.

Gibson, W. (2005). God's little toys. Confessions of a cut-and-paste artist. *Wired,* 13 July. Retrieved on July 23, 2008 from http://www.wired.com/wired/archive/13.07/gibson.html

Haas, C., & Wearden, S. (2003). E-Credibility: Building common ground in Web environments. *L1—Educational Studies in Language and Literature, 3,* 169–184.

Harris, F. (2008). Challenges to teaching credibility assessment in contemporary schooling. In M. Metzger & A. Flanagin (Eds.), *Digital media, youth, and credibility* (pp. 115–179). The John D. and Catherine T. MacArthur Foundation Series. Retrieved on February 20, 2008 from http://www.mitpressjournals.org/doi/pdf/10.1162/dmal.9780262562324.155

Jenkins, H. (2006). Confronting the challenges of participatory culture: Media education for the 21st century. An occasional paper on digital media and learning. Retrieved on January 10, 2008 from http://www.digitallearning.macfound.org/atf/cf/%7B7E45C7E0-A3E0-4B89-AC9C-E807E1B0AE4E%7D/JENKINS_WHITE_PAPER.PDF

Keen, A. (2007). *The cult of the amateur: How today's Internet is killing our culture.* London: Nicholas Brealey.

Kimber, K., Pillay, H., & Richards, C. (2001). Learning through ICT: An analysis of the quality of knowledge developed through computer-mediated learning tools. In P. Singh & E. McWilliam (Eds.), *Designing educational research: Theories, methods and practices, Faculty of Education Postgraduate Student Conference Proceedings* (pp. 95–114). Flaxton: PostPressed.

Kimber, K., Pillay, H., & Richards, C. (2007). Technoliteracy and learning: An analysis of the quality of knowledge in electronic representations of understanding. *Computers and Education,* 48(1), 59–79.

Lehrer, R., Erickson, J., & Connell, T. (1994). Learning by designing hypermedia documents. *Computers in the Schools, 10,* 227–254.

Lenhart, A., Madden, M., Rankin Macgill, A., & Smith, A. (2007). *Teens and social media.* Pew Internet and American Life Project: Washington, DC. Retrieved on January 16, 2008 from http://www.pewinternet.org/pdfs/PIP_Teens_Social_Media_Final.pdf

Macdonald, D. (2003). Curriculum change and the post-modern world: Is the school curriculum-reform movement an anachronism? *Journal of Curriculum Studies, 35* (2), 139–149.

Meredyth, D., Russell, N., Blackwood, L., Thomas, J. & Wise, P. (1999). *Real time: Computers, change and schooling.* National sample study of the information technology skills of Australian students. Brisbane, Australia: J S Macmillan Printing Group. Retrieved on January 16, 2008 from http://www.dest.gov.au/archive/schools/publications/1999/realtime.pdf

Metzger, M., & Flanagin, A. (Eds.) (2008). *Digital media, youth and credibility*. The John D. and Catherine T. MacArthur Foundation Series on Digital Media and Learning. Cambridge, MA: MIT Press. Retrieved on January 16, 2008 from http://www.mitpressjournals.org/toc/dmal/-/2

Ministerial Council on Education, Employment, Training and Youth Affairs. (2007). National Assessment Program—ICT literacy Years 6 and 10 Report, 2005. ACER. Retrieved on July 4, 2008 from http://www.curriculum.edu.au/verve/_resources/NAP_ICTL_2005_Years_6_and_10_Report.pdf

Prensky, M. (2001). Digital natives, digital immigrants. *On the Horizon, 9*(5). Retrieved on August 10, 2006 from http://www.marcprensky.com/writing/Prensky%20-%20Digital%20Natives,%20Digital%20Immigrants%20-%20Part1.pdf

Prensky, M. (2007). Students as designers and creators of educational computer games. Retrieved on March 2, 2008 from http://www.marcprensky.com/writing/Prensky-Students_as_Game_Creators-.pdf

Roberts, D., Foehr, U., & Rideout, V. (2005). *Generation M: Media in the lives of 8–18 year olds*. A Kaiser Family Foundation Study. Mentor Park, CA: The Henry J. Kaiser Family Foundation. Retrieved on March 10, 2008 from http://www.kff.org/entmedia/7251.cfm

Robinson, K., Minkin, L., Bolton, E., French, D., Fryer, L., Greenfield, S., et al. (1999). *All our futures: Creativity, culture and education*. National Advisory Committee on Creative and Cultural Education Report. Retrieved on February 23, 2008 from http://www.cynpi.org.uk/downloads/alloutfutures.pdf

Sadler, D.R. (1985). The origins and functions of evaluative criteria. *Educational Theory, 35*(3), 285–297.

Sadler, D.R. (1989). Formative assessment and the design of instructional systems. *Instructional Science, 18*, 119–144.

Sadler, D.R. (1998). Formative assessment: Revisiting the territory. *Assessment in Education, 5*(1), 77–84.

Sefton-Green, J. (2003). Informal learning: Substance or style? *Teaching Education, 13*(1). Retrieved on April 15, 2004 from http://www.wac.co.uk/sharedspaces/informal_learning.pdf

Stald, Gitte (2008). Mobile identity: Youth, identity, and mobile communication media. In D. Buckingham (Ed.), *Youth, identity, and digital media* (pp. 143–164). The John D. and Catherine T. MacArthur Foundation Series on Digital Media and Learning, Cambridge, MA: MIT Press. Retrieved on January 10, 2008 from http://www.mitpressjournals.org/doi/pdfplus/10.1162/dmal.9780262524834.143

Stern, S. (2008). Producing sites, exploring identities: Youth online authorship. In D. Buckingham (Ed.), *Youth, identity, and digital media* (pp. 95–117). The John D. and Catherine T. MacArthur Foundation Series on Digital Media and Learning, Cambridge, MA: MIT Press. Retrieved on January 10, 2008 from http://www.mitpressjournals.org/doi/pdfplus/10.1162/dmal.9780262524834.095

Sundar, S.S. (2008). The MAIN model: A heuristic approach to understanding technology effects on credibility. In M. Metzger & A. Flanagin (Eds.), *Digital media, youth, and credibility* (pp. 73–100). The John D. and Catherine T. MacArthur Foundation Series on

Digital Media and Learning, Cambridge, MA: MIT Press, Retrieved on March 18, 2008 from http://www.mitpressjournals.org/doi/pdfplus/10.1162/dmal.9780262562324.073

Tapscott, D. (1998). *Growing up digital: The rise of the Net generation.* New York: McGraw-Hill.

The New London Group (2000). A pedagogy of multiliteracies: Designing social futures. In B. Cope & M. Kalantzis (Eds.), *Multiliteracies: Literacy learning and the design of social futures* (pp. 9–37). London: Routledge.

Valentine, G., Marsh, J., & Pattie, C. (2005). *Children and young people's home use of ICT for educational purposes: The impact on attainment at key stages 1–4.* Annesley, Nottingham, UK: Department for Education and Skills. Retrieved on March 10, 2008 from http://www.dfes.gov.uk/research/data/uploadfiles/RR672.pdf

Wallis, C. (2006, March 19). The multitasking generation. *Time Magazine.* Retrieved on April 10, 2008 from http://www.time.com/time/magazine/article/0,9171,1174696,00.html

Walsh, C. (2007, July 8–11). *Literacy in the new media age: Creativity as multimodal design.* Paper presented at Critical Capital: Teaching and Learning, AATE & ALEA National Conference. Retrieved on January 20, 2008 from http://www.englishliteracyconference.com.au/files/documents/Papers/Refereed%20Papers/Chris%20Walsh.pdf

Watson, G., & Johnson, G.C. (2004). Towards a greater understanding of multiliteracies: A multimodal methodology for capturing and analysing young people's out-of-school computer game-playing. In *Doing the public good: Positioning education research.* Australian Association of Research in Education, Melbourne, Australia. Retrieved on March 12, 2008 from http://www.aare.edu.au/04pap/wat04105.pdf

Wyatt-Smith, C.M., & Cumming, J.J. (2003). Curriculum literacies: Expanding domains of assessment. *Assessment in Education: Principles, Policy and Practice, 10*(1), 47–60.

Wyatt-Smith, C., & Elkins, J. (2008). Multimodal reading and comprehension in online environments. In J. Coiro, M. Knobel, C. Lankshear, & D. Leu (Eds.), *Handbook of research on new literacies* (pp. 899–940). Mahwah, NJ: Lawrence Erlbaum Associates.

Wyatt-Smith, C., & Kimber, K. (2005). Valuing and evaluating student-generated online multimodal texts: Rethinking what counts. *English in Education, 39*(2), 22–43.

Digital Tools: Assessing Digital Communication AND Providing Feedback TO Student Writers

RICHARD BEACH, LINDA CLEMENS, AND KIRSTEN JAMSEN

Students are increasingly engaging in Web 2.0 digital communication (O'Reilly, 2005)—in such forms as instant messaging, blogs, wikis, digital storytelling, and online chat—both outside and inside schools. Web 2.0 digital communication tools engage students in social interaction as both readers and writers of digital texts through not only sharing information but also persuading others to adopt a certain position on a topic or issue.

In this chapter, we argue that in addition to using digital tools to foster writing/ multimodal texts, teachers can also use these digital tools to provide feedback to students' digital communication in ways that improve communication skills. We also argue that, in providing this feedback, teachers need to recognize that evaluating digital communication, for example, an effective blog post, requires a different set of criteria than evaluating a print essay, criteria associated with digital literacies of multimodality, hypertextuality, and interactivity. In contrast to providing feedback to print-text drafts, giving feedback to multimodal, new media texts such as video storytelling requires responding while students are engaged in extensive planning, writing, and production processes. And, to foster students' creativity in these new modes, this feedback also needs to continually support students' risk-taking and innovative uses of digital tools (Mack, 2006; Penrod, 2005; Yancey, 2001, 2004).

Multimodality. The multimodality of digital communication involves weaving together and remixing text, images, sound, and video (Albers & Harste, 2007; Selfe,

2007). Assessing the rhetorical effectiveness of multimodality involves determining how visual and audio materials are developed and combined to engage audiences through visual argument (Blair, 2004). For example, in creating digital storytelling about their Oakland urban neighborhoods, students combine images and audio to portray their lives in urban neighborhoods (Hull & Katz, 2006). Assessing uses of multimodality involves providing feedback not only on effective audio, images, or video production—for example, use of a range of different video shots—but also on the ability to mix these different modes in an aesthetically engaging manner (Moran & Herrington, 2003). Teachers need to develop new criteria for assessing the effectiveness of students' use of multimodality in communicating their ideas.

Hypertextuality. Digital communication also involves uses of hypertextual links, for example, links to other sites, blog posts, images, audio, videos, pdfs, or, in hypertext literature, links to optional narrative paths (Bazerman, 2004). Given the need to foster coherence through arrangements of links, Yancey (2004) proposes criteria focusing on ease of audience navigation of multiple links and whether audiences are engaged by moving through links, for example, in moving through a hypertext story. Assessment of links would, therefore, consider ways they engage their audiences, afford pleasure, are coherent, and foster the desire to pursue other links (Bazerman, 2004).

Interactivity. Another central aspect of digital communication is interactivity with audiences fostered through invitations and links that invite audience participation and engagement. Analysis of 126 highly successful blogs indicated that the most popular blogs employed blog features such as comments, hyperlinks to others' posts, archives, search, syndication, blogrolls, tagging, and images/video designed to foster audience interaction (Du & Wagnera, 2006). These features invite readers to engage in interactive dialogue with the author and other readers by adding comments to posts. These blog contributions may include hypertextual links to other participants and conversations in the blogosphere.

The extent to which these features of Web 2.0 digital communication—multimodality, hypertextuality, and interactivity—are rhetorically effective depends on how quickly and visually digital communication engages audiences and encourages popular dissemination via social networking sites. These "immediate impact" criteria are quite different from more formalist expectations of logical organization and coherence typically taught in school, where assessment procedures and criteria are typically applied to print-based texts. This leads us to our central argument. Not only do we need to employ *different criteria* for evaluating digital communication, but we also need to employ *digital communication tools* that themselves enhance teachers' and peers' uses of multimodality, hypertextuality, and interactivity in providing feedback to students. Producing, reading, *and* assessing digital texts, then, emphasizes the ways that communication itself is inherently social, formative, and evolving.

We focus particularly on digital feedback tools that could be used to assess both digital and more traditional texts, tools grouped into three categories: asynchronous, synchronous/hybrid, and reflective/portfolio-based. In sharing these tools and specific illustrations of how they have been used for assessment by students and teachers at our institution, the University of Minnesota, Twin Cities, our goal is to help teachers become more aware of the choices that they have when teaching new media/digital literacies (for additional resources on these literacies, see the resource site, digitalwriting.pbwiki.com [Beach, Anson, Kastman-Breuch, & Swiss, 2009]).

PROVIDING FORMATIVE FEEDBACK TO STUDENTS' DIGITAL COMMUNICATION

How might digital tools be used most effectively to provide feedback to improve students' text composition? Students are most likely to improve the quality of their print and digital texts when they learn to engage in critical self-assessing and revisions of drafts or work in progress (Beach & Friedrich, 2006). Rather than thinking of revision as a matter of simply revising texts, we perceive revision in broader terms as entertaining alternative perspectives and voices that lead them to rethink their status-quo beliefs and ideas, what Amy Lee (2000) describes a "revisioning" (p. 10) of beliefs and ideas.

Multimodal texts, in particular, encourage such "revisioning" (p. 10) in that they typically engage authors in numerous and complex choices about how best to communicate one's message: what medium would be most effective, how could text and images work together, how could readers be motivated to participate online, etc. And, they often involve a longer composing process than producing print texts—one that may involve learning how to use new digital tools as well as working collaboratively with or garnering feedback from others to create multimodal texts.

Because composing digital texts is a complex and extended process, students can learn much from engaging in self-assessment and receiving feedback from peers and teachers. Teachers can foster student self-assessment and revision by providing "reader-based" descriptions of their engagement in or difficulties with processing a text (Elbow, 1973) and asking students to note what issues they struggle with in their writing and addressing those issues directly. For example, a student producing an editorial blog to encourage her school to adopt a recycling plan may be well versed in the arguments for recycling but struggle with how to incorporate digital images and video into her blog posts to motivate her fellow students to care about their impact on the environment. Through the kinds of digital assessment tools described below, teachers and peers could pose questions of the author and

share how they respond to the blog's images. Effective assessment of digital texts engages students in dialogic conversations about the content and design of their texts (Blair, 2003; Carabajal, LaPointe, & Gunawardena, 2003).

These digital feedback tools also mimic the immediacy and interactivity of face-to-face conferences, making it possible to share and model assessing and revising practices with students across space and time boundaries (Ferris, 2003). Such feedback also includes providing ongoing encouragement, something that is particularly important for students engaged in producing complex multimodal texts (Tseng & Tsai, 2007).

USING ASYNCHRONOUS DIGITAL TOOLS FOR PROVIDING FEEDBACK AND ASSESSMENT

Asynchronous digital feedback tools make it possible for students to submit their work and readers to assess that work when it is convenient for them. These tools are also particularly powerful for capturing and archiving feedback, so students have time to digest and reflect on what their readers have said as they revise. Because of the potential time lag between submission and feedback, however, these tools are by their nature less dialogic than more synchronous forms. They can also result in miscommunication and frustration similar to that experienced by students who struggle to understand teachers' written comments on their print texts.

Online comments in Word, Google Docs, Diigo. Teachers can provide comments, particularly editing comments, to Word documents by simply inserting comments in **bold** or in a different color. Or, they can use the "track changes" function to edit a text to show the original text versus the edited text. Or, they can insert comments as a "sticky note" by highlighting a word or words and then typing a comment on a split screen. These comment devices are themselves multimodal in that they rely on distinguishable visual features to embed comments and suggestions within the digital texts and to catch students' attention.

These embedded comments can be used both as a way for readers to give feedback to writers and for students to write about texts they are reading. For example, on Diigo, a tagging site, students can write notes about the texts they are reading online, post their notes for group members to see, and then peers and instructors can add additional comments and feedback using that same tool (for a screencast demonstration, see Diigo: A Social Bookmarking Research Tool [www.screencast-o-matic.com/watch/cij0ev4l]).

Students writing collaborative papers using the online word processing tool, Google Docs (docs.google.com), can also provide similar comments to each other. With Google Docs, as opposed to Word, students can go back through different

historical versions of a text to note the evolution of their peers' comments and revisions.

Instructors and students can also use annotation tools such as Trailfire (a Firefox extension) to highlight and add annotations to students' Websites or use Evernote to store clippings from their Websites for making comments on those clippings. Students prefer feedback embedded within texts as opposed to feedback at the end of texts (Wolsey, 2008). Embedded annotations provide feedback at specific points in their text so that students can readily identify how instructors or other students are responding to their texts. For adding annotations on digital video, instructors and students can use YouTube annotations (au.youtube.com/t/annotations_about) or Video Ant (ant.umn.edu). Having students write their own annotations can enhance their metacognitive awareness about the rhetorical choices they are making when creating digital texts. Audience feedback can expand beyond the classroom when students submit their work, particularly for their fiction writing, for comments or ratings on sites such as FanFiction (www.fanfiction.net) or The Next Big Writer (www.thenextbigwriter.com).

Bulletin board responses. Another digital tool for providing feedback involves the use of email or online bulletin boards/forums (Kaplan, Rupley, Sparks, & Holcomb, 2007). By using email or a threaded bulletin board forum on classroom virtual learning sites such as Moodle, Blackboard, Desire2Learn, Drupal, Ning, or Nicenet.org, students post their writing and receive comments from peers on the bulletin board. Blackboard (www.blackboard.com), Desire2Learn (www.desire2learn.com), and Moodle (moodle.org), offer course management systems (CMS) designed for creating and conducting courses online; Drupal (http://drupal.org) and Ning (http://www.ning.com) can be used for social networking and communication; Nicenet (http://www.nicenet.org) offers an interactive classroom assistant. While Blackboard and Desire2Learn are commercial products, Moodle, Drupal, Ning, and Nicenet are open source and freely available. Each includes a range of communication tools, including bulletin board forums and tools for engaging in synchronous chats.

Blog comments. Because students are increasingly writing blogs or Twitter posts in their writing classes, another important, and easy-to-use, tool for providing feedback is the blog comment function appended to posts in the form of a blog comment box. (Students using WordPress blogs can add the CommentPress plug [www.futureofthebook.org/commentpress] that allows for comments about specific paragraphs within a blog post.)

These comments serve an important role in developing social conversation central to blogging. In using a blog with her students to discuss course readings and their writing processes, Kirsten found that the introverted students, who were often quiet in writing groups and class discussion, had much to say and significant feedback to give on the blog. Her students quickly began to exploit the multimedia

capabilities of the blog, posting videos and photos to express both their positive and negative aspects of the research process. Students then receive feedback about their audiences' engagement with their multimodal presentations.

Instructors can encourage peers to voice their personal reactions to one another's writing with the following social and formative "comment starters" (Davis, 2006) that encourage students to voice descriptive, "reader-based" feedback (Elbow, 1973). Such comment starters provide students with an understanding of how their peers are experiencing their texts, leading them to identify needed revisions:

> "This made me think about..., "I wonder why.... "Your writing made me form an opinion about... "This post is relevant because..., "Your writing made me think that we should..., "I wish I understood why..., "This is important because..., "Another thing to consider is..., "I can relate to this..., "This makes me think of..., "I discovered..., "I don't understand...., "I was reminded that..., or "I found myself wondering...." (p. 1).

When, for example, a peer notes, "I don't understand why you believe that drilling for more oil will not solve the oil shortage," a student then perceives the need to clarify their reasons for their position.

Students may also be using blog posts to reflect on their experiences of completing multimodal projects, using the blog for what Borton and Huot (2007) describe as a "progress-assessment journal." For example, they may reflect on the challenges of editing digital video as part of a digital storytelling project, reflections that teachers can use to assess what they are learning from creating multimodal texts. Teachers and peers can then provide blog comments on students' reflections, comments that may include suggestions for coping with difficulties they encounter in working on their projects.

Digital recorders/podcasts. Another set of asynchronous digital tools involves giving audio feedback using digital recorders or podcasts. Teachers or peers using audio feedback can verbally communicate information more quickly than when they use written comments (Anson, 1997). They also tend to avoid the "cold" or judgmental tone that can be associated with written comments.

In giving feedback to his students' blog posts and final papers, Richard records his comments on an Olympus digital recorder and then emails his students the digital files or posts them as podcasts on iTunes. He finds that in using audio feedback, he adopts a more conversational style than is the case when he gives written comments. Audio feedback works particularly well for providing feedback to multimodal projects that involve video where it is difficult to add written comments other than video annotations. And, because the feedback is stored as files, the students can always archive and refer to these comments at any time.

Advantages. One advantage of using these digital feedback tools is that they are focused on specific aspects of a text, which, of course, could also be the case with written comments. Another advantage of using digital comment tools is that there is no need to deal with paper: Word documents with comments can be emailed and Google Docs texts are totally online. Not having to exchange paper text is a major advantage for communicating outside of class, particularly for use in peer or tutor feedback when students are not able to easily exchange paper copies.

Another advantage of using digital comments on texts is that instructors can readily store examples of teachers' or peers' comments to students' papers, creating a repository of those examples for use in training peers to give meaningful peer feedback (Tseng & Tsai, 2007). For example, teachers can post examples of effective descriptive, reader-based comments on a course website, blog, or wiki. Similarly, teachers can share examples of students' revisions made as a result of feedback, using such tools as the revision history on a wiki—effectively modeling the revision process.

As we argue, the primary advantage of using these tools is apparent when a multimodal text is in digital video format. Teachers and peers who want to provide comments about specific aspects of a digital video are able to employ tools such as video annotations or digital audio feedback when commenting on such multimodal texts.

Challenges. Some of the advantages of asynchronous digital tools can also create challenges: the ability to pinpoint and focus on specific parts of a digital text can make it tempting to focus mostly on the parts of a text, rather than the whole; the ease of typing, rather than handwriting, comments can result in teachers giving students an overwhelming amount of feedback; and the need for specific software or a high speed connection for receiving audio and video files may limit students' ability to access feedback. It is also the case that, without the nonverbal cues operating in face-to-face conferences or the opportunities for interaction in synchronous chat, teachers' or peers' comments can be misinterpreted, sometimes as implying unintended negative judgments.

USING SYNCHRONOUS/HYBRID DIGITAL TOOLS FOR PROVIDING FEEDBACK AND ASSESSMENT

The tools we have discussed so far are primarily used to provide feedback asynchronously after students have shared their digital texts. However, as we noted at the outset, in responding to multimodal, new media texts, teachers need to provide continuous, ongoing feedback during the production process to scaffold students learning to self-assess. Synchronous conferences with teachers or peers serve as an arena for students to practice self-assessing sparked by teacher or peer

feedback. Because students often have difficulty self-assessing on their own, they need the guidance and support of an instructor or peer to help them identify issues in their text productions related to achieving their perceived purpose and intended effects on audiences. When they sense that they are not achieving those purposes and effects, authors then need opportunities to entertain alternative revisions to address these issues, something they can do especially well in a conference setting.

In synchronous online conferences, students submit text to instructors, peers, or writing center tutors (who may be peers who have completed training), who review the text and then discuss the writing and feedback in a chat exchange, encouraging students to self-assess and revise. In contrast to online asynchronous feedback, synchronous chat allows for real-time discussions with a student writer about writing issues or potential revisions (Crank, 2002); synchronous chat may also involve discussions with groups of student writers.

Depending on the characteristics of the online conferencing tool and the student's multimodal text, the synchronous conference may occur as a typed exchange in a basic chat interface, as typed work on an interactive screen (allowing participants to view, brainstorm, write, and edit a document live), or as an audio conference or a video conference accompanying the live screen. Currently, online conferences often occur using synchronous chat tools in Moodle, Blackboard, Desire2Learn, and Nicenet.org (described earlier in this chapter). Other resources for synchronous chats include TappedIn (www.tappedin.org, the site of an international community of educators, offers a range of tools including chat), iChat (a text and video messaging program for Macintosh users), and ooVoo (www.oovoo.com) or Adobe Acrobat Connect (web conferencing software that provides online meeting spaces).

Universities and schools are also beginning to set up their own online conference sites (Cho & Schunn, 2007). For example, the Writing@CSU site at Colorado State University (http://writing.colostate.edu/feedback.cfm), has been a pioneer online writing site; its resources include space for online conferencing.

Using the University of Minnesota SWS.online site. To illustrate the use of an online feedback site, we'll discuss the use of the University of Minnesota Student Writing Support Online (SWS.online), a two-phase writing consultation service available in the Center for Writing at the University of Minnesota, Twin Cities campus. Kirsten directs that Center; she and Linda both consult in SWS.online and also have consulted in asynchronous email-based settings. SWS.online is a secure, custom web application designed and developed by the Center for Writing team and built on open-source code. (For a video of a conference presentation on the development of SWS.online and research conducted on its value: mediamill. cla.umn.edu/mediamill/embedqt/14336.)

SWS.online enables us to conduct individual online writing conferences that consist first of an asynchronous read-and-respond phase, followed by a second phase: a scheduled 45-minute synchronous online conversation about writing. To begin the read-and-respond phase, a student visits the SWS.online web site and initiates one side of a dialogue with the writing consultant. They then engage in self-assessment and goal setting by entering information about the assignment and describing questions, concerns, and goals for coming to SWS.online; the interface for that part of the process appears in Figure 9.1.

After selecting an appointment time and online writing consultant, the student writer uploads their draft document. We encourage the student to continue self-assessing and planning by using online tools to highlight segments and pose specific questions the writing consultant will see when responding to the draft.

Figure 9.1. SWS.online interface for setting online conferencing goals

These requests for guidance from the student writer highlight the social, dialogic nature of the conference and also communicate that the writer maintains ownership of the draft and is engaging in a formative writing process, not merely submitting a product for review.

Although the assignment may be a traditional piece of text-based writing, the process of uploading it to SWS.online causes the work to become digital. The writer can then insert annotations (highlighted in pink on the interface) when preparing the submission; the consultant can modify it by inserting comments (highlighted in green on the interface); and both student and consultant can manipulate the digital text during the synchronous consultation. Using color to highlight text and draw attention to inserted comments may help student writers see their texts as changeable rather than fixed. The tools encourage students to write, revise, consider immediate reader-based feedback, and continue to revise; synchronous consultations can be active writing opportunities rather than just opportunities to talk about writing. The online writing consultant accesses the draft online and, during a scheduled 45-minute session, reviews and types formative comments about the draft. At the end of the first phase, the writing consultant electronically returns the draft and comments to the student.

Increasingly, SWS.online consultants indicate they think of the read-and-respond phase of a consultation as preparation for the synchronous chat about writing—not as a time to offer feedback about a paper or merely issue instructions for "fixing" a paper. Soon after beginning her work in SWS.online, Linda realized that this hybrid model allows her to remain aware that she is working with student writers, not just responding to or evaluating a piece of writing. She thinks of the student's queries and her responses and other comments as part of a conversation that will continue when consultant and student writer meet for the chat.

The SWS.online consultants, while reading and responding, use a range of approaches intended to initiate dialogue, suggest revision strategies, and guide the students to think about the upcoming online chat. The following sample comments, from a response to a high school student enrolled in the College-in-the-Schools program, a program where high school students receive college credits from the University of Minnesota, demonstrate some of the dialogic and formative feedback. In the first example, the writing consultant provides suggestions to the student writer about how they will work together in this online environment:

> [Consultant]: Hey [Student], my name is [Consultant] and I will be reading your paper today. As I read, I will make comments and suggestions in green, like this. Our follow-up chat is scheduled for tonight (Thursday) at 7:30pm. At that time, we can talk about any of my comments and suggestions, as well as any questions you may

have about your paper. We can also work together on revision and brainstorming and creating a check list of things that you may want to continue to do after the chat. I'm looking forward to talking with you tonight.—[Consultant].

The following example shows some of the same high school student's writing with the SWS.online consultant's dialogic comments and questions inserted. On the screen, the consultant's comments are highlighted in green; here, we italicize them for clarity:

> One explanation for this occurrence is the worldwide increase in the amount of precipitation due to global warming and the relocation of some of the precipitation (Gore, 2007, p. 112).
>
> *[Consultant]: Add a transition. How does this paragraph link to the paragraph before it?* Warming is dramatically showing up in the Arctic. All over Greenland and the Arctic, rising temperatures....

At the end of the student's draft, the online consultant restates a key point of her response; reinforces that the comments are suggestions, not directions; and reminds the student that they can discuss how to approach revisions when they meet to chat:

> *[Consultant]: My main suggestion for today is to think about your organization. Consider what the point of each paragraph is and then put all of the paragraphs with similar points together.... We can talk more about this during our chat tonight. I'm looking forward to talking with you then.*

After the response phase ends, at least 45 minutes (often more than that) passes before the synchronous chat begins. Many students use the time to review and consider the writing consultant's comments and make at least some revisions. Students are able to bring any revisions to the chat and use that time to focus on the new writing—if they wish. At the scheduled time, writing consultant and student writer meet online for the synchronous chat, conducted in our secure, password-protected space. This space is depicted in Figure 9.2, in this case, a chat between the same consultant and College-in-the-Schools high school student discussed above.

On the chat interface shown in Figure 9.2, the left portion of the screen presents the conversation in transcript format; the upper right portion displays the writer's document in an interactive DocBox in which the writer can complete revisions and the consultant can insert comments and examples live, during the chat. The document appearing in the DocBox includes comments inserted by the student writer and the writing consultant during the asynchronous phase of

Archived Chat

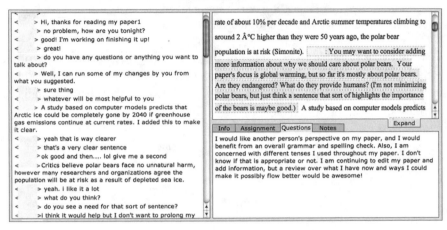

Figure 9.2. Online synchronous writing conference

the writing consultation; this document is editable in the interface, so both the student and consultant can acquire the "token" to revise the text. The lower right section of the interface displays information provided by the writer when submitting the draft. At the conclusion of the chat, SWS.online automatically emails the chat transcript to the student writer, who also has access to the annotated document and any revisions made in the interactive DocBox during the online conference. Students tell us they value having that transcript for reviewing what they need to do to revise.

The transcript depicted in Figure 9.2 reveals several practices that we believe are helpful to students. First, the interface itself sets expectations for interaction. The initially blank chat portion encourages the student to begin conversation; the student has the option of requesting and using the DocBox token; and the student can click amongst the tabs in the lower right section. Ideally, the student writer takes the lead, setting the stage for what she wants to focus on in the conference. Although not all students are so assertive, we find that, with prompting from writing consultants, student writers gradually come to understand that the conference is *their* time to discuss issues of writing in ways that they feel will best help them develop as writers. This student writer refers to comments the writing consultant made on the draft—and then presents some revisions made in preparation for the chat. The consultant and writer then discuss the revisions and how they will fit in the evolving document.

When the text is more multimodal—rather than a traditional print essay— the chat becomes a particularly rich space to discuss issues of audience, voice, and revision in online environments. For example, one student wanted some feedback

about how her audiences may be responding to her highly multimodal blog posts that contained a lot of text along with images:

> *Student*: There's something about blogging that makes me not care who my audience is. Not in a snotty way, but it's a weird public/private sort of vortex. You're right about the article title.
>
> *Consultant*: Yeah, blogging can have that effect, but at the same time you'll lose a lot of your readership if you don't still consider your audience.

Later in this same chat, the conversation returns to the question of media and audience, but here the student engages in her self-assessment in response to the consultant's earlier comments:

> *Student*: I'm looking at your summary comments.
>
> *Student*: I've heard that online writing is supposed to be more concise, way less language.
>
> *Student*: But the blogs I enjoy are ones with a distinct voice.
>
> *Student*: So I appreciate your comment about keeping the "fluff."
>
> *Consultant*: yea, I think that's mainly a style concern, but definitely if you want to get rid of the "fluff" that's something you'd want to start doing in the revision process.

Here, we see the kind of interactive, dialogic response triggered by multimodal writing. Online writing conferences like the ones shown above need not be limited to work with a single student. We are now modifying the SWS.online chat so a collaborative group can work online with a writing consultant, with each group member able to log in from his/her own computer and participate visibly and actively in the chat.

In the future, these synchronous online conferences will increasingly occur in virtual worlds such as Second Life, in which consultants and students will discuss their work via avatars.

Advantages. One of the advantages of online conferences over face-to-face conferences is that students are not limited to a classroom or writing center location; they can participate in conferences from their study locations. If writing consultations are scheduled during nontraditional hours, for example, evenings, students can receive feedback while they are studying—which may be when they most need help. And, while some students may prefer face-to-face conferences given the nonverbal interactions in these conferences, other students may be intimidated by nonverbal feedback and appreciate being able to communicate without concern for nonverbal reactions found in face-to-face conferencing. As a result, they can focus more on constructing the persona of the writer from the writing itself rather than on actual social or racial identities. A recent SWS.online student,

who is deaf, commented that this system enabled her to have a conference without needing to schedule a sign language interpreter. The instructors/peers/writing center tutors and student writers are able to develop interpersonal relationships as they write about writing rather than as they interact in physical spaces (Carlson & Apperson-Williams, 2000). By engaging in online conferences, students write more—and more often—and they may improve their understanding of audience and purpose because they know who is reading, and immediately learn how someone is reading, their words (Breuch, 2004). And, in contrast to face-to-face feedback, students can return to the chat transcript to reference when they are revising their drafts (Hewett, 2000).

Challenges. One of the challenges of online conferences is students' familiarity with using online chat for social purposes such as in Facebook, Twitter, or IMing; in peer conferences they may focus more on socializing than attending to their writing. As a result, student writers may be unsure how to proceed and engage in substantive conversations about their writing. Such situations suggest the need to structure online chats, for example in a "prewriting" conference by having students brainstorm about topic ideas and suggestions for resources for writing about those topics. During the chat, the instructor or online writing consultant can model online communication and might guide the process, when necessary, by setting agendas and asking questions that feature clearly defined choices for how the online conference should proceed. In addition, a particular chat environment may or may not be conducive to sharing all forms of multimodal texts. For example, the SWS.online interface makes it easy for students to select portions of text with hyperlinks out to larger online community, but does not have a means for submitting audio or video files.

USING ELECTRONIC PORTFOLIOS FOR FEEDBACK AND ASSESSMENT

Another digital tool for evaluating or assessing digital communication is the e-portfolio. In contrast to paper file portfolios, e-portfolios provide extensive space for students to store, access, review, and link their writing and other digital artifacts (Barrett, 2007; Gibson & Barrett, 2003; Kimball, 2005; Stefani, Mason, & Pegler, 2007). And, students can then provide ready access not only to their teachers, but also to peers, advisors, instructors, admissions officers, or potential employers, something far more cumbersome with paper portfolios. E-portfolios themselves reflect how multimodality, hypertextuality, and interactivity foster learning.

E-portfolios are particularly useful for fostering student self-reflection about multimodal writing. Students can describe relationships between their writing and digital/video texts in terms of comparisons of use of genre features; writing quality;

evidence of revision; development over time during a course or academic program; satisfaction with their writing quality; selection of media texts based on multimodal aspects of color, font, lighting, camera/production techniques, etc; and their use of digital tools. Students can also reflect on how they developed over time in their use of communication/digital literacies through engaging in multimodal production activities. For example, a student can compare a digital storytelling project completed in the beginning of the year with one completed at the end of the year, noting improvement in uses of combining images, music, and text to convey intended messages. Having some formal mechanism for engaging in ongoing reflections fosters metacognitive awareness essential for learning. It also helps writers see the evolution both of their own processes and their uses of technologies. As Yancey (2001) explained, "Electronic portfolios are live texts. They inform the students' choices, and they continue over time" (p. 24). Instructors report using e-portfolios to help students "make connections between and among classes, experiences, and observations" (p. 28). However, when not used intentionally, an e-portfolio becomes merely an electronic file cabinet filled with disparate digital files.

The University of Minnesota Electronic Portfolio (http://portfolio.umn.edu/portfolio) is an example of a flexible web-based tool that accepts a wide variety of multimodal texts from students and instructors. Students can put their digital texts in progress in the Electronic Portfolio and receive formative feedback from instructors and peers. Instructors can also encourage students to use the Electronic Portfolio as they reflect on their own digital communication, assess their learning over time as evidenced by digital artifacts, consider and use feedback from myriad authorized readers and viewers, and purposefully create individual digital "presentations" to share with instructors, advisors, and prospective employers.

First, a brief description of the tool—which is available to every member of the university system, at all campuses, and is password protected. As depicted in Figure 9.3, a University of Minnesota Electronic Portfolio owner uploads digital files, modifies the files over time, adds and modifies reflection and commentary, and organizes files into digital presentations.

The owner decides which files and presentations remain private and which are shared with others—and decides the length of time a file is available to individuals or groups. Even after the owner leaves the university, his/her Electronic Portfolio remains active and accessible from any Internet connection in the world; through the university's Technology for Life initiative, people can continue to manage, modify, and add to their digital files throughout their educational and professional careers, observing their growth in their uses of new media/digital literacies and assessing what texts are valuable and appropriate for different contexts.

At programmatic assessment level, many departments within the university system have created Electronic Portfolio templates that students use in their

Figure 9.3. Entrance to the University of Minnesota Electronic Portfolio

coursework. For example, the English Department at University of Minnesota, Duluth (UMD) expects their majors, working with their advisors over the course of their studies, to create Electronic Portfolio presentations of their competencies by including essays written during their coursework as well as a resume and cover letter. The department assesses the Electronic Portfolio of each English major before the student can graduate and then uses the Portfolio in departmental assessment activities. Students also use the Electronic Portfolio throughout their studies to receive formative feedback, complete many revision cycles, and identify multiple opportunities for combining and sharing digital files. For example, the student might upload a draft of one of the required documents, annotate the draft with questions and comments; write a reflection about an aspect of the document such as writing issues, audience, purpose, or questions; and then share the document electronically with one or several peers, instructors, and/or advisors, requesting feedback. The authorized reader(s) can read and comment electronically on the draft. Because the Electronic Portfolio accepts all file formats, the reader might provide comments in a digital audio or video file, or as typed comments directly on the document or in a separate comments text box. Importantly, the student can retain those comments files in the Electronic Portfolio—for example to use when making revisions or creating an archive of useful feedback. Students are able to use such artifacts to reflect on their development as writers; after graduation when applying for graduate school or employment, students can combine and share digital files.

E-portfolios can be used very effectively with multimodal texts as well as with written documents, with students including their videos, artwork, images, physical mock-ups, etc., to document their own multimodal learning. For example, the Theater Department requires their majors to include audio and video clips of musical and acting performances, images of their design work, and examples of stage management work. The department encourages students to examine clips of their work over time and write, in the e-portfolio, about their growth and development—and to obtain feedback from faculty who review portfolio segments. The UMN Medical School asks its students to use the Electronic Portfolio to establish a record of becoming a physician. Medical students create Electronic Portfolios that include personal statements, goals statements, specific course assignments, video examples from laboratory clinical work (e.g., interviews with standardized patients), videos of practical physical exams, and numerous reflections on their experiences. For medical students, their use of the tool is intended to "help you build the lifelong habits of independent learning, cultivate your own curiosity, and help you develop a passion for continued growth in knowledge, skills, and understanding" (https://portfolio.umn.edu/portfolio/viewWizard.do?wizard_id=57).

One alternative to using structured or commercial e-portfolios is to use blogs or wikis as e-portfolios that could stay with a student across many years of their academic career (Morgan, 2006). Blogs and wikis lend themselves to multimodal writing in that students can readily embed images and hypertext links. Students can also create links between their blog posts or wiki writing, which can then be searched according to topic using tags or chronological order, leading to reflections on the development of certain topics or development over time. For example, students may note how their later blog posts were more engaging than initial posts because they included more images in their later posts.

Advantages. By using an e-portfolio, instructors can help students learn to develop and revise a range of digital artifacts to demonstrate competencies; self-assess and reflect on their educational and professional development; and obtain feedback from faculty, peers, and other reviewers. Kimball (2005) suggests that reflection is the center of portfolio pedagogy and "is an ongoing process of learning that extends through the creation of individual artifacts and between them" (p. 451). To help students develop their abilities to reflect on learning, teachers can coach students, provide modeling, and give formative feedback over time. Gathercoal, Love, Bryde, and McKean (2001) explained that, in an electronic portfolio "faculty can give reflective feedback to the student, and the student can respond by altering the artifact or by ignoring the faculty member's comment" (p. 32). Students can also request comments from others, sharing their digital artifacts with experts within or beyond the educational community, thereby "reflecting

on each artifact with many mirrors" (Gathercoal, Love, Bryde, & McKean, 2001, p. 32). As has been the case for years with art, design, or architecture students, the e-portfolio becomes a primary tool for housing and fostering reflection on digital multimodal productions.

Challenges. Developing an e-portfolio that is more than an electronic filing cabinet can take time and persistent effort by students and instructors. Students need to see their own work over time, and be coached on how to interpret that work if they are to develop the ability to reflect on their learning. Even though students post digital text on blogs and wikis, they may not understand the full potential of digital communication for revision and development over time, or the value of linking digital files in ways that communicate. Instructor feedback and assessment using digital tools will help students use their e-portfolios to practice and reflect upon their own evolving digital literacies, and ultimately to produce complex, multimodal presentations that illustrate that evolution.

SUMMARY

In this chapter, we argue that effective feedback on students' digital multimodal communication requires criteria that differ from those appropriate for print-based texts. We then contend that digital feedback tools themselves serve to foster multi-modality, hypertextuality, and interactivity, particularly through uses of synchronous feedback and e-portfolio tools.

As the wealth of digital feedback tools in this chapter suggests, teachers can feel overwhelmed by the sheer number of possible options and the learning curves associated with use of these tools. Yet, experimenting with these tools, and learning how to use them alongside our students, can be a powerful way to engage our students in explicit discussions about how and why we assess digital texts. And, by making our own assessment practices more explicit, we have an opportunity to engage students in critical self-assessment and to push ourselves and our students to be more intentional in our composing, revising, and communicating with one another via multimodal texts.

REFERENCES

Albers, P., & Harste, J.C. (2007). The arts, new literacies, and multimodality. *English Education, 40*(1), 6–20.

Anson, C.M. (1997). In our own voices: Using recorded commentary to respond to writing. In P. Elbow & M.D. Sorcinelli (Eds.), *Learning to write: Strategies for assigning and responding to writing across the curriculum* (pp. 105–115). San Francisco, CA: Jossey-Bass.

Barrett, H.C. (2007). Researching electronic portfolios and learner engagement: The REFLECT initiative. *Journal of Adolescent and Adult Literacy, 50*(6), 436–449.

Bazerman, C. (2004). Intertextuality: How texts rely on other texts. In C. Bazerman & P. Prior (Eds.), *What writing does and how it does it: An introduction to analyzing texts and textual practices* (pp. 83–96). Mahwah, NJ: Lawrence Erlbaum.

Beach, R., Anson, C., Kastman-Breuch, L., & Swiss, T. (2009). *Engaging students in digital writing.* Norwood, MA: Christopher Gordon Publishers.

Beach, R., & Friedrich, T. (2006). Response to writing. In C.A. MacArthur, S. Graham, & J. Fitzgerald (Eds.), *Handbook of writing research* (pp. 222–234). New York: Guilford Press.

Blair, L. (2003). Teaching composition online: No longer the second-best choice. *Kairos, 8*(2). Retrieved on March 24, 2004 from http://english.ttu.edu/kairos/8.2/binder.html?praxis/blair/index.html

Blair, J.A. (2004). The rhetoric of visual arguments. In C.A. Hill, & M. Helmers (Eds.), *Defining visual rhetorics* (pp. 41–61). Mahwah, NJ: Erlbaum.

Borton, S.C., & Huot, B. (2007). Responding and assessing. In C. Selfe (Ed.), *Multimodal composition: Resources for teachers* (pp. 99–111). Cresskill, NJ: Hampton Press.

Breuch, L. (2004). *Virtual peer review.* Albany, NY: SUNY Press.

Carabajal, K., LaPointe, D., & Gunawardena, C. (2003). Group development in online learning communities. In M.G. Moore & W.G. Anderson (Eds.), *Handbook of distance education* (pp. 217–234). Mahwah, NJ: Lawrence Erlbaum.

Carlson, D.A., & Apperson-Williams, E. (2000). The anxieties of distance: Online tutors reflect. In J.A. Inman and D.N. Sewell (Eds.), *Taking flight with OWLS: Examining electronic writing center work* (pp. 129–139). Mahwah, NJ: Lawrence Erlbaum.

Cho, K., & Schunn, C.D. (2007). Scaffolded writing and rewriting in the discipline: A web-based reciprocal peer review system. *Computers & Education, 48*(3), 409–426.

Crank, V. (2002). Asynchronous electronic peer response in a hybrid basic writing classroom. *Teaching English in the Two-Year College, 30*(2), 145–155.

Davis, A. (2006). Significant comments. Improving instruction through the use of weblogs. Retrieved on February 28, 2008 from http://adavis.pbwiki.com/Significant-Comments

Du, H.S., & Wagnera, C. (2006). Weblog success: Exploring the role of technology. *International Journal of Human-Computer Studies, 64*(9), 789–798.

Elbow, P. (1973). *Writing without teachers.* New York: Oxford University Press.

Ferris, D.R. (2003). *Response to student writing: Implications for second language students.* Mahwah, NJ: Lawrence Erlbaum.

Gathercoal, P., Love, D., Bryde, B., & McKean, G. (2001). On implementing web-based electronic portfolios. *Educause Quarterly, 25*(2), 29–37.

Gore, A. (2007). *The assault on reason.* New York: Penguin Press.

Gibson, D., & Barrett, H. (2003). Directions in electronic portfolio development. *Contemporary Issues in Technology and Teacher Education, 2*(4), 559–576. Retrieved on April 26, 2007 from http://www.citejournal.org/vol2/iss4/general/CITEGibsonGeneral2.pdf

Hewett, B.L. (2000). Characteristics of interactive oral and computer-mediated peer group talk and its influence on revision. *Computers and Composition, 17*(3), 265–288.

Hull, G., & Katz, M. (2006). Crafting an agentive self: Case studies of digital storytelling. *Research in the Teaching of English, 41*(1), 43–81.

Kaplan, D.S., Rupley, W.H., Sparks, J., & Holcomb, A. (2007). Comparing traditional journal writing with journal writing shared over e-mail list serves as tools for facilitating reflective thinking: A study of preservice teachers. *Journal of Literacy Research, 39*(3), 357–387.

Kimball, M. (2005). Database e-portfolio systems: A critical appraisal. *Computers and Composition, 22*(4), 434–458.

Lee, A. (2000). *Composing critical pedagogies: Teaching writing as revision*. Urbana, IL: National Council of Teachers of English.

Mack, S. (2006). Improving students' writing using online workshops. Read, write, think lesson plan. Retrieved on March 13, 2008 from http://www.readwritethink.org/lessons/lesson_view.asp?id=1036

Moran, C., & Herrington, A. (2003). Evaluating academic hypertexts. In P. Takayoshi & B. Huot (Eds.), *Teaching writing with computers: An introduction* (pp. 247–257). Boston, MA: Houghton Mifflin.

Morgan, M.C. (2006). Wiki, blog, eFolio: How wikis and weblogs trump eportfolios. Retrieved on March 13, 2008 from http://mcmorgan.org/papers_and_presentations/wikis_blogs_and_efolio_how_.html

O'Reilly, T. (2005). What is Web 2.0: Design patterns and business models for the next generation of software. Retrieved on June 24, 2008 from http://www.oreillynet.com/pub/a/oreilly/tim/news/2005/09/30/what-is-web-20.html

Penrod, D. (2005). *Composition in convergence: The impact of new media on writing assessment*. Mahwah, NJ: Lawrence Erlbaum Associates.

Selfe, C.L. (Ed.) (2007). *Multimodal composition: Resources for teachers*. Cresskill, NJ: Hampton Press.

Stefani, L., Mason, R., & Pegler, C. (2007). *The educational potential of e-portfolios: Supporting personal development and reflective learning*. New York: Routledge.

Tseng, S., & Tsai, C. (2007). On-line peer assessment and the role of the peer feedback: A study of high school computer course. *Computers & Education, 49*(4), 943–1386.

Wolsey, T. (2008). Efficacy of instructor feedback on written work in an online program. *International Journal on E-Learning, 7*(2), 311–329.

Yancey, K.B. (2001). Digitized student portfolios. In B.L. Cambridge (Ed.), *Electronic portfolios: Emerging practices in student, faculty, and institutional learning* (pp. 15–30). Washington, DC: American Association for Higher Education.

Yancey, K.B. (2004). Looking for sources of coherence in a fragmented world: Notes toward a new assessment design. *Computers and Composition, 21*(1), 89–102.

New Literacies AND Teacher Education

ROBERTA F. HAMMETT

Recently in a London hotel room, I perused my hotel chain's tourist guide, even though I was at the end of my vacation. The front cover of the magazine caught my eye; it displayed a keyhole through which a number of iconic representations of London's offerings were depicted: haute couture, theatrical productions, Asian and Italian cuisine, beer and cocktails. The visual images conveyed it all; words were not needed to tell visitors what they could enjoy in London. As I traveled homeward by airplane, I unplugged my earphones from my MP3 player to hear the audio announcements on the plane's intercom system, even as I selected programs on the personal interactive video screen in front of me. One advertisement preceding the selected entertainment informed me that I could watch and vote for my favorite student video entry online at Enroutefilm.com. In my copy of *The Guardian* I read reviews of the top ten instructional videos posted on YouTube by "the new...stars who will change your life," selecting a few and jotting them in my notebook to watch when I had a free moment at the computer (Cooper, 2008, G2, p. 6). I also read, in the Media section: "Geeks rule the world like never before. Traditional media platforms—rocked by scandal and controversy—are faltering as digital outlets foster creativity" (Plunkett, 2008, Media, p. 1). The article continues as follows: "The new generation of UK media power are ditching the traditional gatekeepers and going straight to their audience on the web" (p. 2).

In Prensky's terms, I am a "digital immigrant"; he asserts that today's youth are "natives" and, like other researchers already cited in this book's introduction, argues that schools are not accommodating quickly enough to the multimodality and new literacies that characterize our global culture (Prensky, 2001). All too often curriculum, pedagogy, and assessment in schools stress reading and writing print texts and leave digital texts and multimodal communications for students' out of school pleasures (Hull & Schultz, 2002). Curricula, in most jurisdictions in the Western world, soundly endorse expanded notions of literacy—reading and writing, viewing and representing, speaking and listening. My list of texts at the beginning of this chapter (accessed as I returned from London) serves to remind all of us that ours is a multimodal and digital world, one in which new literacies constantly demand our attention and one in which knowledge of and skill in reading and writing, viewing and representing, speaking and listening are all important and often deeply integrated.

As several chapters in this book and published research discuss, many teachers may not always be comfortable integrating new literacies in their courses, or adopting different pedagogical practices (see Kedersha-McClay & Mackey, in Chapter 7 in this volume; Kimber & Wyatt-Smith, in Chapter 8 in this volume). Thus, I argue, teacher education has the responsibility of ensuring that early career teachers enter schools able to engage in new literacies, along with their students, and understand what learning goals and curricular outcomes might be achieved with digital technologies. In this chapter I will offer some possibilities for incorporating new literacies into school activities and suggest potential directions for implementing and assessing digital texts. I will draw on data collected in a study with preservice teachers to illustrate my arguments.

UNDERSTANDING NEW LITERACIES

The chapters in this book have provided a great deal of information about multimodal and digital texts. I use as my definition of literacies one that is provided by Lankshear and Knobel: "socially recognized ways of generating, communicating, and negotiating meaningful content through the medium of encoded texts within contexts of participation in Discourses (or, as members of Discourses)" (Lankshear & Knobel, 2006, p. 64). This definition stresses the participatory and collaborative nature of new literacies, particularly as enabled by Web 2.0. Although my discussions of new literacies in this chapter generally relate to online sites and technologies, computer technologies are not essential to new literacies (as demonstrated by Kendrick et al., in Chapter 4 in this volume; see also Kist, 2005, p. 23).

A wide variety of sites on the Internet illustrate Lankshear and Knobel's definition and offer possibilities for teaching current curriculum, like the writing process. Fan fiction sites (like Fanfiction.net) encourage reading and writing/rewriting stories. This "production" aspect is what interests me about new literacies; on a fan fiction site, for example, users not only read others' stories but also write reviews. Authors can request specific kinds of feedback they wish to receive. The site is also participatory in another way. Consider these announcements from the home page of the site:

> October 12th, 2007—The site is looking for 25 volunteers to help test a new feature in development. We are looking for long time users of the site that are both active readers and writers. Interested parties must have an [sic] site account for at least 1 year and is knowledgeable to the world of beta-reading. If you qualify and are willing, please email support@fanfiction.com with "Tester Account" as the subject line.

> Stepember [sic] 28th, 2007—Polls/Surveys Feature: Thanks to all the beta testers we are able to round out all the remaining issues with the new polling feature.

Thus, users may contribute as site consultants as well as readers and writers.

Another important aspect of new literacies is the extent to which producing texts and representing identities are involved. As YouTube says, "Broadcast Yourself." A YouTube user, for example, creates a digital video (video recording or assembling images and audio into a movie) to represent self. It may be biographical, political, humourous, or commonplace, portraying daily life. A recent favorite, combining all these elements, was Handmade Portraits: MV Knits. Users also respond (written comments) and rate others' videos. They may post their own video response, flag the video or add it to their personal playlists, or share it with friends by sending an email through the YouTube site. Such a site might easily be used by educators in teaching media literacy (both critique and production).

Activities are similar in a host of other Internet sites, including *I Can Has Cheezburger* which provides the technology to caption personal cat (pet) photos, according to set conventions, and post them on the site for others' enjoyment, recaptioning, and ratings. The conventions: speak for the cat by misspelling, misdeclining verbs, etc. If you are unsure how to LOLspeak, check out *The Definitive Lolcats Glossary* (http://speaklolspeak.com/?t=anon) for links to help sites. Students might enjoy learning correct grammar from this nongrammatical exercise.

These few examples are intended to exemplify the social, interactive, and communicative nature of new literacies online, as well as their classroom potential; the same sorts of activities can be reproduced on local area networks (LANs), in closed blogs, or using other technologies in schools. This article presents an argument for integrating these activities in schools, supported by others' research

that suggests that even traditional literacy skills (still highly valued in many institutions) can be enhanced by use of information and communication technologies (ICTs) in purposeful ways. Ensuring that all future teachers are familiar with new literacies and their pedagogical possibilities continues to be important even when younger generations are assumed to be "digital natives" (Prensky, 2001, p. 1). Furthermore, teachers have responsibility to promote equity in knowledge and skill with 21st century literacies, and to "attend to the ethical responsibilities required by these complex environments" (National Council of Teachers of English (NCTE), 2008, p. xx). As in the past, the onus for teaching technology-related skills, understandings, and attitudes sits with English language arts teachers.

TEACHING TECHNOLOGIES

As an educator, I have long been excited by the possibilities of computer and Internet technologies in the English classroom; in fact, when I miss-type the word "technologies," as I did just now, it often comes out as "teachnologies," and I always smile at the appropriateness of this error. In my previous research and writing (see, for example, Barrell & Hammett 2000; Hammett & Barrell, 2002; Hammett, 2000), I have discussed a number of ways that digital technologies might be incorporated in curriculum and pedagogy. Communication technologies such as email and asynchronous chat sites (closed or public) facilitate collaboration and peer editing. Image and movie-making technologies (e.g., Photo Story—www.microsoft.com/windowsxp/using/digitalphotography/photostory/default.mspx) may be used to combine audio (music and recorded commentary) with visual files (images and video clips) to create a movie. In my early teacher research with colleagues (Barrell & Hammett, 1999, 2002), we introduced preservice teachers to web conferencing (asynchronous chat rooms or closed bulletin boards) and to web page composition. We required our education students to contribute three "pages" each to comprehensive websites we created. In one case they responded in any way they wished to the novel *The Shipping News* (Website: Newfoundlanders Read *The Shipping News*) and in another case to the nonfiction works of Cassie Brown.[1] Important, in my view, have been the pedagogical aspects of this work. By this I mean what the students have learned about teaching and what they have produced rather than what technologies they have mastered or which texts produced by others they have consumed. We required preservice teachers to reflect on curriculum and pedagogical links to their web pages in class discussions and in self-evaluation activities. (These data are presented below.)

PRESERVICE TEACHERS' INSIGHTS

I asked the students in my teacher education course to submit self-evaluations of their technology work, and, with informed consent, I archived these documents as part of ongoing data collection in my research into preservice teachers' computer projects. I draw on these data, though ten years old, to support my inquiry into the importance of supporting technology learning and integration—new literacies integration—in teacher education, most particularly in English education.

Learning new skills and practices. Most preservice teachers began with little computer knowledge or skills beyond word processing and basic Internet use: "When I began making my first web page I was totally lost." They, thus, described new skills acquired: scanning; selecting, downloading, and inserting images and backgrounds; "playing with aesthetics"; creating and uploading web pages, downloading and installing software; and crediting sources and respecting copyright. They also expressed frustration with the steep learning curve they underwent, describing their experience as "trying, not to mention traumatizing at times" and "frightening in the beginning."

Collaboration was also a subtheme, particularly in regard to using technologies as these were individual compositions: "Aside from possessing zero knowledge of how to even begin a web page, I found it very frustrating having to ask for help." They did, however, come to value the help they could give to and receive from colleagues.

Another sense of collaboration—or, possibly, the social and participatory nature of the project—was also expressed by one preservice teacher who said creating web pages "provides opportunities for them to visit various [Internet] sites, converse with other students, and provides opportunities for them to share what they are learning with their community and classmates."

Another prospective teacher, reflecting on the bulletin board, wrote:

> If one thinks of all the worries and thoughts that adolescents experience during high school, I believe that such a writing experience as using a bulletin board can actually "open students up" and encourage them to share their views regarding life, not only literature. It's all about peers helping/advising peers.

These opportunities for social interaction, whether collaboration, mutual support, or sharing and cultural dialog are strong arguments for new literacies and technologies in schools.

Learning about text interpretation. I hoped the preservice teachers in my course would learn that there are many different alternatives to having students read a text and then answer comprehension questions about it; many of them did experience

this realization. One preservice teacher observed: "I have finally learned that every individual can read the exact same text in a completely different way resulting in various points of view on the author's style, the story's meaning, and the overall impressions of the book." Another explained:

> [T]eaching a novel doesn't necessarily demand a dull, read-aloud-to-the-class-while-they-drift-in-and-out-of-consciousness type of approach. It can be more interactive, hands-on type of approach that gets the class, as well as the teacher, involved.

Thinking about application of their experiences to their students' learning. Many of the preservice teachers in this study were able to think about their own learning and its potential use in their classes. One preservice teacher said, "I learned that web pages would be a good way to motivate my students in learning about any topic. I took great pride in the completion of the web pages and I think high school students would feel the same." Another said, "the web page activity has forced me to think critically about the text in a variety of different ways." And another wrote, "I learned through the web pages of others how different each student is and how the internet can be a vehicle by which to express these differences while keeping them in one forum [website] to be viewed and reacted to. I was able to see many different perspectives of the novel, when I read the other web pages, some of which had a profound influence on me." Together, these students expressed the elements in Lankshear and Knobel's definition of literacies cited earlier in this chapter: literacies are "socially recognized ways of generating, communicating and negotiating meaningful content through the medium of encoded texts within contexts of participation in Discourses (or, as members of Discourses)" (Lankshear and Knobel, 2006, p. 64).

These prospective teachers also recognized that their projects "represented student centered learning and critical thinking. Students have the opportunity to come to their own conclusions, demonstrate their own ideas and support their evaluations of the [novel]," as one student explained. Another stated:

> The web pages represent a critical, personal response to the text. This process allows the students to use affective, creative, and critical domains of thinking which represent higher thinking processes. The process also involves learning other media texts and the differences in presentation, and reading of those texts: colour, text, images etc.

While this latter comment illustrates the need for a metalanguage for discussing the various symbol systems involved, it also demonstrates the prospective teachers understanding of multiliteracies.

They also commented on the challenges presented by this assignment: "Effort was exerted in translating my ideas to the computer screen," explained one. And

"This was very much a 0 to 60 in three months performance for me—I came to this a tyro and now I'm acceptably literate," described another.

Several preservice teachers discussed the usefulness of web conferences (i.e., online class bulletin board, computer mediated communication) used in my course for discussing English education topics and readings. One subtheme centered on the comfort factor:

> The bulletin board allowed me to open my mouth and vocalize my thoughts. This is important for students that are too shy to speak up in class, as in my case. Speaking up in front of your peers can be a frightening experience especially if you fear "having the wrong answer."

Another echoed that sentiment: "The web pages I felt were a good way to break the ice with your peers." Dwight (2004) notes that online communications afford students (and other users) opportunities to "play at being other" (p. 97) to "to express multiple and often unexplored aspects of the self" (p. 98) to feel "more comfortable being able to communicate respectfully online" (p. 101) and to overcome "conventionally feminine discourse norms [that] are their natural way of communicating" (p. 102).

Another commonly-mentioned aspect of the asynchronous chat space offered in the course was its "opportunity for students to formulate their own opinions about other [postings], and…the opportunity to take their time in responding, not placed on the spot and left with nothing to say." Such sentiments are confirmed by research (see Berge & Collins, 1995; Garrison & Anderson, 2003; Graham & Scarborough, 1999).

In a variety of ways, prospective teachers experienced the potential of new literacies in teaching and learning. One preservice teacher summed it all up well:

> In producing web pages students will be able to access various sites and information, which can aid further understanding of a concept. Not only will they be able to surf, but they will become able to construct, download, and insert images and information. It also reinforces copyright laws, research skills, and an overall awareness of technology and what it can do for you, as a student, and as a teacher. It's a tool that opens so many doors of opportunity, and I, as a teacher will be including many computer-related activities to my students, whether it be in the form of e-mails, bulletin boards, presentations, research assignments, homework, assignments, journal writing, or web [page] construction. Computers will be used!!!

Learning about assessment. A few preservice teachers commented on assessment in their reflections. One observed (about her self-evaluation): "Sometimes it is not the finished product that is the most important but what the student learned along the way which matters the most. So in the ideal world this would be what determined the grade." Another observed, "The product is important and students will

take great pride and hopefully responsibility in their work but it cannot be graded without thought given to the process." While such comments argue the importance of process, there seems to be an absence of method for documenting and assessing the process and the learning; ah, there's the rub! This assessment issue eludes many educators. This data theme and the following two categories demonstrate my failure to build adequate understanding of the pedagogy of this activity.

Reservations/concern about ability to integrate technology. Some preservice teachers finished the course less confident that they would be capable of integrating technology in their teaching with assurance. One said, "I do not feel that I learned enough to confidently incorporate it into an ELA course." Her additional concern was "how to integrate technology without sacrificing the traditional student/teacher relationship." Another said: "I do not feel I learned enough...[but] will continue to try new things."

Projecting experiences toward their future teaching. Although, as illustrated above, these preservice teachers were able to articulate some applications of their experiences to their future teaching, there were opportunities missed to articulate a potential similarity between their learning and their pedagogy. For example, though many spoke of their sense of satisfaction at meeting a challenge, I did not get the sense they were projecting forward to how (or whether) their future students might benefit from similar challenges and thus derive similar pleasure. Rather, they ended with their own concerns: "I accomplished more than constructing three web pages. I met a challenge I thought near impossible...I also learned not to be intimidated by things which seem a little scary and insurmountable at first."

Additionally, although they appreciated the openness of the assignment, most did not articulate any sense that they would/could teach this way. For example, this student explained her learning opportunity well but did not carry it forward to a teaching possibility: "My Pulitzer Prize web page was created out of personal interest, and the fact that I could do an English assignment solely out of interest also felt liberating."

These data demonstrate both my students and me (and colleagues) as learners in integrating literacy and technology. They also illustrate that I did not adequately connect the activities required of the students with their future teaching; I needed to emphasize a pedagogy of integration. In the next section of the chapter, I would like to build on my earlier work and suggest pedagogy and curriculum that might be appropriate for new literacies in the classroom and, in particular, to encourage prospective teachers and their university instructors to undertake the incorporation of new literacies in education programs and courses. Included in the pedagogy should be assessment strategies.

PEDAGOGIES FOR NEW LITERACIES

To support pedagogical considerations in setting up a new literacies classroom, several frameworks for understanding literacy and literacy learning could be useful. These models, which I outline below, were generally developed in relation to reading and writing, but have been or can be adapted to other modes or semiotic systems and could guide new literacies integration. I suggest they can be useful in new literacies learning for both teacher education and K-to-12 classrooms.

Luke and Freebody (1999) developed the four resources model of reading, including four roles or resources for interacting with texts: code breaking, meaning making, text use, and text critique. These interrelated practices, given the caveats outlined by Luke and Freebody, provide a framework for teachers and students as they work with texts. Coauthors and I recently demonstrated how these practices might be applied to reading images (Hammett et al., in press). They might also be useful (as demonstrated by Anstey & Bull, 2006) to guide viewing and creating a wide variety of texts online and in various electronic media. As pedagogical activities, textual investigations might begin with decoding and encoding activities, including understanding and applying the semiotic systems, structures, and patterns of the text (code breaking); move on to meaning making by exploring and sharing the cultural and personal experiences they bring to make sense of the text; explore and develop goals, purposes, audiences, social, and cultural functions of the text and note or select appropriate tone, structure, and sequence in relation to the purposes and functions (text use); and, not least, "critically analyze and transform the texts" by examining their point of view, stereotypes, ideological perspectives, exclusions, assumptions, and taken for granted beliefs (Luke & Freebody, 1999, Mapping the Dimensions section). These same categories of interaction with texts can easily become the basis of assessment. The website My Read: Strategies for Teaching Reading in the Middle Years (www. myread.org) further explicates this model and provides examples of assessment strategies based on the model.

Green (1988) and Durrant and Green (2000) offered a way of thinking about literacies that they tagged a "3D model"; that is, a model that looked at literacy from three sides or interlocking dimensions: operational, cultural, and critical. In the operational dimension, skills, proficiencies, and technical competence, as well as "how to" knowledge prevail; in the cultural dimension, contexts and purposes of language and literacy are understood; and, in the critical dimension, political, perspectival, and relational aspects of knowledge and power as deployed within language and literacy and encoded within particular texts are considered. Within

a classroom, this model could guide reflection, response, and composition as set out in the curriculum and as enhanced by new literacies.

Nixon and Kerin (2001) describe a collaborative research project with teachers in two middle school classrooms, using Green's 3D model of l(IT)eracy to think about the pedagogy enacted. Comber and Green (1999) built on Green's (1988) 3D model, adding information and communication technologies (ICT) and "emphasising the IT in the word l(IT)eracy to symbolise the bringing together theoretically of literacy and IT" (Nixon and Kerin, 2001, para. 4 of A 3D model of l(IT)eracy section). Thus, the operational dimension includes technological basics of using computer hardware and software to access and create texts. The cultural dimension "includes understanding that we use texts and technologies to do things in the world" (para. 4 of A 3D model of l(IT)eracy section). The critical dimension "includes being able to assess and critique software and other resources, and to appropriately re-design them" (para. 4 of A 3D model of l(IT) eracy section). Using this model, applying all three dimensions simultaneously, teachers might build a l(IT)eracy curriculum integrating technology with official or mandated curriculum which is likely to be mostly based in print texts. As with the Freebody and Luke model discussed above, Green's 3D model leads appropriately into assessment, attending to the functional/operational dimension, the "how to do" dimension; the cultural dimension of what the text is doing; and the critical dimension of understanding, critiquing, and challenging the wider implications of the text.

Anstey and Bull (2006) map out a pedagogy of multiliteracies in their book *Teaching and Learning Multiliteracies*. As well as drawing on Luke and Freebody's work, they utilize the ground-breaking ideas of the New London Group (1996) and Cope and Kalantzis (2000). They describe the "characteristics of a multiliterate person" (Anstey & Bull, 2006, p. 41), suggesting that "[t]his description can help shape guidelines for balancing a multiliteracies curriculum" (p. 40). Their figure, translated roughly to a sentence, defines a multiliterate person thus: "The multiliterate person can interpret, use, and produce electronic, live, and paper texts that employ linguistic, visual, auditory, gestural, and special semiotic systems for social, cultural, political, civic, and economic purposes in socially and culturally diverse contexts" (p. 41). Throughout the book, they outline teaching and learning activities that are likely to help students construct this identity of a multiliterate person. Importantly, they outline some of the theory, terminology, and structures needed to understand and confidently interact with the various semiotic systems (aural, gestural, linguistic, visual, and spatial). They also provide auditing and assessment instruments for use within the four resources model.

Kress (2000), as one of the authors and proponents of multiliteracies (New London Group, 1996; Cope & Kalantzis, 2000), uses the concept design to frame

representation and transformation in multiliteracies. Design at its most basic level involves the selection of the most apt mode(s) to carry the various aspects of a particular message (Kress, 2000, p. 158). Kress (2004) makes clear that "the processes of making texts and reading texts are both processes of design" (p. 115). Kress argues that we need to consider the materiality of modes, "to describe the potentials and limitations for meaning which inhere in different modes" (p. 112). Design is about choice, about rhetoric, given the context of the communication. As Kress explains,

> If I have a number of ways of expressing and shaping my message, then the questions that confront me are: which mode is best, most apt, for the content/meaning I wish to communicate? Which mode most appeals to the audience whom I intend to address? Which mode most corresponds to my own interest at this point in shaping the message for communication? Which medium is preferred by my audience? Or by me? How am I positioning myself if I choose this medium or this mode rather than those others? (2004, p. 116).

As a pedagogical frame, this concept of design could involve learners in exploring and cataloging modes and their affordances, their rhetorical purposes and effects, within different media (as suggested by Bearne, this volume). These catalogs may then become the bases for self- and peer assessment, and for both formative and summative assessment by the teacher/instructor.

In preservice education programs, prospective teachers could be encouraged to select a pedagogical model to develop instruction (unit plan) in new literacies. Course activities could include blogging, developing course websites, tracking particular contributions on YouTube or fan fiction sites, exploring and demonstrating a Second Life site like Angela Thomas's *Shakespeare's Macbeth in Second Life* (see http://angelaathomas.files.wordpress.com/2008/10/virtual-macbeth.pdf), or investigating the affordances of a virtual play site like Webkinz World. Preservice teachers might be required to build an electronic portfolio that demonstrates they are "multiliterate" according to Anstey and Bull's definition (2006, p. 41).

Kist (2005) documented six classrooms in which teachers were integrating new literacies in their daily learning activities. In selecting the classrooms for his study, Kist used as his criteria "daily work in multiple forms of representation,... explicit discussions of the merits of using certain symbol systems in certain situations with much choice,... metadialogues [while] working through problems using certain symbol systems, [and]... tak[ing] part in a mix of individual and collaborative activities,... achieving a 'flow' state" (Kist, 2005, p. 16). I am suggesting that these characteristics may be considered a guide to teaching and assessing in a teacher education new literacies program.

CONCLUSION: ASSESSING NEW LITERACIES

While the models or pedagogical frameworks outlined above provide excellent options for incorporating new literacies in classrooms, both in preservice education and, subsequently, by prospective teachers in their own classrooms, the question remains how we might assess these new literate practices.

As he describes each classroom in which he observed new literacies in action, Kist (2005) documents assessment practices. He describes an assessment rubric that requires written records of research, citations of research material, evidence of self- and peer evaluations and evaluation of products, and outlines for culmination presentations (p. 31). He recounts another assessment strategy that requires students to demonstrate in writing their knowledge of symbol systems and to create non–print-based texts to convey underlying meanings of print texts (p. 115). In addition, teachers described in this study use rubrics and clear articulation of expectations and assignment criteria as assessment strategies (pp. 116–119). Like many researchers in classroom implementation of new literacies, Kist notes "tensions between goals of the teacher and goals of the official curriculum" (Kist, 2005, 58; see also Jacobsen, 2001; Keller & Bichelmeyer, 2004; Asselin et al., 2005). Thus, it is important in teacher education programs to examine current curriculum documents for spaces that invite new literacies activities and social practices.

In this chapter I have included quotations from preservice teachers' reflective self-evaluations of their computer work, written in response to my questions:

- Web page composing: What have you accomplished/produced and what have you learned?
- Novel: What did you learn about the novel?
- Teaching literature: What teaching concepts do your web pages represent?
- Web conferences: What did you do on the BBS [bulletin board system] and what did you learn from the experience?
- Technology integration: What did you learn/think about integrating computer technology in ELA [English language arts] teaching?

In retrospect I realize collaborative discussions and sharing might have been more productive than the individual responses. Overall, criteria appropriate for assessment were generated in the self-evaluations, but greater involvement in articulating explicit strategies for assessment is important in developing prospective teachers' understandings of its integration in pedagogy. In general, in their self-evaluations,

the prospective teachers emphasized their change from frustration to pride and confidence. A representative comment is as follows:

> Just a few months ago I did not have a clue about web pages, let alone how to create one. I was very intimidated at the beginning, and I think overcoming this fear and intimidation is one of the biggest accomplishments I have made this term, in any course. I am amazed at what I have produced.

It is important for preservice teachers to build upon such metacognitive reflection and incorporate it in a developing pedagogy for their own classrooms. As educators, both K-to-12 and university, we should ensure that students are left with the impression that learning, not technology, is the key. This emphasis on new literacies, and the technologies old and new that support them, is not technological literacy or information literacy, but rather an assertion that thought and action may be enacted and facilitated through technologies by users in particular contexts for particular purposes. Many educators include social justice and global understandings in their goals (Blackledge, 2000; Comber & Hill, 2000; Comber, Nixon & Reid, 2007).

It is also important that prospective teachers have opportunities to engage in technologies that afford new understandings of how they might integrate new literacies in their own classrooms. As Kist explains, teachers in his study did not always seem sure of the point of new literacies practices and seemed to implement "an autonomous model of new literacies" (2005, p. 128). Collaboration is not always social and participatory, in the Lankshear and Knobel sense of the phrase (2006, cited above). In my study, sometimes collaboration was limited to helping one another manage the technologies. However, preservice teachers recognized another sense of collaboration—that they were learning and interacting both within and outside themselves and our classroom with a wider world:

> It was well into the semester before I viewed [a fellow student's] intertextual connection page. This hit me like a ton of bricks. What a wonderful atmosphere in which to connect two texts. The option existed to link the page to other impressions of the two connected texts and enable the viewer to form their own conceptions concerning my views and those of others. The shrinking of the physical world enables this and the internet is the vessel by which to accomplish it. Connecting two texts in an essay in class demands the professor/teacher's intimate knowledge of both texts, thereby limiting the connections that can be adequately assessed and evaluated. The internet makes this much easier. It puts other perceptions of the same texts at the evaluator's fingertips.

Although the thinking here may be tentative and the articulation somewhat unsure, the point is made that only through the Internet can a wide variety of

texts and perspectives be hyperlinked and thus considered within a context that is social and participatory even though geographically distributed.

My final assertion is that the insights from the data discussed in this chapter, though generally related to technologies that are not "new," demonstrate the importance of challenging prospective teachers with new literacies and the pedagogies possible for their implementation in schools. Ten years after this study, we are still researching technology integration in schools and noting the divide between home and school literacies. Instructors in education programs must lead the way if boundaries between schools and homes and communities are to be crossed and new literacies are to be implemented across the curriculum, with goals of social justice. We all live in the world of multiple media that I described at the beginning of this chapter; I would hope young people find schools places where they learn to think critically about the digital, multimodal texts they encounter daily in their lives.

NOTE

1. This pedagogical work with co-instructor Robert Dawe has not been reported on in research journals, but the website is available for viewing at http://www.educ.mun.ca/e4142f00/index.html (accessed November 18, 2008).

REFERENCES

Anstey, M., & Bull, G. (2006). *Teaching and learning multiliteracies: Changing times, changing literacies.* Newark, DE: International Reading Association.

Asselin, M., Early, M., & Filipenko, M. (2005). Accountability, assessment, and the literacies of information and communication technologies. *Canadian Journal of Education, 28*(4), 802–826.

Barrell, B., & Hammett, R.F. (1999). Hypermedia as a medium for textual resistance. *English in Education, 33*(3), 21–30.

Barrell, B., & Hammett, R.F. (2000). *Advocating change: Contemporary issues in subject English.* Toronto, ON: Irwin Publishing.

Barrell, B., & Hammett, R.F. (2002). A critical social literacy project: Newfoundlanders challenge *The Shipping News.* 2002. *Interchange, 33*(2), 139–158.

Berge, Z., & Collins, M. (1995). Computer-mediated communication and the online classroom in distance learning. *Computer-Mediated Communication Magazine, 2*(4), 6. Retrieved on November 18, 2008 from http://www.ibiblio.org/cmc/mag/1995/apr/berge.html

Blackledge, A. (2000). *Literacy, power, and social justice.* Stoke on Trent, UK: Trentham Books.

Comber, B., & Green, B. (1999). *Information technology, literacy and educational disadvantage research and development*. Project Report to DETE SA, Vol. 1 (Adelaide, University of South Australia).

Comber, B., & Hill, S. (2000). Socio-economic disadvantage, literacy and social justice: Learning from longitudinal case study research. *The Australian Educational Researcher*, 27(3), 79–97.

Comber, B., Nixon, H., & Reid, J. (Eds.) (2007). *Literacies in place: Teaching environmental communication*. Newtown, NSW (AU): Primary English Teaching Association.

Cooper, L. (2008). Show and tell, *The Guardian*, July 14, G2, 6–9.

Cope, B., & Kalantzis, M. (2000). *Multiliteracies: Literacy learning and the design of social futures*. London and New York: Routledge.

Durrant, C., & Green, B. (2000) Literacy and the new technologies in school education: Meeting the l(IT)eracy challenge? *The Australian Journal of Language and Literacy*, 23(2), 88–109.

Dwight, J. (2004). "I'm just shy": Using structured computer-mediated communication to disrupt masculine discursive norms. *E–Learning, 1*(1), 94–104. Retrieved on November 18, 2008 from http://www.wwwords.co.uk/pdf/freetoview.asp?j=elea&vol=1&issue=1&year=2004&article=4_Dwight_ELEA_1_1_web

Garrison, D.R., & Anderson, T. (2003). *E-learning in the 21st century: A framework for research and practice*. London: RoutledgeFalmer.

Graham, M., & Scarborough, H. (1999). Computer mediated communication and collaborative learning in an undergraduate distance education environment. *Australian Journal of Educational Technology, 15*(1), 20–46. Retrieved on November 18, 2008 from http://www.ascilite.org.au/ajet/ajet15/graham.html

Green, B. (1988). Subject-specific literacy and school learning : A focus on writing. *Australian Journal of Education, 32*, 156–179.

Hammett, R.F. (2000). Girlfriend in a coma: Responding to literature through hypermedia. In A. Watts-Pailliotet & P. Mosenthal (Eds.), *Reconceptualizing literacy in the media age* (pp. 105–127). Vol. 8 of Advances in Reading/Language Research. Stamford, CT: JAI Press.

Hammett, R.F., & Barrell, B. (2002). *Digital expressions: Media literacy and English language arts*. Calgary: Detselig Enterprises Ltd.

Hammett, R.F., Burke, A., & Courtland, M.C. (In Press). Multicultural and visual elements. In *Josepha: A Prairie boy's story*. To be published in *Language and Literacy: A Canadian educational e-journal*.

Hull, G., & Schultz, K. (Eds.) (2002). *School's out!: Bridging out-of-school literacies with classroom practice*. New York: Teachers College Press.

Jacobsen, D.M. (2001). *Building different bridges: Technology integration, engaged student learning, and new approaches to professional development*. Paper presented at the 82nd Annual Meeting of the American Educational Research Association, Seattle, WA: April 10–14, 2001. Retrieved on November 18, 2008 from http://www.ucalgary.ca/~dmjacobs/aera/building_bridges.html

Keller, J.B., & Bichelmeyer, B. (2004). What happens when accountability meets technology integration. *TechTrends, 48*(3), 17–24.

Kist, W. (2005). *New literacies in action: Teaching and learning in multiple media.* New York: Teachers College Press.

Kress, G. (2000). Design and transformation: New theories of meaning. In B. Cope & M. Kalantzis (Eds.), *Multiliteracies: Literacy learning and the design of social futures* (pp. 153–161). London and New York: Routledge.

Kress, G. (2004). Reading images: Multimodality, representation and new media. *Information Design Journal + Document Design, 12*(2), 110–119.

Lankshear, C., & Knobel, M. (2006). *New literacies: Everyday practices and classroom learning* (2nd edn). Maidenhead: Open University Press.

Luke, A., & Freebody, P. (1999). Further notes on the four resources model. *Reading Online* (International Reading Association). Retrieved on November 18, 2008 from http://www.readingonline.org/research/lukefreebody.html

National Council of Teachers of English (NCTE), *A Definition of 21st-Century Literacies.* Retrieved on March 20, 2009 from http://www.ncte.org/positions/statements/21stcentdefinition

New London Group. (1996). A pedagogy of multiliteracies: Designing social futures. *Harvard Educational Review, 66*, 60–92.

Nixon, H., & Kerin, R. (2001, December). Collaborative research into ICT and the literacy curriculum: Expanding our repertoires of capabilities. Paper presented at the Australian Association for Research in Education Conference, Fremantle, WA, Australia. Retrieved on March 21, 2009 from http://www.aare.edu.au/01pap/nix01095.htm

Plunkett, J. (2008). Let's get digital. *The Guardian*, July 14, Media, 1–10.

Prensky, M. (2001). Digital natives, digital immigrants: Part1. *On the Horizon, 9*(5), 1–6.

Epilogue

JULIAN SEFTON-GREEN

Whilst New Literacies, as defined and used throughout this book, draw on changing and developing forms of digital technologies, they are not determined by the technology. Most authors here are interested not only in the social uses of technology but stress the opportunities for intervention and change that this moment seems to be offering education. Not only do many chapters suggest forms of assessment developed from the differing notions of authority and value that underpin social uses of new technologies but they pursue a logic reconfiguring power and the text within these new paradigms of author(ity) and meaning. As an outsider to this collection I was struck by how the exploration and teaching of new kinds of reading and writing were used reflexively, as a way of re-thinking good practices of teaching and learning emphasising formative evaluation and the co-production of meaning, and above all how assessing new literacies might lead to productive teaching and learning.

However much we might espouse these opportunities and welcome how new literacies and new kinds of technologically mediated reading and writing alter teacher/learner power relations, this is to ignore the work of new technologies in promoting standardisation, surveillance, control and forms of de-humanisation. This project too is not technologically determined but it has its own politico-economic logic and, it should be noted, is highly influential. In England, where I am based, the uses of e-assessment are relatively in their infancy but spreading.

Forms of multiple-choice, machine read assessment and changing forms of teacher participation in assessment , some deriving from well intentioned and benign philosophies (Sawyer, 2005) and some deriving from pragmatic understanding of the role of teachers[1] are gathering apace.

Whatever the rationale and whatever the motivation, it seems to me far from certain that the opportunities identified in this book for reframing evaluation or assessment as part of the wider beliefs underpinning the new literacies project will be scaled up let alone grasped by the mainstream. This book is surely right to identify a moment within curriculum development as schools and teachers negotiate social changes beyond their existing traditions, but we need to reflect on how schooling will recuperate and incorporate these changes within dominant paradigms.

For these reasons I want to offer some scenarios which perhaps pay more attention to the 'dark side' of digital technologies and try to imagine a continuation of the historically unfair and conservative trends in contemporary schooling. I do this partly because a part of me thinks this is what will happen but also to highlight that we shouldn't underestimate the barriers to the sorts of changes outlined in the rest of this book.

For many people yoking together digital technologies and assessment means developing forms of e-assessment. In general, this implies assessment that takes place by computer. Some e-assessment is formative and diagnostic but in many cases the quality judgments of teachers are processes carried out by machine which implies concomitant changes in defining what can get evaluated. There are a number of reasons (mainly to do with cost-effectiveness but also with questions of standardisation) why school systems embrace forms of e-assessment. One key advantage is that evaluation data from e-assessment can be translated seamlessly into databases describing student progress and achievement which can be inspected by other stakeholders within an education system. Developments in Artificial Intelligence suggest ever more sophisticated methods of assessing with more complex capacities to mimic judgement but given that many authors in this collection are fascinated by the nature of the dialogue stimulated between writers and readers of digital texts, it is not clear whether what is identified here can be replicated in future kinds of e-assessment.

A particular challenge for e-assessment is the multimodal nature of many new and changing kinds of texts. Whilst in theory we can imagine machines that can process multimedia, it would take considerable ambition to utilise computerised feedback on multimodal texts—in other words, forms of electronic response that are built around the actual digital uses practiced by young people. Most e-assessment enforces curriculum changes to produce the kinds of knowledge (in the appropriate forms) that can be examined. At present this will remain a source of conflict and tension.

One implication here is that evaluation and assessment will become two tier, with those in more privileged surroundings with more direct access to teacher time (online or face-to-face) being able to develop the kinds of imaginative liberal evaluation procedures outlined in many chapters above. However, digital assessment might also mean wholesale computerised marking of digital texts where the specifics of digital culture and the new-literacy ecology of reputational systems and even its necessary multimodality will be stripped away in the interests of corporate efficiency.

In that scenario Digital Literacy will therefore become less interesting as a social process and become reduced and constrained, almost commodified—with repeated tropes and conventions in order for it to become examin-able. It will have to be reduced to a series of commonly accepted descriptors normativising what at present are varied, organic and exceptional. Whilst many of the chapters above describe emerging practices, often bringing into school habits and interests developed outside, it seems a fair bet that many of the literacy activities identified here will become normativised with notions of competence and incompetent performance (going against a democratic empowerment deep grain identified by many authors) or such activities will simply become proscribed—or ignored—by mainstream education. In other words I am suggesting by way of provocation an authentic educational dialogue taking place in private, wealthy educational systems where teacher time, and teacher judgements are respected and where teachers know enough about new literacies to genuinely engage with their students. At the same time I suggest, mainstream public education will tend to e-assessed conventionalised performance criteria.

A key motivation here will be the need to prepare the future elites for the kinds of digital literacy competence described in many chapters here as a central part of necessary performance within a globalised technology. Equally, a familiarity with a wide range of the social uses of new literacies is a necessary component of the contemporary 'competent' child (Buckingham, 2000). The kinds of regimes I am hinting at will support and develop the performance of such subjectivities as part of their moral purpose.

At the same time, and this is of course not prophecy but simply flying a kite, digital literacy will become a kind of can/can't do competence within mainstream public education. It will appear on curricula in deference to notions of work-readiness. Large swathes of literacy learning will become prey to e-assessment procedures and that which cannot be examined will simply fall outside definitions of competence. This scenario is of course no more than critics of Literacy have maintained happens anyway, and other than the uses of e-assessment, shows how mainstream conceptualisations of literacy always veer to the normative and the constrained.

In a way, of course the kinds of differentiation outlined in these scenarios is also pertinent to the discussion because without some notions of incompetence or failure, assessment cannot work with a school system that is oriented towards stratification and forms of sorting. The status and value of incorporating new literacies within mainstream education come at this cost: that with recognition comes the sorts of value that many contributors to this volume actually argue are circumvented by the operations of new literacy practices in the digital domain.

One key issue then will be the development of learning progressions in digital literacy, including as I have already suggested ideas of in-competence and digital illiteracy. These ideas are, on the whole absent from the New Literacies movement and intellectual tradition for a range of scholarly and political reasons. However the assessment lens immediately forces consideration of these questions if assessment is to be consonant with what happens in schools in other subjects or in relation to other processes.

On the whole, although, for example computer game-players might have a clear sense of progressively difficult 'texts,' we don't know enough about participation in other kinds of online culture to differentiate between beginner, intermediate or 'advanced' reader/users. Equally developing grade criteria to match notions of levels will require the development of norms, conventions and above all professional consensus. Here then we have to distinguish between the 'natural' kinds of learning that take place through induction into practice, and the need to be taught and learn higher order skills (whatever might define a skill in this context). In what ways do some new literacy practices only need entry level 'skills'? And of course what might be their relationships between other kinds of learning progressions and other disciplines? Clearly further research and consensus building are necessary to imagine, develop and implement a complete assessment apparatus.

At present people without access to digital technologies (mainly through socio-economic exclusion or marginalised by gender, for example) cannot demonstrate understanding of new literacies and therefore would be deemed illiterate or digitally incompetent. Social exclusion is of course difficult to remediate through education and although studies of the provision of computers in schools as a way of building the sorts social capital in order to compete with those who have access to such resources at home are somewhat pessimistic about such strategies[2], in practice and day-to-day, teachers have been loath to embrace responsibilities which might lead to 'penalising' poorer students for the position they find themselves in. An enlightened use of the assessment of new digital literacies will have to bite this bullet.

Many of the contributors to this book are both more optimistic and more constructive than I am. By addressing these sorts of challenges and by exploring from the ground up how new literacy practices are constructed and developed, how they

clash or can be integrated in curriculum, at what level and in what way is clearly a sensible way forward offering a distinctly modernist vision of improving teaching and learning. A number of contributors note that only by addressing assessment can we really be at the heart of any drive to change schools, and such ambitions are crucial to the New Literacies project. However such aims will always be contested and assessment as a domain is more usually recuperated by conservative strategies than radical ones. There is nothing inevitable about the more gloomy scenarios I have suggested here, and it never does any harm to have a decent understanding of any forces one might oppose. I do however, suggest that the challenges identified here will have to be overcome if the enlightened and exciting possibilities of ways to approach, develop and understand the assessment of new literacies described in the preceding pages are to be realised in full.

NOTES

1. See for example, work undertaken, http://www.kcl.ac.uk/schools/sspp/education/research/groups/assess.html.
2. See for example Selwyn, 2007.

REFERENCES

Buckingham, D. (2000). *After the death of childhood: Growing up in the age of electronic media.* Cambridge: Polity Press.

Sawyer, R.K. (2005). Conclusion: The schools of the future. In R.K. Sawyer (Ed.), *The Cambridge handbook of the learning sciences* (pp. 567–580). Cambridge: Cambridge University Press.

Selwyn, N. (2007). Curriculum online? Exploring the political and commercial construction of the UK digital learning marketplace. *British Journal of Sociology of Education, 28*(2), 223–240.

Biographical Notes

Richard Beach is Professor of English Education at the University of Minnesota. His research focuses on response to literature and student writing as well as inquiry-based literacy instruction. He is the author of 16 books, including the co-authored books, *Teaching Writing Using Blogs, Wikis, and Other Digital Tools* (2009) and *High School Students' Competing Social Worlds: Negotiating Identities and Allegiances in Response to Multicultural Literature* (2007), and *Teaching Literature to Adolescents* (2006), as well as *Teachingmedialiteracy.com: A Web-based Guide to Links and Activities* (2007). Correspondence: Richard Beach, 359 Peik Hall, 159 Pillsbury Dr., SE, University of Minnesota, Minneapolis, MN 55455. Email: rbeach@umn.edu

Eve Bearne's research interests while at the University of Cambridge Faculty of Education have been children's production of multimodal texts and gender, language and literacy. She has also written and edited books about language and literacy and about children's literature. She is currently responsible for Publications for the United Kingdom Literacy Association.

Anne Burke is Assistant Professor of Literacy Education and Early Childhood Learning at the Faculty of Education, Memorial University of Newfoundland. Her research focuses on digital reading practices, assessment of new literacies, multimodal literacies, family literacy, children's multicultural literature, and virtual

play worlds for the young child. She is the author of two books in the area of pop culture for youth, *The Beat: Behind the Music* (2006) and *That's Entertainment* (2007); has published in *English Journal, E-Learning, JAAL, Changing English, International Journal of Learning*; and has made several book chapter contributions. She has researched and written widely in the area of new literacies and screen reading. Currently, she is researching virtual play environments, and participating as a coresearcher in a Canadian study on multicultural literature and teacher identity. Correspondence: Anne Burke, Memorial University, Faculty of Education, St. John's Newfoundland, Canada, A1B-3X8. Email: amburke@mun.ca

Linda Clemens is a Ph.D. candidate in Rhetoric and Scientific and Technical Communication, University of Minnesota. In the Center for Writing, she is a member of the online feedback team and consults both online and face-to-face. Her research interests include the relationships between writing pedagogy and interactive technologies, students' experiences with forms of online education and communication, and the roles of interactive technologies in graduate students' development as writers. Correspondence: Linda Clemens, Center for Writing, 10 Nicholson Hall, 216 Pillsbury Dr. SE, University of Minnesota, Minneapolis, MN 55455 USA. Email: cleme017@umn.edu

Margaret C. Hagood is Associate Professor in the School of Education at the College of Charleston. She teaches undergraduate and graduate courses in early childhood, elementary, and middle grade literacies, focusing on sociocultural and poststructural theories relevant to new literacies. She is a principal investigator and the director of research for the Center of the Advancement of New Literacies in Middle Grades, studying how middle grades educators and students understand new literacies and utilize out-of-school literacies to improve their literacy performance in teaching and learning in in-school settings. Correspondence: College of Charleston, School of Education, 86 Wentworth Street, Charleston, SC 29401. Email: hagoodm@cofc.edu.

Roberta F. Hammett is Professor of Education at Memorial University of Newfoundland. Her research interests centre on literacies, with a particular emphasis on their intersections with gender, identities, ICTs, secondary education, teacher education, media, community, and teacher professional development. Her recent publications include *Boys, Girls, and the Myths of Literacies and Learning*, co-edited with Kathy Sanford. Correspondence: Roberta F. Hammett, Faculty of Education, Memorial University, St. John's, NL, A1B 3X8 Canada. Email: hammett@mun.ca

Kirsten Jamsen is the Director of the Center for Writing at the University of Minnesota. Her teaching and research focus on the role of technology in writing

centers, the theory and practice of writing consultancy, the relationship between writing centers and institutional change, teacher professional development in preK–college settings, and writing across the curriculum. Correspondence: Kirsten Jamsen, Center for Writing, 10 Nicholson Hall, 216 Pillsbury Dr. SE, University of Minnesota, Minneapolis, MN 55455 Email: kjamsen@umn.edu

Jill Kedersha McClay is Professor in the Faculty of Education at the University of Alberta. Her research interests include writing theory and pedagogy, writing in contemporary literacy environments, and teacher education and development. Her recent publications include McClay, JK, Mackey, M, Carbonaro, M, Szafron, D, & Schaeffer, J. (2007). "Adolescents Composing Fiction in Digital Game and Written Formats: Tacit, Explicit, and Metacognitive Strategies," *e-Learning, 4*, 3, 273–284. Correspondence: Jill McClay, Dept. of Elementary Education, 551 Education South, University of Alberta, Edmonton, AB T6G 2G5 Canada. Email: jill.mcclay@ualberta.ca

Maureen Kendrick is Associate Professor in the Department of Language and Literacy Education at the University of British Columbia. Her research interests are in literacy and multimodality in diverse contexts, literacy and international development, digital literacies and teacher education, and family literacy. Correspondence: Maureen Kendrick, 2034 Lower Mall Road, University of British Columbia, Vancouver, BC V6T 1Z2. Email: maureen.kendrick@ubc.ca

Kay Kimber is currently on research secondment to Griffith University from Brisbane Girls Grammar School in the final year of an ARC-funded longitudinal study into secondary students' use and creation of curricular knowledge in online environments. Her doctoral research and English classroom practice have focused on the engagement of students-as-designers in creating digital representations of their developing understandings of texts. Email: k.kimber@griffith.edu.au

Margaret Mackey is Professor of Library and Information Studies at the University of Alberta. Her research explores how literacies are changing in the face of technological development, territory that includes children's and young adult literature, media adaptations, and a study of the narrative elements of books, films, and games. Recent publications include *Mapping Recreational Literacies* (Lang, 2007) and a four-volume edited anthology *Media Literacies: Major Themes in Education* (Routledge, 2008). Correspondence: School of Library and Information Studies, 3–20 Rutherford South, University of Alberta, Edmonton, AB, Canada T6G 2J4. Email: margaret.mackey@ualberta.ca

Roberta McKay is Professor Emerita in the Department of Elementary Education at the University of Alberta. She is currently the Director of the Masters of Education in the University of Alberta's Educational Studies Program.

Harriet Mutonyi is a Lecturer in the Faculty of Education at Uganda Martyrs University in Kampala Uganda. She recently completed her Ph.D. in Curriculum and Instruction at the University of British Columbia.

Jennifer Rowsell is Assistant Professor at Rutgers Graduate School of Education, where she teaches undergraduate and graduate courses in elementary and secondary literacy education. She teaches courses in the areas of multimodality, New Literacy Studies, multiliteracies, and family literacy. She is currently involved in three research projects: one looking at the notion of artifactual English with forty students at a secondary school in New Jersey, USA; another ARC-funded research study with colleagues Sue Nichols, Helen Nixon, and Sophia Rainbird of the University of South Australia on parents' networks of information on children's literacy and development; and, a research study on the production of new media and digital technologies as a pedagogy of innovation with Mary P. Sheridan-Rabideau at the University of Wyoming.

Julian Sefton-Green is an independent researcher working in Education and the Cultural and Creative Industries. He is a special Professor of Education at the University of Nottingham, UK and a research fellow at the University of Oslo. He has worked in an out-of-school centre for informal education and as Media Studies teacher in an inner city comprehensive school as well as in teacher training. He has researched and written widely on many aspects of media education, new technologies and informal learning and has directed research projects for the Arts Council of England, the British Film Institute, the London Development Agency and Creative Partnerships. www.julianseftongreen.net

Emily N. Skinner is Assistant Professor in the School of Education at the College of Charleston. Emily teaches literacy development and literacy methods courses for undergraduate and graduate students preparing to teach in preK–8th grade contexts. Emily is a principal investigator and the director of professional development for the Center for the Advancement of New Literacies in Middle Grades, a grant collaboration between the College of Charleston and the South Carolina Commission of Higher Education. The Center's work is focused on providing professional development and engaging in research related to middle school teachers' implementation of new literacies strategies in their classrooms. Correspondence: College of Charleston, School of Education, 86 Wentworth Street, Charleston, SC 29401. Email: skinnere@cofc.edu.

Melissa Venters is a graduate student at Teachers College, New York, studying the teaching of social studies. She is also a middle school history teacher. She has taught South Carolina History in Charleston, SC for four years. She currently teaches social studies in a single gender program. Email: miv2104@columbia.edu.

Claire Wyatt-Smith is Dean of the Faculty of Education at Griffith University. She has been a sole or chief investigator on a number of ARC- and DETYA/ DEST-funded projects over the last decade, primarily in the fields of literacy and assessment. Her research papers focus on teacher judgment, standards, digital literacies and the literacy-curriculum-assessment interface. Email: c.wyatt-smith@ griffith.edu.au

Benjamin Yelm is a middle school social studies teacher of Ancient World History and Modern History. He employs a variety of new literacies strategies learned while participating in a new literacies research project in his work with 6th and 7th grade students. Email: benjamin_yelm@charleston.k12.sc.us

Colin Lankshear, Michele Knobel,
& Michael Peters
*General Editor*s

New literacies and new knowledges are being invented "in
the streets" as people from all walks of life wrestle with
new technologies, shifting values, changing institutions,
and new structures of personality and temperament emerging
in a global informational age. These new literacies and
ways of knowing remain absent from classrooms. Many educa-
tion administrators, teachers, teacher educators, and aca-
demics seem largely unaware of them. Others actively
oppose them. Yet, they increasingly shape the engagements
and worlds of young people in societies like our own. The
New Literacies and Digital Epistemologies series will ex-
plore this terrain with a view to informing educational
theory and practice in constructively critical ways.

For further information about the series and submitting
manuscripts, please contact:

Michele Knobel & Colin Lankshear
Montclair State University
Dept. of Education and Human Services
3173 University Hall
Montclair, NJ 07043
michele@coatepec.net

To order other books in this series, please contact our
Customer Service Department at:

(800) 770-LANG (within the U.S.)
(212) 647-7706 (outside the U.S.)
(212) 647-7707 FAX

Or browse online by series at:

www.peterlang.com